Textual Practice

Contents

Volume 10 Issue 2

T'

Gayatri Chakravorty Spivak

Diasporas old and new: women in the transnational world

This essay is the text of a talk delivered at Rutgers University in March 1994. The dynamic of women in diaspora is so fast moving that it is hopeless to attempt to 'update' this. The reader might want to check Spivak, ' "Woman" as global theatre: Beijing 1995', *Radical Philosophy*, 75 (January/February 1996), pp. 2–4 for the line of revision that I would take. Increasingly and metaleptically, transnationality is becoming the name of the increased migrancy of labour. To substitute this name for the change from multinational capital in the economic restructuring of the (developed/ developing) globe – to re-code a change in the determination of capital as a cultural change – is a scary symptom of Cultural Studies, especially Feminist Cultural Studies.

What do I understand today by a 'transnational world?' That it is impossible for the new and developing states, the newly decolonizing or the old decolonizing nations, to escape the orthodox constraints of a 'neo-liberal' world economic system which, in the name of Development, and now 'sustainable development', removes all bar- riers between itself and fragile national economies, so that any possi- bility of building for social redistribution is severely damaged. In this new transnationality, what is usually meant by 'the new diaspora', the new scattering of the seeds of 'developing' nations, so that they can take root on developed ground? Eurocentric migration, labour export both male and female, border crossings, the seeking of political asylum, and the haunting in-place uprooting of 'comfort women' in Asia and Africa. What were the old diasporas, before the world was thoroughly consolidated as transnational? They were the results of religious oppression and war, of slavery and indenturing, trade and conquest, and intra-European economic migration which, since the nineteenth century, took the form of migration and immigration into the United States.

Textual Practice 10(2), 1996, 245–269 © 1996 Routledge 0950–236X

These are complex phenomena, each with a singular history of its own. And woman's relationship to each of these phenomena is oblique, ex-orbitant to the general story. It is true that, in transnationality their lines seem to cross mostly, though not always, in First World spaces, where the lines seem to end; labour migrancy is increasingly an object of investigation and oral history. Yet even this tremendous complexity cannot accommodate some issues involving 'women in the transnational world'. I list them here: (1) homeworking, (2) population control, (3) groups that cannot become diasporic, and (4) indigenous women outside of the Americas.

Homeworking involves women who, within all the divisions of the world, and in modes of production extending from the precapitalist to the post-fordist, embracing all class processes, do piece-work at home with no control over wages; and thus absorb the cost of health care, day care, work place safety, maintenance, management; through manipulation of the notion that feminine ethics is unpaid domestic labour ('nurturing') into the meretricious position that paid domestic labour is munificent or feminist, as the case may be. The concept of a diasporic multiculturalism is irrelevant here. The women stay at home, often impervious to organizational attempts through internalized gendering as a survival technique. They are part (but only part) of the group necessarily excluded from the implied readership of this essay.

Population Control is the name of the policy that is regularly tied to so-called aid packages, by transnational agencies, upon the poorest women. As workers like Malini Karkal, Farida Akhter, and many others have shown, the policy is no less than gynocide and war on women.[1] It is not only a way of concealing over-consumption – and each one of us in this room is on the average twenty to thirty times the size of a person in Somalia or Bangladesh; but it also stands in the way of feminist theory because it identifies women with their reproductive apparatus and grants them no other subjectship.

For 'groups that cannot become diasporic', I turn to the original definition of the 'subaltern' as it was transplanted from Gramsci:

> ... the demographic difference between the total ... population [of a colonial state] and all those who can be described as the 'elite'. Some of these classes and groups such as the lesser rural gentry, impoverished landlords, rich peasants ... upper-middle peasants [and now some sections of the urban white- and blue-collar work force and their wives] who 'naturally' ranked among the 'subaltern', [can] under certain circumstances act for the

'elite' . . . – an ambiguity which it is up to the [feminist] to sort
out on the basis of a close and judicious reading.[2]

Large groups within this space of difference subsist in transnationality
without escaping into diaspora. And indeed they would include most
indigenous groups outside Euramerica, which brings me to the last
item on the list of strategic exclusions above. Womanspace within
these groups cannot necessarily be charted when we consider diasp-
oras, old or new. Yet they are an important part of 'the transnational
world'.

What I have said so far is, strictly speaking, what Derrida called
an exergue.[3] It is both outside of the body of the work of this paper,
and the face of the coin upon which the currency of the Northern
interest in transnationality is stamped. This brief consideration of the
asymmetrical title of the conference can lead to a number of laby-
rinths that we cannot explore. I cut the meditation short and turn to
my general argument.

Nearly two years later, as I revise, I will linger a moment longer and
inscribe the 'groups that cannot become diasporic' more affirmatively,
as those who have stayed in place for more than thirty thousand
years. I do not value this by itself, but I must count it. Is there an
alternative vision of the human here? The tempo of learning to learn
from this immensely slow temporizing will not only take us clear
out of diasporas, but will also yield no answers or conclusions readily.
Let this stand as the name of the other of the question of diaspora.
That question, so taken for granted these days as the historically
necessary ground of resistance, marks the forgetting of this . . .

When we literary folk in the US do multiculturist feminist work in
the areas of our individual research and identity, we tend to produce
three sorts of thing: identitarian or theoretist (sometimes both at
once) analyses of literary/filmic texts available in English and other
European languages; accounts of more recognizably political
phenomena from a descriptive-culturalist or ideology-critical point
of view; and, when we speak of transnationality in a general way, we
think of global hybridity from the point of view of popular public
culture, military intervention, and the neocolonialism of *multi-
nationals*.

Thus from our areas of individual research and identity-group
in the United States, we produce exciting and good work. If we place
this list within the two lists I have already made, it becomes clear
that we do not often focus on the question of civil society. Hidden
and transmogrified in the foucauldian term 'civility', it hardly ever

surfaces in a transnationalist feminist discourse. In a brilliant and important recent essay, 'The heart of ex-nomination: nation, woman and the Indian immigrant bourgeoisie', Ananya Bhattacharjee has turned her attention to the topic.[4] But in the absence of developed supportive work in the transnationalist feminist collectivity, this interventionist intellectual has not been able to take her hunch on civil society as far as the rest of her otherwise instructive essay.

In an ideal democratic (as opposed to a theocratic, absolutist, or fascist) state, there are structures other than military and systemic or elective-political from which the individual – organized as a group if necessary – can demand service or redress. This is the abstract individual as citizen, who is 'concretely' re-coded as the witness, the source of attestation, in Marxian formulation the 'bearer' of the nation form of appearance. This 'person' is private neither in the legal nor the psychological sense. Some commonly understood arenas such as health, education, welfare and social security, and the civil as opposed to penal or criminal legal code fall within the purview of civil society. The individual who can thus call on the services of the civil society – the civil service of the state – is, ideally, the citizen. How far this is from the realized scene, especially if seen from the point of view of gays, women, indigenous and indigent peoples, and old and new diasporas, is of course obvious to all of us. However, it is still necessary to add that, within the definitions of an ideal civil society, if the state is a welfare state, it is directly the servant of the individual. When increasingly privatized, as in the New World Order, the priorities of the civil society are shifted from service to the citizen to capital maximization. It then becomes increasingly correct to say that the only source of male dignity is employment, just as the only source of genuine female dignity is unpaid domestic labour.[5]

I write under the sign of the reminder that the other scene, supposing any possible thought of civil societies (which is itself race-class- gender differentiated between South and North) of an almost tempoless temporizing, negotiating with the gift of time (if there is any), is not this.[6] It is our arrogant habit to think that other scene only as an exception to the temporizing focused by the Industrial Revolution, which I pursue below.

I began these remarks by saying that transnationality has severely damaged the possibilities of social redistribution in developing nations. Re-stated in the context of the argument from civil societies, we might say that transnationality is shrinking the possibility of an operative civil society in developing nations. The story of these nations can be incanted by the following formulas since the Industrial Revolution: colonialism, imperialism, neocolonialism, transnationality.

In the shift from imperialism to neocolonialism in the middle of this century the most urgent task that increasingly backfired was the very establishment of a civil society. We call this the failure of decolonization. And in transnationality possibilities of redressing this failure are being destroyed. I do not think it is incorrect to say that much of the new diaspora is determined by the increasing failure of a civil society in developing nations.

Strictly speaking, the undermining of the civil structures of society is now a global situation. Yet a general contrast can be made: in the North, welfare structures long in place are being dismantled. The diasporic underclass is often the worst victim. In the South, welfare structures cannot emerge as a result of the priorities of the transnational agencies. The rural poor and the urban subproletariat are the worst victims. In both these sectors, women are the super-dominated, the super-exploited, but *not in the same way*. And, even in the North, the formerly imperial European countries are in a different situation from the US or Japan. And in the South, the situations of Bangladesh and India, of South Africa and Zaire are not comparable. Political asylum, at first sight so different from economic migration, finally finds it much easier to re-code capitalism as democracy. It too, then, inscribes itself in the narrative of the manipulation of civil social structures in the interest of the financialization of the globe.

Elsewhere I have proposed the idea of the rise of varieties of theocracy, fascism, and ethnic cleansing as the flip side of this particular loosening of the hyphen between nation and state, the undermining of the civil structures of society. Here I want to emphasize that, as important as the displacement of 'culture', – which relates to the first word in the compound, 'nation', and is an ideological arena – is the exchange of state, which is an abstract area of calculation. Women, with other disenfranchised groups, have never been full subjects of and agents in civil society: in other words, first-class citizens of a state. And the mechanisms of civil society, although distinct from the state, are peculiar to it. And now, in transnationality, precisely because the limits and openings of a particular civil society are never transnational, the transnationalization of global capital requires a post-state class-system. The use of women in its establishment is the universalization of feminism of which the United Nations is increasingly becoming the instrument. In this re-territorialization, the collaborative non-governmental organizations are increasingly being called an 'international civil society', precisely to efface the role of the state. Saskia Sassen, although her confidence in the mechan-

isms of the state remains puzzling, has located a new 'economic citizenship' of power and legitimation in financial capital markets.[7]

Thus elite, upwardly mobile (generally academic) women of the new diasporas join hands with similar women in the so-called developing world to celebrate a new global public or private 'culture', often in the name of the underclass.[8]

Much work has been done on the relationship between the deliberate withholding of citizenship and internal colonization. In her 'Organizational resistance to care: African American women in policing', Mary Texeira has recently cited Mike Davis's idea of the 'designer drug-busts' in Los Angeles as 'easy victor[ies] in a drug "war" that the LAPD secretly loves losing'.[9] Michael Kearney shows vividly how the US Border Patrol keeps the illegal migrants illegal on the Mexican border.[10] The state can use their labour but must keep them out of civil society. In Marx's terms, capital extends its mode of exploitation but not its mode of social production. In Amin's, the periphery must remain feudalized.[11] In Walter Rodney's, underdevelopment must be developed.

In other words, are the new diasporas quite new? Every rupture is also a repetition. The only significant difference is the use, abuse, participation, and role of women. In broad strokes within the temporizing thematics of the Industrial Revolution, let us risk the following: Like the Bolshevik experiment, imperial and nationalist feminisms have also prepared the way for the abstract itinerary of the calculus of capital. 'Body as property' (see note 8) is an episode in 'The Eighteenth Brumaire of Bella Abzug'.

The study of diasporic women and the ambivalent use of culture in access to a national civil society is a subject of immense complexity whose surface has been barely scratched in terms of such cases as the *hijab*-debates in France. What is woman's relationship to cultural explanations in the nation-state of origin? What is 'culture' without the structural support of the state? And, as I have been insisting, the issue is different for women who are no longer seriously diasporic with reference to the modern state. This difference was brought home to me forcefully when a new diasporic student of mine, because her notion of citizenship was related to getting citizenship papers, was unable quite to grasp the following remark by Jean Franco:

> The imperative for Latin American women is thus not only the occupation and transformation of public space, the seizure of citizenship, but also the recognition that speaking as a woman within a pluralistic society may actually reinstitute, in a disguised

form, the same relationship of privilege that has separated the intelligentsia from the subaltern classes.[12]

Franco is suggesting, of course, that even women who resist and reject their politico-cultural description and collectively take the risk of acting as subjects of and agents in the civil society of their nation-state are not necessarily acting for all women.

In the case of Martinez vs. Santa Clara Pueblo, where by tribal law the mother cannot claim child custody because her divorced husband belonged to another tribe, and the Supreme Court refuses to interfere, Catherine McKinnon invokes, among other things, the matriarchal tribal laws of yore.[13] A transnational perspective would have allowed her to perceive this as the colonizing technique of all settler colonies: to create an artificial enclave within a general civil society to appease the rising patriarchal sentiments of the colonized. As the Women's Charter of the ANC pointed out forty years ago, invoking culture in such contexts is dangerous.[14]

I have suggested above that the boundaries of civil societies mark out the state but are still nationally defined. I have further suggested that a hyperreal class-consolidated civil society is now being produced to secure the post-statist conjuncture, even as religious nationalisms and ethnic conflict can be seen as 'retrogressive' ways of negotiating the transformation of the state in capitalist postmodernization. Feminists with a transnational consciousness will also be aware that the very civil structure *here* that they seek to shore up for gender justice can continue to participate in providing alibis for the operation of the major and definitive transnational activity, the financialization of the globe, and thus the suppression of the possibility of decolonization – the establishment and consolidation of a civil society *there*, the only means for an efficient and continuing calculus of gender justice *everywhere*.

The painstaking cultivation of such a contradictory, indeed aporetic, practical acknowledgement is the basis of a decolonization of the mind. The disenfranchised new or old diasporic woman cannot be called upon to inhabit this aporia. Her entire energy must be spent upon successful transplantation or insertion into the new state, often in the name of an old nation in the new. She is the site of global public culture privatized: the proper subject of real migrant activism. She may also be the victim of an exacerbated and violent patriarchy which operates in the name of the old nation as well – a sorry simulacrum of women in nationalism. Melanie Klein has allowed us the possibility of thinking this male violence as a reactive displace-

ment of the envy of the Anglos and the Anglo-clones, rather than proof that the culture of origin is necessarily more patriarchal.[15]

The disenfranchised woman of the diaspora – new and old – cannot, then, engage in the *critical* agency of civil society – citizenship in the most robust sense – to fight the depredations of 'global economic citizenship'. This is not to silence her, but rather desist from guilt-tripping her. For her the struggle is for access to the subjectship of the civil society of her new state: basic civil rights. Escaping from the failure of decolonization at home and abroad, she is not yet so secure in the state of desperate choice or chance as to even conceive of ridding her mind of the burden of transnationality. But perhaps her daughters or granddaughters – whichever generation arrives on the threshold of tertiary education – can. And the interventionist academic can assist them in this possibility rather than participate in their gradual indoctrination into an unexamined culturalism. This group of gendered outsiders inside are much in demand by the transnational agencies of globalization for employment and collaboration. It is therefore not altogether idle to ask that they should think of themselves collectively, not as victims below but agents above, resisting the consequences of globalization as well as redressing the cultural vicissitudes of migrancy.

This, then, is something like the situation of diasporas, and, in that situation, of our implied reader. The image of the classroom has already entered as a sort of threshold of description for the latter. Therefore we might well speak of classroom teaching. The so-called 'immediate experience' of migrancy is not necessarily consonant with transnational literacy, just as the suffering of individual labour is not consonant with the impetus of socialized resistance. In order that a transnationally literate resistance may, in the best case, develop, academic interventions may therefore be necessary; and we should not, perhaps, conflate the two.

Even if one is interventionist only in the academy, there are systemic problems, of course. And I do not intend to minimize them. It is again because of constraints on time that I am reminding ourselves only of the methodological *problems*. The first one is that the academy operates on the trickle down theory, with rather a minor change in the old dominant, which is that the essence of knowledge is knowledge about knowledge, and if you know the right thing your mind will change, and if your mind changes you will do good. I know how one must fight to change the components of academic knowledge. None the less one cannot fall into the habit of mere descriptive ideology-critical analyses – incidentally often called 'deconstruction' – and reproduce one's own kind in an individualistic

and competitive system in the name of transnationalism. We must remind ourselves that knowledge and thinking are halfway houses, that they are judged when they are set to work. Perhaps this can break our vanguardism that knowledge is acquired to be applied. I have tried to suggest that setting thought to work within the US civil structure in the interest of domestic justice is not necessarily a just intervention in transnationality. Thus we confront an agenda as impossible as it is necessary.

It is in the spirit of such speculation that I will move now to some thoughts about intervention only in the academy. In the Fall of 1993 I attempted to teach a course on global feminist theory. I will share with you some of the lessons I learnt during the semester. My earlier examples from Jean Franco and Catherine McKinnon are from that class, from the Latin and North American weeks respectively.

This is a list-making kind of essay. This part too will be a list of problems. The book list is long and I will only pick a few items on it. I have generally assigned collective responsibility for the problems. Of course that was not always the case. What I say will seem simple, but to implement what we proposed to ourselves, and to make a habit of it is difficult, certainly more difficult than inspirational political talk in the name of transnationality that silently presupposes a civil structure.

Starting with Ifi Amadiume's *Male Daughters, Female Husbands* we had our first problem: the internalization of European-style academic training.[16] All but one student was against Eurocentrism. But they valued non-contradiction above all else. (Students who come to my poststructuralism seminar can be coerced into relaxing this requirement. But global feminism is a tougher proposition. And, given the subdivision of labour in my institution at the moment and the reputation of the English Department, there were no Black students.) Amadiume, a Nigerian diasporic in London, wasn't doing too well by those standards. The only alternative the class could envision was the belligerent romanticization of cultural relativism. What seems contradictory to European may not to Africans? Nigerians? Ibos? I am not an Africanist and have been faulted for wanting to study African feminism in a general course. But even to me these relativist positions seemed offensive.

A combination of this impatience with illogic hardly covered over with relativist benevolence has now become the hallmark of UN-style feminist universalism.[17] I think it is therefore counterproductive today to keep out resistant non-natives or non-specialists from speaking on the obstacles to transnational literacy as they arise with

reference to different points on the map. At any rate, I learned to propose that we look always at what was at stake, a question that seemed to be much more practical than the litany of confessional or accusatory, but always determinist, descriptions of so-called 'subject-positions'.

I did not of course have the kind of insider's knowledge of Amadiume's place in the African field that I would have had if I had been an African or an Africanist. It did however seem fairly clear from Amadiume's text that she was pitting her own academic preparation in the house of apparent non-contradiction against 'my knowledge of my own people':

> When in the 1960s and 1970s female academics and western feminists began to attack social anthropology, riding on the crest of the new wave of women's studies, the issues they took on were androcentrism and sexism. [She cites Michelle Rosaldo, Louise Lamphere, and Rayna Reiter, among others.] The methods they adopted indicated to Black women that white feminists were no less racist than the patriarchs of social anthropology whom they were busy condemning for male bias.

If we take the magnitude of her predicament into account, we can look at the book as a strategic intervention.

Another problem that some found with Amadiume, and that was to surface again and again through the semester with reference to material from different geographical areas, was that the traditional gender-systems seemed too static and too rigid. Once again, I asked the class to consider the politics of the production of theory. Amadiume is an anthropologist by training. Africa has been a definitive object of anthropology. Oral traditions do not represent the dynamism of historicity in a way that we in the university recognize. And orality cannot be an *instrument* for historicizing in a book that we can read in class. I reminded myself silently of Derrida's tribute to the mnemic graph in orality: 'The genealogical relation and social classification are the stitched seam of arche-writing, condition of the (so-called oral) language, and of writing in the colloquial sense'.[18] Neither Amadiume nor her readers have at their command the memory active within an oral tradition as a medium. The only kind of thing we are capable of recognizing is where the technical instrument is European and the references alone are bits of 'ethnic' idiom, such as Mnouchkine's *Oresteia*, or Locsin's *Ballet Philippine*. But Amadiume is *questioning* the European technical instrument, from within, with no practical access to the instrumentality of her tradition, which makes a poorer showing in a medium not its own.[19] Of course,

the traditional gender system will seem 'too static' by contrast with the system we fight within.

In addition, as I have pointed out, traditional gender-systems have been used to appease colonized patriarchy by the fabrication of personal codes as opposed to imposed colonial civil and penal codes. They have also been the instrument for working out the displaced Envy of the colonized patriarchy against the colonizer. We must learn to look at customary law as a site of struggle, not as a competitor on a dynamism-count. This became most evident in our readings on Southern Africa.

But let me linger another moment on the question of what is at stake: who is addressed, within what institution? The class seemed to be most comfortable with the work of Niara Sudarkasa (Gloria A. Marshall), from the Department of Anthropology at the University of Michigan, a woman from an old US diaspora, produced through a reputable US university, who has taken a name from her cultural origin and is explaining that cultural material to other US tertiary students. I am not asking us to denigrate the evident excellence of her work. I am asking us to consider that our approval comes from the comfort of a shared cultural transcription; cultural difference domesticated and transcoded for a shared academic audience. Reading Filomena Steady's *Black Women Cross-Culturally*, I asked the students to read the notes on contributors as texts: what is at stake, who is addressed, what institution, *cui bono*?[20]

Given the difference, for example, between the liberal University of Cape Town and the radical University of the Western Cape, I could not dismiss out of hand a black man teaching customary law at the former institution as yet another academic. Indeed, the inventive constitutional transmogrification of customary law in some Southern African feminist constitutionalist work, in order that the frontage road to the highway of constitutional subjectship can be left open for the subaltern woman, attempts to face the contradiction which Jean Franco signals. We must learn to make a distinction between the demand, in itself worthy, for the museumization of national or national-origin 'cultures' within the instrumentality of an alien and oppressive civil society, and these attempts to invent a gendered civility. In this latter struggle, civil concerns within the new nation under duress must be aware of the threat of economic transnationaliz-ation, whose euphemistic description is 'Development' capital D, and the lifting of the barriers between international capital and developing national economies, euphemistically known as liberalization. Let us, for example, look at the warning issued by Mary Maboreke, Professor of Law at the University of Zimbabwe:

> Zimbabwe attained independence on 18 April 1980.... As of 1 October 1990, Zimbabwe abandoned its strict trade controls over trade liberalization.... [T]he new economic order flash[es] a warning light.... All the gains made so far would vanish.... Analyses of how deregulation programmes affected women should have been done before the problems arose. It is now rather late to demand the necessary guarantees and protections. As it is we have lost the initiative and are now limited to reacting to what authorities initiate.[21]

Unless we are able to open ourselves to the grounding feeling, however counterintuitive, that first world diasporic women are, by the principles of the case, on the other side from Maboreke, we will not be able to think transnationality in its transnational scope, let alone act upon it. We 'know' that to ground thinking upon feeling cannot be the basis of theory, but that 'is' how theory is 'judged in the wholly other', that 'is' the 'ghost of the undecidable' in every decision, that 'is' how the 'truth' of work is set or posited [*gesetzt*] in the work(ing), that is why logocentrism is not a pathology to be exposed or corrected, that is how we are disclosed and effaced in so-called human living, we cannot get around it in the name of academic or arty anti-essentialism.

When a prominent section of Australian feminists claim uniqueness by virtue of being 'femocrats', namely being systemically involved in civil society, we can certainly learn from them, but we might also mark their 'sanctioned ignorance' of the Southern African effort, sanctioned, among others, by themselves and us.[22] Some of us in the class pointed out that faith in constitutionality was betrayed after the Civil Rights struggle with the advent of the Reagan-Bush era. This certainly seems plausible in the US context. But this too is to universalize the United States as ground of evidence, one of the banes of United Nations feminism. Academic efforts at thinking global feminism must avoid this at all costs. The ungendered and unraced US constitution was and is widely supposed to be the first full flowering of the Enlightened State. To be foiled by its conservative strength is not to be equated with the attempt to put together a new constitution in Southern Africa – Zimbabwe, Botswana, Namibia, and now South Africa – and to strive to make it gender sensitive from the start. If the US experience is taken as *historically* determining, it is, whether we like it or not, Eurocentric. Philosophically, on the other hand, a persistent critique – that the subject of the constitution is the site of a performative passed off as a constative, that the restricted universalism of all ethno-customary systems share in some

such ruse, that all contemporary constitutions are male-reactively gendered – seems appropriate from those who have earned the right to practise it, so that a constitution is seen as dangerous and powerful; as a means, a skeleton, a halfway-house.[23]

I have repeatedly suggested that the word Development covers over the economics and epistemics of transnationality. 'Women in Development' can be its worst scam. Nowhere is this more evident than in Southeast Asia. This taught us (in the class) the importance of checking the specificity of imperial formations in our consideration of the women of each region. For it is in the clash and conflict of imperial subject-formation, indigenous/customary law, and regulative psychobiographies (the history of which we cannot enter without a solid foundation in local languages) that the track of women in the history of the transnational present can be haltingly followed.

In the case of Southeast Asia, for example, we have to follow the uneven example of US imperialism and the culture of development proper – export-processing zones, international subcontracting, post-fordism and how it reconstitutes women. Aihwa Ong helped us to see how the conventional story of colonialism and patriarchy will not allow us to solve the problem.[24] Her most telling object of investigation is so-called examples of mass hysteria among women in the workplace, and her analytical tool is foucauldian theory. Although Ong herself is impeccable in the politics of her intellectual production, she, like the rest of us, cannot be assured of a transnationally literate audience in the United States in the current conjunctures. The habit of differance between using 'high theory' to diagnose the suffering of the exploited or dominated on the one hand, and a self-righteous unexamined empiricism or 'experiencism' on the other produces the problem of recognizing theory when it does not come dressed in appropriate language. Foucault is full-dress and we had less difficulty in gaining mastery over our material by way of his speculations, when used by a developing nation-marked US diasporic, especially since the instructor's position of authority was also occupied by a similar subject, namely, Gayatri Spivak. When we resist this within the US field, our only route seems to be an altogether anti-theoreticist position, privileging anything that is offered by non-governmental activists and their constituencies, not to mention writers who describe them with a seemingly unmediated combination of statistics and restrained pathos. I cannot, at this fast clip, walk with you through learning and earning the right to discriminate among positions offered by 'participants'. Let me simply say here that out of all the good and fact-filled books on Southeast Asia we read, when we encountered, at the end of Noeleen Heyzer's painstaking book,

Working Women of Southeast Asia, full of activist research, words I am about to quote presently, we had difficulty recognizing theory because it was not framed in a Heideggerian staging of care, or a Derridean staging of responsibility.[25] But here *is* theory asking to be set into – posited in – the work (at least, as long as we are in the classroom) of reading, a task that would inform – and indeed this is what I have been trying to say in these crowded pages – an impossible and necessary task that would inform the overall theme of the conference where these words were first uttered beyond the outlines of the diasporic subject into transnationality; and make indeterminate the borders between the two.

> Women are culturally perceived as really responsible for tasks associated with the private sphere, especially of the family.... It is ... in the public sphere that bonds of solidarity are formed with others sharing similar views of the world.... [Yet] many cultures perceive the need to 'protect' women from being exposed to these.... [By contrast, t]he task ahead is certainly to spread the ethics of care and concern. This concern entails an alternative conception or vision of what is possible in human society ... a vision in which everyone will be responded to....

Let us linger a moment on the possibility of rethinking the opposition between diaspora and globality in the name of woman, *if* we can all recognize theory in activist feminist writing (since in the house of theory there is still a glass ceiling). In *Situating the Self* Seyla Benhabib is clearly looking for a more robust thinking of responsibility to supplement masculist political philosophies that radiate out from social needs and rights thinking.[26]

She cannot, however, conceive of the South as a locus of criticism. Her companions are all located in the North:

> Communitarian critics of liberalism like Alasdair MacIntyre, Michael Sandel, Charles Taylor and Michael Walzer ... [f]eminist thinkers like Carol Gilligan, Carole Pateman, Susan Moller Okin, Virginia Held, Iris Young, Nancy Fraser, and Drucilla Cornell ... [p]ostmodernists, ... by which we have come to designate the works of Michel Foucault, Jacques Derrida and Jean-François Lyotard ...

Following the Euro-US history of the division between public and private as male and female, her particular prophet is Carol Gilligan. She cannot find responsibility except in the private sphere of the family, and perhaps, today – though one cannot readily see why this is specifically modern – in friendship. She cannot, of course, recognize

an altogether more encompassing thought of responsibility in what she calls 'postmodernism'.[27] But neither 'postmodernism' nor Benhabib can acknowledge the battering of women in their normality by way of notions of responsibility.[28] It is left to women like Heyzer to recognize that responsibility – the impossible vision of responding to all – has the greatest chance of animating the ethical in the public sphere of women in development, when it becomes another name for superexploitation, precisely because, in such a case, feminine responsibility is conveniently defined, by the enemy, as it were, within the public sphere.[29] Here the incessant movements of restricted diasporas become more instructive than the cultural clamour of Eurocentric economic migration.

When Lily Moya, thwarted in her attempt to move from subalternity into organic intellectuality, runs away into Sophiatown and says 'the witchdoctor is menstruation' and 'My life was a transfer', even so astute a writer as Shula Marks looks for a diagnosis.[30] In the comfort of our fourth-floor seminar room, we were learning to recognize theory in unconventional representations, 'philosophy in the text of metaphor'.[31] Moya's propositions were to us as much of a challenge as 'man is a rational animal'.

On page 129 of *Beyond the Veil*, a common Arabic women's expression is quoted: *Kunt haida felwlad*.[32] It is rather a pity Fatima Mernissi translates this as: 'I was preoccupied with children'. If we translate this literally as 'I was then in boys', we get a theoretical lever. 'Boys' for all 'children' packs the same punch as 'man' for all persons. And if we take that 'in' and place it against the gynocidal thrust of the International Council on Population and Development connected to capital export and capital maximization – the correct description of transnationality – we come to understand the killing schizophrenia which these women suffer, caught in the unresolved contradiction of abusive pharmaceutical coercion to long-term or permanent contraception on the one side and ideological coercion to phallocentric reproduction on the other.[33] And *devenir-femme* in Deleuze and Guattari's *Capitalism and Schizophrenia* can then undergo a feminist reinscription which is para-sitical to the authors' *pouvoir-savoir*.[34]

I touch here upon the crucial topic of the task of the feminist translator as informant. Diaspora entails this task and permits its negligent performance. For diasporas also entail, at once, a necessary loss of contact with the idiomatic indispensability of the mother tongue. In the unexamined culturalism of academic diasporism, which ignores the urgency of transnationality, there is no one to check

uncaring translations that transcode in the interest of dominant feminist knowledge.

I began these remarks with a list of the groups that a title such as ours cannot grasp. I then rewrote their name as 'those who have stayed in place for more than thirty thousand years', as the limit to the authorized temporizing of our civilization as leading to and proceeding from the Industrial Revolution; the experience of the impossible that opens the calculus of resistance to transnationality. I suggested then that we are called by this limit only by way of battered and gender-compromised versions of responsibility-based ethical systems. Just as for the women of each geopolitical region, we have to surmise some network of response or reaction to hegemonic and/or imperialist subject-constitution, to distinguish the heterogeneities of the repositories of these systems one calculates the moves made by different modes of settler colonizations. And out of the remnants of one such settlement we were able to gain a bit of theory that gave the lie to ontopology and to identitarian culturalisms.

This lesson in theory is contained in the philosopheme 'lost our language', used by Australian aborigines of the East Kimberly region.[35] This expression does not mean that the persons involved do not know their aboriginal mother-tongue. It means, in the words of a social worker, that 'they have lost touch with their cultural base'. They no longer compute with it. It is not their software. Therefore what these people, who are the inheritors of settler colonial oppression, ask for is, quite appropriately, mainstream education, insertion into civil society, and the inclusion of some information about their culture in the curriculum; under the circumstances the only practical request. The concept-metaphor 'language' is here standing in for that word which names the main instrument for the performance of the temporizing that is called life. What the aboriginals are asking for is hegemonic access to chunks of narrative and descriptions of practice so that a representation of that instrumentality becomes available for performance as what is called theatre (or art, or literature, or indeed culture, even theory).[36] Given the rupture between the many languages of aboriginality and the waves of migration and colonial adventure clustered around the Industrial Revolution narrative, demands for multilingual education would be risible.[37]

What will happen to the woman's part in the lost 'software', so lovingly described by Diane Bell in *Daughters of the Dreaming*, is beyond or short of verification.[38] For 'culture' is changeful, and emerges when least referenced. This lesson I have learned, for

example, by way of the displacement of the scattered subaltern anti-colonialist ghost-dance initiative among the First Nations of the North American continent in the 1890s, then into political protest within the civil society at Wounded Knee in the 1970s and its current literary/authentic multiculturalist feminist transformations in Silko's *Almanac of the Dead.*[39]

For reasons of time, appropriate also because of my unease about academic identity politics in these transnationalizing times, South Asia, the place of my citizenship, the United States, the source of my income, and Northwestern Europe, the object of my limited expertise, remained blank on the first time of these remarks. And, apart from reasons of time at this second time, these omissions still seem appropriate. We certainly enjoyed reading some texts of Italian feminism.[40] But it was remarkable that, although diasporic third-world women offer large-scale support, through homeworking, to Italy's post-industrial base, and Benetton is one of the leaders in the field of post-fordist feminization of transnationality, these women and this phenomenon were never mentioned. The class discussions of civil society around the Italian feminists' expressed concerns were therefore interesting, especially since we followed up Swasti Mitter's documentation in her own work on economic restructuring in general.[41] Lack of time will not allow me to touch on the new postcoloniality in post-Soviet Asia and the Balkans; nor on the reasons why East Asia defeated me. These two complex issues do not fit within the broad lines I have laid out. Here's why, briefly.

The historical narratives which constituted 'the Balkans' and 'inner Asia' as regions are, in themselves, profoundly dissimilar. Yet, by way of their unified definition as Soviet Bloc, and thus their equally single dismantling, albeit into a disclosure of their heterogeneous historicity, they *seem* similar. Our temporizing is organized, not only around the Industrial Revolution, but also around single-nation empires. To see the uneven sovietization of the 'Soviet Bloc' in terms of the pre-capitalist multinational empires as well as the Asian bloc, we must examine the difference between Lenin's and Stalin's versions of imperialism and nationalism.[42] Although the unifying bulldozer of financialization is at work in the pores of the Balkans and the Transcaucasus – USAID building a 'civic society' in Bosnia, the IMF pressuring Armenia to settle Nogorny-Karabakh before loans are assured – the general question of the diaspora, as perceived by remote-control bleeding-heart feminism, is so patheticized by the human interest that can fill in the loosened hyphen between nation and state that questions of transnationality cannot be considered within a general feminist conference or course. Inner Asia, by

contrast, seems only too ready for anthologization into feminism. This may be a result of the existence of a small Russianized corps of emancipated bourgeois women in this sector. But who will gauge their separation from the subaltern, from Asian Islam; how, in more senses than one, they have 'lost their language' without being in the almost tempoless temporizing of the aboriginal limit? A new sort of subaltern studies is needed there, for which the appropriate discipline is history and an intimate knowledge of the local languages an absolute requirement. This is all the more necessary because this region's 'liberation' comes concurrently with the United States' consolidation for a culturally relativist feminist universalism making the world ultimately safe for Capital. My minimal attempts at tracking this region's preparation for the Fourth World Women's Conference organized by the United Nations at Beijing (1995) increases a conviction that the constitution of 'woman' as object-beneficiary of investigation and 'feminist' as subject-participant of investigation are as dubious here as elsewhere. I have not the languages for touching the phenomenon. And therefore it fitted neither my syllabus nor our title.

And East Asia. As controlling capital often a major player with the North. As superexploited womanspace one with the South and its non-elite networks. Hong Kong unravelling the previous conjuncture, territorial imperialism, the mark of Britain. China unravelling a planned economy to enter the US-dominated new empire. Economic miracle and strangulation of civil society in Vietnam. New World Asians (the old migrants) and New Immigrant Asians (often 'model minorities') being disciplinarized together. How will I understand feminist self-representation here? How set it to work? How trust the conference circuit? A simple academic limit, marked by a promise of future work.

To end with a warning. In the untrammelled financialization of the globe which is the New International Order, women marked by origins in the developing nations yet integrated or integrating into the US or EEC civil structure are a useful item. Gramsci uncannily predicted in his jail cell that the US would use its minorities in this way.[43] And remember Clarice Lispector's story, 'The smallest woman in the world', where the pregnant pygmy woman is the male anthropologist's most authentic object of reverence?[44] It is as if these two ingredients should combine. An example:

A little over a decade ago, I wrote a turgid piece called 'Can the Subaltern Speak?', which I have cited in footnote 8. The story there was of a 17-year-old woman who had hanged herself rather than kill, even in the armed struggle against Imperialism, and in the act had

tried to write a feminist statement with her body, using the script of menstruation to assert a claim to the public sphere which could not be received into what may be called a 'speech act'. Hence I lamented about this singular (non-)event: 'The subaltern cannot speak.' Her name was Bhubaneswari Bhaduri.

Bhubaneswari's elder sister's eldest daughter's eldest daughter's eldest daughter is a new US immigrant and has just been promoted to an executive position in a US-based transnational. This too is a historical silencing of the subaltern. When the news of this young woman's promotion was broadcast in the family amidst general jubilation, I could not help remarking to the eldest surviving female member: 'Bhubaneswari' – her nickname had been Talu – 'hanged herself in vain', but not too loudly. Is it any wonder that this young woman is a staunch multiculturalist, wears only cotton, and believes in natural childbirth?

There are, then, at least two problems that come with making the diaspora definitive: first, that we forget that postnationalist (NGO) talk is a way to cover over the decimation of the state as instrument of redistribution and redress. To think transnationality as labour migrancy, rather than one of the latest forms of appearance of postmodern capital, is to work, however remotely, in the ideological interest of the financialization of the globe.

And, secondly, it begins from the calculus of hybridity, forgetting the impossible other vision (just, perhaps, but not 'pure') of civilization, 'the loss of language' at the origin.

Meaghan Morris had apparently remarked to Dipesh Chakrabarty that most trashings of 'Can the Subaltern Speak?' read the title as 'Can the Subaltern Talk?' I will not improve upon that good word. I will simply thank Meaghan Morris for her witty support, as I will thank Abena Busia, Wahneema Lubiano, Geraldine Heng, Cassandra Kavanaugh, Ellen Rooney, Rey Chow, Jean Franco, and others, for making the syllabus possible; and the members of my seminar at Columbia in Fall 1993 and at the University of California-Riverside in Spring 1994 for teaching me with what responsibility we, women in a transnational world, must address ourselves to the topic: 'Diasporas Old and New'.

Columbia University

Notes

1 As I will show later, the complexity of Farida Akhter's position is to be understood from the weave (or text-ile) of her work, not merely her

verbal texts, which are, like all translations, not a substitute for the 'originals'. Let me cite, with this proviso, Akhter, *Depopulating Bangladesh* (Dhaka: Narigrantha, 1992) and Malini Karkal, *Can Family Planning Solve Population Problem?* (Bombay: Stree Uvach, 1989). The scene has been so Eurocentrically obfuscated that I hasten to add that this is not a socalled 'pro-life' position, but rather a dismissal of Western (Northern) universalization of its domestic problems in the name of woman. See also Spivak, 'Empowering women?', *Environment*, XXVII.I (January/February 1995), pp. 2–3.

2 Ranajit Guha, 'On some aspects of the historiography of Colonial India', in Guha (ed.), *Subaltern Studies: Writings on South Asian History and Society* (Delhi: Oxford University Press, 1982), p. 8.

3 Jacques Derrida, 'White mythology: metaphor in the text of philosophy', in Alan Bass, trans. *Margins of Philosophy* (Chicago: University of Chicago Press, 1982), p. 209: for update, see *Diacritics* 25:2 (Summer 1995), p. 12.

4 In *Public Culture*, 5, 1 (Fall 1992).

5 For the usual debate on civil society between left and right, see Justin Rosenberg, *The Empire of Civil Society: A Critique of the Realist Theory of International Relations* (New York: Verso, 1994) and Ernest Gellner, *Conditions of Liberty: Civil Society and Its Rivals* (New York: Allen Lane, 1994).

6 I use 'sup-pose' (rather than 'pre-suppose', which presupposes the subject's agency) here in what I understand to be Derrida's sense in *The Other Heading: Reflections on Today's Europe*, trans. Pascale-Anne Brault and Michael Naas (Bloomington: Indiana University Press, 1992), p. 76. The word *suppose* is unfortunately translated 'presuppose' in the English version. The imaginary map of geo-graphy as we understand it today has been traced by pushing the so-called aboriginals back, out, away, in. The story of the emergence of civil societies is sup-posed in that movement.

7 Saskia Sassen, *On Governance in the Global Economy* (New York: Columbia University Press, 1996, forthcoming).

8 The argument about feminist universalism propagated through the United Nations is beginning to invaginate this essay in its current revision. I am now convinced that the re-coding of transnationality (an economic phenomenon) as people moving across frontiers is part of this propagation: capital being recoded into capital-ism. I have proposed elsewhere that these United Nations initiatives in the name of woman have produced feminist apparatchiks whose activism is to organize the poorest women of the developing world incidentally in their own image ('train them to be women', in Christine Nicholls's bitter felicitous phrase) primarily in the interest of generating research fodder according to the old dominant: the essence of knowledge is knowledge about knowledge. As part of this endeavour, some large US-based organizations secure funds for non-elite NGOs in order to enrich their own databases, or to redirect the latter's energies towards activities favoured by the former: ideological manipulation of the simplest sort; rather like buying votes (in the interest of 'economic citizenship'). Recently I have twice heard this kind of activity described by two different people as 'working with' these NGOs. Here again the academic diasporic or minority woman thinking transnationality must be literate enough to ask: *cui bono*, working *for* whom,

in what interest? In 'The Body As Property: A Feminist Re-Vision' (in Faye Ginsburg and Rayna Rapp (eds), *Conceiving the New World Order,* Berkeley: University of California Press, 1995), Rosalind Pollack Petchesky almost quotes Farida Akhter, a Bangladeshi activist, for a few lines, only to substitute Carol Pateman, whose 'critique' seems to her to have an 'affinity' with Akhter but to be 'more systematic and encompassing' (p. 395). Not content with silencing Akhter by substitution, she then proceeds to provide a 'feminist' alternative to such 'essentialism' by way of ethnography (New Guinea tribal women can't be different from women exploited by post-fordism in Bangladesh!), sixteenth-century Paris, 'the early-modern European origins of ideas about owning one's own body' among the women of the British Levellers, and, finally, the work of Patricia Williams, the African-American legal theorist. Here is her version of Akhter: 'Farida Akhter, a women's health activist and researcher in Bangladesh, condemns "the individual right of woman over her own body" as an "unconscious mirroring of the capitalist-patriarchal ideology . . . premised on the logic of bourgeois individualism and inner urge of private property". According to Akhter, the idea that a woman owns her body turns it into a "reproductive factory," objectifies it, and denies that reproductive capacity is a "natural power we carry within ourselves." Behind her call for a "new social relationship" with regard to this "natural power" of woman lies a split between "the natural" woman and "the social" woman that brings Akhter closer to the essentialized embrace of "difference" by radical feminists than her Marxist framework might suggest' (pp. 394–5). In *Capital* I, Marx writes that the pivot of socialist resistance is to understand that labour *power* is the only commodity which is the site of a dynamic struggle (*Zwieschlächtigkeit*) between the private and the socializable. If the worker gets beyond thinking of work as *Privatarbeit* or individual work, and perceives it as a potential commodity (labourpower) of which s/he is the part-subject (since labourpower is an abstract average), s/he can begin to resist the appropriation of surplus value and turn capital toward social redistribution. As a person who is daily organizing struggles against transnationalization, Akhter expects familiarity with this first lesson of training for resistance. The trivial meaning of the proletarian is that s/he possesses nothing but the body, and is therefore 'free'. If one remains stuck on that, there is no possibility of socialism, but only employment on the factory floor. This *Zwieschlägtigkeit* between 'private' and 'social' (labour and labourpower) is Akhter's 'split between the "natural" and the "social" '. Notice that, in keeping with Marx, she uses 'power', where Petchesky substitutes 'woman'. And indeed, there is a bit of a paradox here: that the 'natural' in the human body should be susceptible to 'socialization'! Why is Akhter speaking of a 'reproductive power?' Because, as a person working against the depredations of capitalist/individualist reproductive engineering, she is daily aware that reproductive labourpower has been socialized. When she calls for a 'new social relationship', she is using it in the strict Marxist sense of 'social relations of production'. New because of the Marxist distinction between all other commodities and labourpower will not hold here. The produced commodities are children, also coded within the affective value form, not things. US personalism cannot think Marx's risky formulation of the

resistant use of socialized labourpower, just as it reduces Freud's risky metapsychology to ego psychoanalysis. Further, since its implied subject is the agent of rights-based bourgeois liberalism, it cannot think of the owned body from the proletarian perspective, as a dead-end road. It can only be the bearer of the 'abstract' legal body coded as 'concrete'. (It is of course also true that US-based UN feminism works in the interest of global financialization, aka development. Here I should say of Petchesky what I have said of Brontë and Freud in 'Three women's texts and a critique of imperialism', in Henry Louis Gates, Jr (ed.), *'Race', Writing and Difference* (Chicago: University of Chicago Press, 1985), p. 263; and in 'Can the subaltern speak?', in Cary Nelson and Lawrence Grossberg (eds), *Marxism and the Interpretation of Culture* (Champaign-Urbana: University of Illinois Press, 1988), pp. 296–7. Akhter expresses similar sentiments more simply in 'unconscious mirroring'.) Incidentally, it is also possible that the split between 'natural' and 'social' is that split between species-life and species-being that the young Marx brings forward and displaces into his later work as that between the realm of freedom and the realm of necessity: the limit to planning. But it would take the tempo of classroom teaching to show how US-based feminism cannot recognize theoretical sophistication in the South, which can only be the repository of an ethnographic 'cultural difference'. Here suffice it to say that Carol Pateman, with respect, is certainly not a more 'systematic and encompassing' version of Akhter. Where Akhter is a transnationalist Marxist, Pateman's excellent text could not negotiate the transition from feudalism to capitalism by putting surrogacy in line with prostitution and marriage. And you cannot answer the demand for a new social relation of production in the New World Order (post-Soviet financialization, patenting of the DNA of the subaltern body for pharmaceutical speculation etc.) by citing anthropology and early modern Europe. Indeed, it is not a question of citing coloured folks against coloured folks, but understanding the analysis. But perhaps the worst moment is the use of Patricia Williams. I cannot comment on the ethico-political agenda of silencing the critical voice of the South by way of a woman of colour in the North. It should at least be obvious that the abusive constitution of the body in chattel slavery is not the socialization of the body in exploitation. The matrilineality of slavery cannot be used as an affective alibi for the commodification of reproductive labour power. Williams herself makes it quite clear that today's underclass African-American wants to *feel* ownership of the body in reaction against her specific history and situation. And that situation is the contradiction of the use of chattel slavery to advance industrial capitalism. Patricia Williams writes of this use, this passage within the US juridico-legal system. She cannot be further used to 'disprove' the conjunctural predicament of the South. Women in a transnational world – notice Petchesky's use of artistic representation as evidence through the diasporic artists Mira Nair and Meena Alexander, both of Indian origin; not to mention the fact that, in transnationalization, the cases of Bangladesh and India are altogether dissimilar – must beware of the politics of the appropriation of theory.

9 Mike Davis, *City of Quartz: Excavating the Future in Los Angeles* (New York: Vintage Books, 1992), p. 267.

10 Michael Kearney, 'Borders and boundaries: state and self at the end of empire', *Journal of Historical Sociology*, vol. 4, no. 1 (March 1991), pp. 52–74.

11 Samir Amin, *Unequal Development: An Essay on the Social Formations of Peripheral Capitalism*, trans. Brian Pearce (New York: Monthly Review Press, 1976); Walter Rodney, *How Europe Underdeveloped Africa* (Washington DC: Howard University Press, 1981).

12 Jean Franco, *Plotting Women: Gender and Representation in Mexico* (New York: Columbia University Press, 1992), p. 11.

13 Catherine MacKinnon, *Feminism Unmediated: Discourses on Life and Law* (Cambridge, Mass.: Harvard University Press, 1987), pp. 63–9.

14 Raymond Suttner and Jeremy Cronin (eds), *Thirty Years of the Freedom Charter* (Johannesburg: Ravan Press, 1986), pp. 162–3.

15 Melanie Klein, *Envy and Gratitude* (London: Tavistock, 1957).

16 Ifi Amadiume, *Male Daughters, Female Husbands: Gender and Sex in African Society* (London: Zed Books, 1987). The passage quoted below is from p. 9.

17 A discussion of the impossible situation of the Bangladesh garment industry, caught between World Bank pressure against unionization and post-GATT social dumping, resulting in the fetishization of child labour with a total incomprehension of the situation of urban subaltern children in Bangladesh drew from a grant-rich 'feminist' sociologist colleague, conversant with the depredations upon welfare in New York, the remark that one must of course remember cultural difference! It had quite escaped this intellectual that I was speaking of Northern exploitation, not of some imagined Bangladeshi cultural preference for making children work! It's not much better with Southern academics. A similar discussion in Sri Lanka had elicited from a female graduate student the question: 'Is Gayatri Spivak for child labour?'

18 Derrida, *Of Grammatology*, trans. Spivak (Baltimore: Johns Hopkins University Press, 1976), p. 125.

19 I have tried to describe a similar predicament for myself in 'A response to Jean-Luc Nancy', in Juliet Flower MacCannell and Lara Zakarin (eds), *Thinking Bodies* (Stanford: Stanford University Press, 1994), pp. 39–48.

20 Filomina Chioma Steady (ed.), *The Black Woman Cross-Culturally* (Rochester: Schenkman, 1981).

21 'Women and law in post-independence Zimbabwe: experience and lessons', in Susan Bazilli (ed.), *Putting Women on the Agenda* (Johannesburg: Ravan Press, 1991), pp. 215, 236–7.

22 Hester Eisenstein, 'Speaking for women? Voices from the Australian Femocrat experiment', in *Australian Feminist Studies*, 14 (Summer 1991), pp. 29–42.

23 Derrida, 'Declarations of independence', trans. Thomas W. Keenan, in *New Political Science*, 15 (Summer 1986), pp. 7–15. But here too we must remind ourselves that the feeling/thinking ground is what makes the critique persistent even as it foils it: disclosure, alas, in effacement. All uses of 'deconstruction' as verb or noun are practically breached by this double bind. No use talking about infinite regress, for infinite progress is no different, only differant, in(de)finitely.

24 Aihwa Ong, *Spirits of Resistance and Capitalist Discipline: Factory Women in Malaysia* (Albany: Suny Press, 1987), Chapters 7, 8, 9, 10 (pp. 140–221).

25 Noeleen Heyzer, *Working Women in South-East Asia: Development, Subordination and Emancipation* (Philadelphia: Open University Press, 1986). The passage quoted is from pp. 131, 132.

26 Seyla Benhabib, *Situating the Self: Gender, Community and Postmodernism in Contemporary Ethics* (New York: Routledge, 1992). The passage quoted below is from pp. 2–3.

27 Thomas W. Keenan, *Fables of Responsibility: Between Literature and Politics* (Stanford: Stanford University Press, 1996, forthcoming).

28 Friga Haugg's excellent book, *Beyond Female Masochism: Memory-Work and Politics*, trans. Rodney Livingstone (London: Verso, 1992), indispensable for consciousness raising, legitimizes the European history of the compromising of responsibility-in-gender, by a mere reversal. To tease this out for responsibility-based systems requires a different sense of one's own position ('textuality'), a different agenda.

29 I am drawing on a big theme here, which I have merely touched upon by way of the notion of the differance between socialism and capitalism. (See Spivak, 'Supplementing Marxism', in Stephen Cullenberg and Bernd Magnus (eds), *Whither Marxism?* (New York: Routledge, 1994) p. 118–19. Derrida puts these impossibilities in the place of the figuration of the gift, if there is any. But a thinker like Karl-Otto Apel would simply dismiss them as 'utopian' ('Is the Ideal Communication Community a Utopia?', quoted in Benhabib, p. 81). My 'experience' here is of young women working in the garment factories in Bangladesh, displaced from their family, seemingly on a superior footing from the unemployed young men on the street, and yet without any care taken to recode their ethical beings into the public. I admire Carol Gilligan, but to cite her here is an insult; for she must retrain herself with a different group under observation and with the instruction of experts in the field such as Heyzer. *Mutatis mutandis*, I encounter a similar problem with the industry in revising Freudo-Lacanian psychoanalysis in the name of feminist cultural studies.

30 Shula Marks (ed.), *Not Either An Experimental Doll: The Separate Lives of Three South African Women* (Bloomington: Indiana University Press, 1987), pp. 207, 209.

31 I am of course reversing the subtitle of that essay by Derrida which I cited in note 3.

32 Fatima Mernissi, *Beyond the Veil: Male-Female Dynamics in Modern Muslim Society* (London: Al Saqi, 1985).

33 This contradiction is a *gendered* displacement of the broader contradiction, which has been pointed out in David Washbrook's essay 'Law, state and agrarian society in Colonial India' (*Modern Asian Studies*, 15.3, 1981, pp. 649–721), that if colonial practice operated in the interest of capitalist social productivity, the indigenous practices within which local capitalisms flourished contradicted that interest. See Ritu Birla, 'Hedging bets: politics of commercial ethics in late Colonial India', Department of History, Columbia University, dissertation in progress. The contradiction we are discussing is also a *classed* displacement of the earlier contradiction between emancipation and culturalism for women in the colonies.

34 Gilles Deleuze and Felix Guattari, *Anti-Oedipus: Capitalism and Schizophrenia*, trans. Robert Hurley, *et al.* (Minnesota: University of Minneapolis Press, 1983).

35 Kaye Thies, *Aboriginal Viewpoints on Education: A Survey in the East Kimberley Region* (Needlands: University of Western Australia, 1987).

36 After the Massacre at Wounded Knee Sitting Bull's cabin was taken to the 1893 Columbian Exposition at Chicago. This is claiming the right to theatre by the dominant, exactly the opposite of what we are commenting on. Or, not quite exactly. For the historically subordinated 'had' the language to lose, which the dominant only destroyed. Somewhere in between is Buffalo Bill Cody, who acquired the freedom of Wounded Knee participants so that they could show 'Wounded Knee'. Today's restricted multicultural diasporists would find in Cody their prototype. It is Capital in the abstract that 'frees' the subject of Eurocentric economic migration to stage 'culture' in First World multiculturalism.

37 See Gordon Brotherston, *The Book of the Fourth World* (Cambridge: Cambridge University Press, 1993); and, in the context of contemporary Canadian bilingualist struggle, Merwan Hassan, 'Articulation and coercion: the language crisis in Canada', in *Border/Lines* 36 (April 1995), pp. 28–35.

38 Diane Bell, *Daughters of the Dreaming* (Minneapolis: University of Minnesota Press, 1993).

39 Leslie Marmon Silko, *Almanac of the Dead* (Harmondsworth: Penguin, 1991).

40 Paola Bono and Sandra Kemp (eds), *Italian Feminist Thought: A Reader* (London: Blackwell, 1991). Patricia Cicogna and Teresa de Lauretis (eds), *Sexual Differences: A Theory of Social-Symbolic Practice* (Bloomington: Indiana University Press, 1990). Mirna Cicogna, 'Women subjects and women projects', *Australian Feminist Studies*, 4 (Autumn 1987). Rosi Braidotti, 'The Italian Women's Movement in the 1980s', *Australian Feminist Studies*, 3 (Summer 1986).

41 Swasti Mitter, 'Industrial restructuring and manufacturing homework: immigrant women in the UK clothing industry', *Capital and Class*, pp. 27, 47–9, 62, 75–6.

42 See Joseph Stalin, *Marxism and the National-Colonial Question: A Collection of Articles and Speeches* (San Francisco: Proletarian Publishers, 1975); and V. I. Lenin, *Imperialism, the Highest Stage of Capitalism: A Popular Outline* (New York: International Publishers, 1939). Although Stalin constantly invokes Lenin in order to legitimize himself, Lenin is speaking of the Northwestern European single nation empires and their connections to the march of Capital, whereas Stalin is speaking of the Russian, Ottoman, and Habsburg empires, and the manipulation of their cultures and identities in the interest of forming something like a future new empire. Thus their lines lead toward finance capital and linguistic and cultural politics respectively; in their current displacements, the economic phenomenon of transnationalization and its re-territorialization into migrant hybridity by multiculturalist diasporists, respectively.

43 See passage quoted in Mahasweta Devi, *Imaginary Maps*, trans. Spivak (New York: Routledge, 1995), pp. 212–13.

44 In Clarice Lispector, *Family Ties*, trans. Giovanni Pontiero (Austin: University of Texas Press, 1972), pp. 88–95.

ROUTLEDGE

THE ROUTLEDGE READER IN CARIBBEAN LITERATURE

Edited by
ALISON DONNELL,
Nottingham Trent University and
SARAH LAWSON WELSH,
College of Ripon and York St John

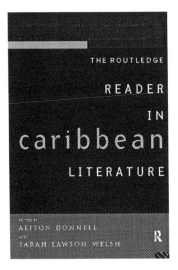

THE ROUTLEDGE

READER

IN

caribbean

LITERATURE

ALISON DONNELL
SARAH LAWSON WELSH

An outstanding compilation of over seventy primary and secondary texts of writing from the Caribbean. *The Routledge Reader in Caribbean Literature* convincingly demonstrates that these singular voices have emerged from a rich literary tradition which has, until now, been unknown or critically neglected.

August 1996: 234x156: 560pp
Hb: 0-415-12048-9: **£45.00**
Pb: 0-415-12049-7: **£14.99**

For further information please contact
Kevin Waudby, Routledge, 11 New
Fetter Lane, London EC4P 4EE.
Tel: 0171 842 2032 Fax: 0171 842 2306
E-mail: info.literature@routledge.com

THE ENGLISH LITERATURES OF AMERICA: AN ANTHOLOGY 1500-1800

Edited by MYRA JEHLEN and
MICHAEL WARNER,
both at Rutgers University

This anthology surveys the emergence of Anglo-American cultures in the first period of the European empires. It encompasses a wide range of writing from both sides of the ocean: early texts of the Native American, commentary from elite as well as common cultures, the Puritans in New England as well as the grand cosmopolitan culture of imperial London.

March 1996: 234x156: illus. 100
Pb: 0-415-90873-6: **£16.99**

HUMAN, ALL TOO HUMAN

Edited by DIANA FUSS,
Princeton University

The nine essays in this volume succeed in rethinking the category of the human, challenging some of our most cherished cultural classifications. By inviting us to place the traditional subject of knowledge in the unsettling position of object, these writers interrogate the distinctions that, until now, have exempted the human from the vigilant analysis it so urgently requires.

March 1996: 234x156: illus. 20 illustrations
Hb: 0-415-91499-X: **£40.00**
Pb: 0-415-91500-7: **£12.99**

REPRESENTING BLACK MEN

Edited by MARCELLUS BLOUNT,
Columbia University and
GEORGE CUNNINGHAM,
City University of New York

Representing Black Men focuses on gender, race and representation in the literary and cultural work of black men. It examines the ways in which black masculinities figure in African-American and American cultures, exploring their constructions in theory, culture and literature.

September 1996: 234x156: 256pp
Hb: 0-415-90758-6: **£37.50**
Pb: 0-415-90759-4: **£12.99**

Alan Sinfield

Diaspora and hybridity: queer identities and the ethnicity model

'It's as if we were an ethnic grouping' – Peter Burton writes in *Gay Times* (April 1995). The idea goes back, at least, to *The Homosexualization of America* (1982), where Dennis Altman observes that gay men in the United States have since the 1970s adopted an 'ethnic' mode of identification: 'As gays are increasingly being perceived as a minority in the best American tradition, it is hardly surprising that they have come to claim a political role based on this fact.'[1]

Ethnicity is not the only framework through which we have envizaged same-sex passion. As Eve Sedgwick points out, we have operated, together and incoherently, two ideas: minoritizing and universalizing. In the former, lesbians and gay men constitute a fairly fixed minority, as an ethnic group is supposed to do; in the latter, virtually everyone has a potential for same-sex passion.[2] Hence the ongoing argy-bargy about how 'widespread' homosexuality is: it depends how the question is put. If 'it' is defined so as to require an acknowledged identity and a gay 'lifestyle', research will find few instances. If 'it' is any intense same-sex bonding or the occasional occurrence of any same-sex act, then research will find hardly anyone to be immune.

Thinking of lesbians and/or gay men as an ethnic group is a minoritizing move, and it runs counter to the constructed and decentred status of the subject as s/he is apprehended in current theory. Nonetheless, very many lesbians and gay men today feel, intuitively, that the ethnicity model best accounts for them. This is partly because, as Steven Epstein suggests, we have constituted ourselves in the period when ethnicity, following the precedent of the Black Civil Rights movement, has offered the dominant paradigm for political advancement. It has become 'the default model for all minority movements', Michael Warner remarks.[3] So we too claim our rights: that is what ethnic groups do. The culmination of this tend-

Textual Practice 10(2), 1996, 271–293

ency is Simon LeVay's belief that he is doing us all a good turn by locating a part of the brain that is different in gay men, because this will enable US gays to claim recognition in the courts as a minority having immutable characteristics.[4] So North American lesbians and gays can get to be as well-off as the Indian peoples.

In other quarters, the ethnic model is under new kinds of question. In a review of Marjorie Garber's book, *Vice Versa: Bisexuality and the Eroticism of Everyday Life*, Edmund White begins by remarking: 'In the United States, where so many political factions are linked to ethnic identity, homosexuals have been astute in presenting themselves as something very much like a racial or cultural identity.' But White concludes by wondering 'whether I myself might not have been bisexual had I lived in another era'. The post-Stonewall drive to *be gay* limited him: 'I denied the authenticity of my earlier heterosexual feelings in the light of my later homosexual identity'.[5]

It is not, altogether, a matter of deciding how far we want to go with ethnicity-and-rights; the dominance of that model is not incidental. For it is not that existing categories of gay men and lesbians have come forward to claim their rights, but that we have become constituted *as gay* in the terms of a discourse of ethnicity-and-rights. This discourse was active, and apparently effective, elsewhere in the political formation, and afforded us opportunity to identify ourselves – to *become ourselves*. This has meant both adding to and subtracting from our potential subjectivities. As Didi Herman puts it, rights frameworks 'pull in "new" identities . . . people are forced to compartmentalize their complex subjectivities in order to "make a claim" '.[6] Again: 'The person who takes up a post-Stonewall gay identity feels compelled to act in a way that will constitute her or himself as a subject appropriate to civil rights discourse', Cindy Patton observes.[7] Gay men and lesbians *are*: a group, or groups, claiming rights.

There are drawbacks with envisaging ourselves through a framework of ethnicity-and-rights. One is that it consolidates our constituency at the expense of limiting it. If you are lower-class, gay lobbying and lifestyle are less convenient and may seem alien. If you are young, the call to declare a sexual identity imposes the anxiety that exploration of your gay potential may close your options for ever. And if you are a person of colour, the prominence of a mainly white model makes it more difficult for you to negotiate ways of thinking about sexualities that will be compatible with your subcultures of family and neighbourhood.

Also, fixing our constituency on the ethnicity-and-rights model lets the sex-gender system off the hook. It encourages the inference

that an out-group needs concessions, rather than the mainstream needing correction; so lesbians and gay men, Herman observes, may be 'granted legitimacy, not on the basis that there might be something problematic with gender roles and sexual hierarchies, but on the basis that they constitute a fixed group of "others" who need and deserve protection'.[8] Initially in Gay Liberation, we aspired to open out the scope of sexual expression for everyone, in the process displacing the oppressive ideologies that sexuality is used to police. By inviting us to perceive ourselves as settled in our sexuality, the ethnicity-and-rights model releases others from the invitation to re-envision theirs. 'At best, a minority group analysis and a civil rights strategy pertain to those of us who already are gay', John D'Emilio argues. 'Our movement may have begun as the struggle of a "minority", but what we should now be trying to "liberate" is an aspect of the personal lives of all people – sexual expression.'[9]

Correcting the exclusiveness of lesbian and gay identities was one goal of 'Queer Nation'. 'Queer', Michael Warner writes, 'rejects a minoritizing logic of toleration or simple political interest-representation in favour of a more thorough resistance to regimes of the normal'.[10] Henry Abelove reads 'nation', in 'Queer Nation', as an aspiration, in the tradition of Henry David Thoreau's *Walden* (a gayer book than is generally acknowledged) not to join, but to *become* 'America' – *the* nation.[11] The problem for Queer Nation was the scale of that aspiration: relatively few people were ready for it. In many small-town and rural circumstances, being gay is quite a struggle; the last thing you want is someone from a city telling you that you don't measure up because you can't handle 'queer'. Like many vanguard movements, Queer Nation was a minority within a minority.

The Castro and the White House

The ethnicity-and-rights model encourages us to imagine a process whereby, win some/lose some, we all advance gradually towards full, democratic citizenship. However, 'citizen' has never meant 'inhabitant'. It always counterposes some others who are present but not full citizens – at best, visitors, but usually also racial, ethnic and sexual minorities, slaves, criminals, the lower classes, women, children, the elderly. In our Enlightenment inheritance, the nation is an unstable construct, and ideas of citizenship are deployed, typically, in a hegemonic process whereby outsiders are stigmatized and potential deviants jostled into place.[12] The corollary of the 'Citizens' Charter', propa-

gated by the UK Conservative Government in the early 1990s, is the harassing of people who try to live outside a narrow norm.

Discussion of citizenship in the United Kingdom usually invokes T. H. Marshall, who in 1947 analysed modern constitutional history as a broad progress – from class hierarchy, towards equal rights of citizenship. Civil rights - of property, speech and religion, justice before the law - developed in the eighteenth century, Marshall says; political rights (mainly the franchise) were achieved during the nineteenth and early twentieth centuries; and, lately, in the 1940s, social rights were being added – 'the components of a civilised and cultured life, formerly the monopoly of a few, were brought progressively within the reach of the many'.[13] Marshall's analysis reflects the optimistic, egalitarian climate at the end of the Second World War, when an apparatus of welfare benefits was installed to ameliorate the worst consequences of capitalism, effectively relegitimating the British state through an ideology of fairness and consensus. In this framework, even homosexuals became a 'social problem' requiring a benign state solution; the Wolfenden Report was commissioned in 1954 to find one, and in 1967 its proposals became the basis of the current law.[14]

The UK version of citizenship positions out-groups as petitioning for concessions, which appear analogous to the welfare granted to the unfortunate. In the USA, where a constitution professes to guarantee rights to all citizens, it is more a matter of asserting a claim. 'Each time there is a major defeat of gay rights in the voting polls of middle America, gays take to the streets of San Francisco chanting "Civil Rights or Civil War" ', Manuel Castells notes.[15] This threatens, metaphorically, a repeat of the founding revolt of the United States, or perhaps of the war that freed Black slaves. Either way, it wouldn't work in England because our civil war means differently (probably the dominant meaning is upper-class incompetence versus vulgar fanaticism; this is echoed, still, in perceptions of the two main parliamentary parties today). However, gay activism in Britain often adopts an 'American' rhetoric, because it seems more determined and dignified. (In fact, I think, British images of male gayness are generally dependent on North American examples – to a far larger extent than British people realize.)

The US ideology of rights, as Epstein says, 'functions typically through appeals to the professed beliefs of the dominant culture, emphasizing traditional American values such as equality, fairness, and freedom from persecution'; it implies the goal of 'gaining entry into the system'; it appeals to 'the rules of the modern American pluralist myth, which portrays a harmonious competition among distinct social groups'.[16] How far that myth is to be trusted is a

question far wider than queer politics: it is about how much we expect from the institutions through which capitalism and hetero-patriarchy are reproduced.

The ethnicity-and-rights model aspires to two main spheres of political effectivity. One is a claim for space within which the minority may legitimately express itself. For gay men, classically, this was the Castro district of San Francisco. Manuel Castells, in a moment of exuberance in the early 1980s, saw there a recovery of the merchant citizenship of the Italian Renaissance: 'We are almost in the world of the Renaissance city where political freedom, economic exchange, and cultural innovation, as well as open sexuality, developed together in a self-reinforcing process on the basis of a common space won by citizens struggling for their freedom.' Castro gay leaders spoke of a 'liberated zone'.[17]

However, if it is hard to achieve socialism in one country, as Trotsky insisted against Stalin, it is even less likely that sexual liberation can work in one sector of one, capitalist, city. Castells observes how inter-communal hostility developed in and around the Castro, as gentrification (also known as 'gay sensibility') raised property values and squeezed out other, mainly Black and Latino, minorities.

The clashing of competing interests is endemic to the ethnicity-and-rights model. When ACT UP intruded on the Roman Catholic service of Cardinal O'Connor in New York, Douglas Crimp reports, it was said that they had 'denied Catholic parishioners their freedom of religion'. Similarly in Britain, Rachel Thomson notes, Department of Education and Science circular 11/87 declares: 'It must also be recognized that for many people, including members of religious faiths, homosexual practice is not morally acceptable.'[18] One interest group is used against another. Castells observes: 'each player defines him/herself as having to pursue his/her own interests in a remarkable mirror image of the ideal model of the free market'.[19] However, the free market, we should know, does not generally present itself in 'ideal' form. Generally, it sets us all at each other's throats.

The second sphere where the ethnicity-and-rights model aspires to political effectivity is through the organs of the state. In *Close to the Knives* David Wojnarowicz propounds an urgent critique of US political, religious and judicial systems (that aspect of his book is left out of Steve McLean's 1994 film, *Postcards from America*). However, alongside that Wojnarowicz manifests an underlying vein of surprise that gay rights have not been acknowledged; he is shocked to read of a Supreme Court ruling (presumably *Bowers v. Hardwick*), that it is 'only people who are heterosexual or married or who have families that expect these constitutional rights'.[20] Lamenting the suicide of his

friend Dakota, Wojnarowitz asks: 'Man, why did you do it? Why didn't you wait for the possibilities to reveal themselves in this shit country, on this planet?' (p.241). Despite his indictment, Wojnarowitz still expects Uncle Sam to come up trumps eventually. A persistent leitmotiv in *Close to the Knives* is that if only President Reagan would pay attention to AIDS, we would begin to get somewhere with it. Wojnarowitz writes:

> I imagine what it would be like if, each time a lover, friend or stranger died of this disease, their friends, lovers or neighbors would take the dead body and drive with it in a car a hundred miles an hour to washington d.c. and blast through the gates of the white house and come to a screeching halt before the entrance and dump their lifeless form on the front steps.
>
> (p. 122)

It is as if recognition in official quarters would not only help resource a campaign to alert gay men to HIV and AIDS; not only legitimate the campaign; but somehow magic away the epidemic.

In comparable fashion, Larry Kramer's persona in *The Normal Heart* (1985) throws his energy into getting the attention of city hall, the mayor, and the *New York Times* newspaper. In 1995 Kramer says in an interview with Lisa Power that he has been

> accepting and facing . . . that all these myths I have swallowed about humanity and America and 'one voice can make a difference' – these things that we're all taught, that democracy works and all – turn out to be bullshit when you're gay or you have AIDS or are a member of a minority or whatever the reason.

'That was a surprise?' the interviewer asks, 'curiously'.[21]

Is homosexuality intolerable? – that is the ultimate question. One answer is that actually lesbians and gay men are pretty much like other people but we got off on the wrong foot somewhere around St Paul; it just needs a few more of us to come out, so that the nervous among our compatriots can see we really aren't so dreadful, and then everyone will live and let live; sexuality will become unimportant. That scenario is offered by Bruce Bawer, who calls himself a conservative, in his book *A Place at the Table*. He believes US gay men can rely upon 'democracy' to gain 'acceptance', because 'to attempt to place restrictions on individual liberty and the right of others to pursue happiness is, quite simply, un-American'.[22] What Bawer calls 'subculture-oriented gays' impede this process by appearing radical and bohemian.

The other answer is that homophobia contributes crucially to

structures of capital and patriarchy, and that lesbian and gay people offer, willy-nilly, a profound resistance to prevailing values in our kinds of society. The point may be figured through a distinction which Shane Phelan draws, between ethnicity and race. While ethnicity has enabled a discourse of rights and incorporation, race (despite the formative moment of Black Civil Rights) has proved less pliable. People deriving from Europe, Phelan observes, have been assimilated, but 'Race in the United States has been the mark of the unassimilable, the "truly different" '.[23] Racial difference is doing more ideological work, and hence is more – perhaps ultimately – resistant. Which is closer to the situations of lesbians and gay men?

We cannot expect to settle this question. However, it would be rash to suppose that the criminalizing and stigmatizing of same-sex practices and lifestyles is an incidental kink in an otherwise reasonable structure; that the present system could, without cost, relinquish its legitimations and interdictions. Consider: parents will repudiate their offspring because of gayness. Something very powerful is operating there.

In my view, the pluralist myth which legitimates the ethnicity-and-rights model affords useful tactical opportunities, but it is optimistic to suppose that it will get us very far. Nevertheless, I will argue eventually that we cannot afford entirely to abandon a minoritizing model because we cannot afford to abandon subculture.

Diaspora, hybridity, and the doorstep Christian

Meanwhile, in another part of the wood, theorists of 'race' and 'ethnicity' have been questioning how far those constructs offer a secure base for self-understanding and political action. Stuart Hall traces two phases in self-awareness among British Black people. In the first, 'Black' is the organizing principle: instead of colluding with hegemonic versions of themselves, Blacks seek to make their own images, to represent themselves. In the second phase (which Hall says does not displace the first) it is recognized that representation is formative – active, constitutive – rather than mimetic. ' "Black" is essentially a politically and culturally *constructed* category', Hall writes, 'one which cannot be grounded in a set of fixed transcultural or transcendental racial categories and which therefore has no guarantees in Nature'.[24] In similar vein, Henry Louis Gates Jr calls for a 'thorough critique of blackness as a presence, which is merely another transcendent signified'.[25]

In respect of European and American – *diasporic* – Black peoples,

this may seem merely a necessary move: after forced migration, forced miscegenation and all kinds of economic and cultural oppression it must be hard to isolate an uncontaminated Africanness. 'Our task is not to reinvent our traditions as if they bore no relation to that tradition created and borne, in the main, by white men', Gates declares (p. xxiii). 'Diaspora' (a Greek, biblical term, denoting the captivity of the Hebrews in Babylon and, latterly, the worldwide dispersal of Jewry) usually invokes a true point of origin, and an authentic line – hereditary and/or historical – back to that. However, diasporic Black culture, Hall says, is defined 'not by essence or purity, but by the recognition of a necessary heterogeneity and diversity; by a conception of "identity" which lives with and through, not despite, difference; by *hybridity*'. Alluding to the improvisatory virtuosity of Black jazz musicians, blues singers, rappers, dubbers and samplers, Hall writes of 'the process of unsettling, recombination, hybridization and "cut-and-mix" ' arising out of '*diaspora* experience'.[26]

Hall is inclined to celebrate hybridity; I mean to question that. But two immediate qualifications are appropriate. First, many non-white cultures are neither diasporic nor notably hybrid; those of Africans born and living in Africa, for instance. In his book *After Amnesia*, G. N. Devy invokes an Indian tradition that preceded a relatively slight Western imperial intrusion and continues through and beyond it – not as a static past, but a 'never-ending transition'.[27] Second, it is quite hard to envisage a culture that is not hybrid; Lévi-Strauss specifies *bricolage* as the vital process through which cultures extend themselves, and Hall deployed the concept a while ago, with white youth cultures mainly in view.[28]

With these provisos, it still makes intuitive sense to regard diasporic Black cultures as distinctively hybrid. Paul Gilroy in his book *The Black Atlantic* offers the image of a ship, situated in mid-Atlantic – in continuous negotiation between Africa, the Americas and Western Europe. 'Because of the experience of diaspora', says Gates, 'the fragments that contain the traces of a coherent system of order must be reassembled'.[29] He discusses myths of the trickster, myths which embody a self-reflexive attitude to Black traditions, prizing agility and cunning at adaptation and insinuation in African-American culture, rather than an authentic African heritage.

The argument for hybridity has not gone unchallenged. Molefi Kete Asante in his book *Afrocentricity* acknowledges that African genes have been mixed with others, but

> it is also a fact that the core of our collective being is African, that is, our awareness of separateness from the Anglo-American

experience is a function of our historical memory, the memory we have frequently denied or distorted. Such experiences are rooted in our ancestral home and defined by social and legal sanctions of four hundred years in America. Regardless to our various complexions and degrees of consciousness we are by virtue of commitments, history, and convictions an African people.[30]

Of course, anti-essentialist Black commentators do not mean to abandon 'commitments, history, and convictions'. 'The past continues to speak to us. But it no longer addresses us as a simple, factual "past"', Hall declares.[31] bell hooks writes: 'There is a radical difference between a repudiation of the idea that there is a black "essence" and recognition of the way black identity has been specifically constituted in the experience of exile and struggle.'[32]

In practice, it is not easy to keep tradition and hybridity together in the same frame. Gates, for instance, sounds *just a bit* essentialist when he argues that a distinctively Black pattern can be uncovered in the hybrid history that we know: 'The Black tradition has inscribed within it the very principles by which it can be read.' To be sure, these principles cannot be securely discerned – 'To reassemble fragments, of course, is to engage in an act of speculation, to attempt to weave a fiction of origins and subgeneration.' Nonetheless, Gates believes he can 'render the implicit as explicit' and 'imagine the whole from the part'.[33] He needs to do this partly because the idea of hybridity implies *at least some* identifiable element of Blackness in the mix, and partly because the thought that African-Americans may have nothing that they can call their own is intolerable.

Recognition that race and ethnicity might be constructed, hybrid and insecure, but yet necessary, has obvious resonances for lesbian and gay cultural politics, and may help us to think about ourselves. For gay subculture, certainly, is hybrid; to the point where it is difficult to locate anything that is crucially gay – either at the core of gayness, or having gayness at its core. What about drag, then? Mostly – from pantomime and music hall to working-men's clubs and film and television comedy – it is consumed by straight audiences. Drag plays with gender boundaries, and all sorts of people are interested in that. The disco scene, perhaps? Well yes, except that a standard feature is the latest diva calling down God's punishment on people with AIDS. The ancient Greeks, maybe? Well, the organizing principle of their sexual regime seems to have been that a citizen (male) may fuck any inferior – women, slaves, boys. That is the stuff heroes are made of, but hardly sexual liberation. Camp then? Since Susan Sontag's defining essay of 1964, it has appeared to be anybody's,

and now it is co-opted into 'the postmodern'. There is art and literature: surely gay men are justly famed for our achievement there? Yes, but we have been allowed to produce quality culture on condition that we are discreet – thereby confirming our unspeakableness. Decoding the work of closeted homosexual artists, I have argued elsewhere, discovers not a ground for congratulation but a record of oppression and humiliation.[34] Opera even – since 'The Three Tenors' were offered as a curtain-raiser for the World Cup Final in 1994 – now correlates with football rather than, in Wayne Koestenbaum's title, *The Queen's Throat*.

When Frank Mort writes of 'a well-established homosexual diaspora, crossing nation states and linking individuals and social constituencies', we know what he means. However, as Warner remarks, there is no remote place or time, not even in myth and fantasy, from which lesbians and gay men have dispersed.[35] Our hybridity is constituted differently. Indeed, while ethnicity is transmitted usually through family and lineage, most of us are born and/or socialized into (presumptively) heterosexual families. We have to move away from them, at least to some degree; and *into*, if we are lucky, the culture of a minority community. 'Home is the place you get to, not the place you came from', it says at the end of Paul Monette's novel, *Half-way Home*.[36] In fact, for lesbians and gay men the diasporic sense of separation and loss, so far from affording a principle of coherence for our subcultures, may actually attach to aspects of the (heterosexual) culture of our childhood, where we are no longer 'at home'. Instead of dispersing, we assemble.

The hybridity of our subcultures derives not from the loss of even a mythical unity, but from the difficulty we experience in envisioning ourselves beyond the framework of normative heterosexism – the *straightgeist* – as Nicholson Baker calls it, on the model of *zeitgeist* (compare Monique Wittig on 'the straight mind').[37] If diasporic Africans are poised between alternative homelands – in mid-Atlantic, Gilroy suggests – then lesbians and gay men are stuck at the moment of emergence. For coming out is not once-and-for-all; like the Africans, we never quite arrive. Now, I am not proposing any equivalence between the oppressions of race and sexuality – anyway, there is not one oppression of either race or sexuality, there are many. But, while in some instances race and ethnicity are not manifest, for lesbians and gay men passing is almost unavoidable.[38] It rehearses continually our moment of enforced but imperfect separation from the *straightgeist*. You can try to be up-front all the time – wearing a queer badge or T-shirt, perhaps – but you still get the telephone salesperson who wants to speak to the man of the house

or to his lady wife. Or the doorstep Christian who catches you in only your bathtowel, bereft of signifiers. The phrase 'coming out', even, is not special to us. It is a hybrid appropriation, alluding parodically to what debutantes do; the joke is that they emerge, through balls, garden parties, and the court pages of *The Times*, into centrality, whereas we come out into the marginal spaces of discos, cruising grounds and Lesbian and Gay Studies.

This implication in the heterosexism that others us has advantages. It allows us to know what people say when they think we aren't around. And at least we can't be told to go back to where we came from, as happens to racial minorities in Britain. Conversely though, it makes us the perfect subversive implants, the quintessential enemy within. We instance what Jonathan Dollimore calls a 'perverse dynamic': we emanate from within the dominant, exciting a particular insecurity – 'that fearful interconnectedness whereby the antithetical inheres within, and is partly produced by, what it opposes'.[39] The lesbian or gay person is poised at the brink of a perpetual emergence, troubling the *straightgeist* with a separation that cannot be completed, a distinction that cannot be confirmed. It makes it hard for us to know, even to recognize, ourselves. It is a kind of reverse diaspora that makes our subcultures hybrid.

Hybridity and dissidence

I was set on to this phase of work by a passage in Philip Roth's novel *Operation Shylock* (1993), where it is remarked how Irving Berlin, a Jew, wrote 'Easter Parade' and 'White Christmas':

> The two holidays that celebrate the divinity of Christ – the divinity that's the very heart of the Jewish rejection of Christianity . . . Easter he turns into a fashion show and Christmas into a holiday about snow. Gone is the gore and the murder of Christ – down with the crucifix and up with the bonnet! *He turns their religion into schlock.* But nicely! Nicely! So nicely the goyim don't even know what hit 'em.[40]

Hybrid, diasporic Jewish culture is preferred to the arrogance that typifies the ethnically-authorized state of Israel. Jews belong in central Europe, it is suggested, and the brief dominance of the Nazis should not be allowed to wipe out centuries of Jewish-European, hybrid civilization: 'The time has come to return to the Europe that was for centuries, and remains to this day, the most authentic Jewish homeland there has ever been, the birthplace of rabbinic Judaism,

Hasidic Judaism, Jewish secularism, socialism – on and on' (pp. 31–2). The boldness of this conception challenges other subcultural formations to review their own traditions and their relations with other cultures. However, hybridity is, so to speak, a mixed blessing.

Because the prime strategy of ideology is to naturalize itself, it has been tempting to suppose that virtually any disruption of symbolic categories or levels is dissident. This can lead to the inference that hybridity is, in its general nature and effects, progressive. Thus Homi Bhabha:

> hybridity to me is the 'third space' which enables other positions to emerge. This third space displaces the histories that constitute it, and sets up new structures of authority, new political initiatives, which are inadequately understood through received wisdom. . . . The process of cultural hybridity gives rise to something different, something new and unrecognisable, a new area of meaning and representation.[41]

On this argument, virtually *any* instability is progressive; the problem, Bhabha suggests, lies with left politics 'not being able to cope with certain forms of uncertainty and fixity in the construction of political identity and its programmatic, policy implications'. We should be welcoming opportunities for 'negotiation' – to 'translate your principles, rethink them, extend them'. In fact, since Bhabha has just said that 'all forms of culture are continually in a process of hybridity', it would seem that everything that happens is potentially progressive, and only the dreary old (new) left is holding us all back.[42] Well, we have to work, of course, with the situations that global capitalism and its local conditions visit upon us, but this sounds indiscriminately stoic.

Bhabha's case for hybridity is related to his argument that the 'mimicry' of the colonial subject hovers, indeterminately, between respect and mockery; that it menaces, through 'its *double* vision which in disclosing the ambivalence of colonial discourse, also disrupts its authority'. Judith Butler makes a compatible case for cross-dressing, suggesting that it 'implicitly reveals the imitative structure of gender itself – as well as its contingency'.[43] Bhabha and Butler are proposing that the subtle imperfection in subaltern imitation of colonial discourse, or in the drag artist's mimicking of gender norms, plays back the dominant manner in a way that discloses the precariousness of its authority.

Now, symbolic disjunction may indeed disturb settled categories and demand new alignments. However, I fear that imperialists cope all too conveniently with the subaltern mimic – simply, he or she

cannot be the genuine article because of an intrinsic inferiority; and gay pastiche and its excesses may easily be pigeon-holed as illustrating all too well that lesbians and gay men can only play at true manliness and womanliness. To say this is not to deny resistance; only to doubt how far it may be advanced by cultural hybridity. The Stonewall queens instigated Gay Liberation not because they were camp or wore drag – there was nothing new about that; but because they fought the police.

We have supposed too readily that to demonstrate indeterminacy in a dominant construct is to demonstrate its weakness and its vulnerability to subversion. That is optimistic. To be sure, the ideologies of the British and US states exhort us to credit the stabilizing virtues of our political institutions and cultural heritage. But in actuality, as Marx tells us, capitalism thrives on instability:

> Constant revolutionizing of production, uninterrupted disturbance of all social conditions, everlasting uncertainty and agitation distinguish the bourgeois epoch from all earlier ones. All fixed, fast-frozen relations, with their train of ancient and venerable prejudices and opinions, are swept away, all new-formed ones become antiquated before they can ossify.[44]

Capital ruthlessly transforms the conditions of life: industries are introduced and abandoned; people are trained for skills that become useless, employed and made redundant, shifted from town to town, from country to country.

It is easier than we once imagined to dislocate language and ideology; and harder to get such dislocations to make a practical difference. Hybridity has to be addressed not in the abstract, but as social practice. Kobena Mercer posits a dialectic between dissidence and incorporation. He takes a difficult instance – the straightened hairstyle favoured by African-Americans in the 1940s:

> On the one hand, the conk was conceived in a subaltern culture, dominated and hedged in by a capitalist master culture, yet operating in an 'underground' manner to subvert given elements by creolizing stylization. Style encoded political 'messages' to those in the know which were otherwise unintelligible to white society by virtue of their ambiguous accentuation and intonation. But, on the other hand, that dominant commodity culture appropriated bits and pieces from the otherness of ethnic differentiation in order to reproduce the 'new' and so, in turn, to strengthen its dominance and revalorize its own symbolic capital.[45]

Hybridity, this instance says, is both an imposition and an

opportunity. Which of these will win out depends on the forces, in that context, against us, and on our resourcefulness. 'Once "camp" is commodified by the culture industry, how do we continue to camp it up?' Danae Clark asks. 'The only assurance we have in the shadow of colonization is that lesbians *as lesbians* have developed strategies of selection, (re)appropriation, resistance, and subversion'.[46]

Going West

An instance. The record 'Go West' was made by the Village People in 1979. David Drake, in his play *The Night Larry Kramer Kissed Me* (1992), recalls the Village People, as apprehended by the eight-year-old David when he bought Mommy their record 'YMCA' for Christmas. 'They're fairies!' his sister exclaims.

> But they don't look like fairies on the record cover. They look really tough – really cool. There's a Cowboy and an Indian and a Policeman and an Army Guy and a Motorcycle Guy – and he looks really tough. . . . So, why are they called Village People? Do they all like live in the same small town or something? . . . Boy, if I was big and tough like the Village People, Cliffy sure wouldn't mess with me. He'd be the one getting chased through the woods.[47]

In 'Go West' the excessively butch manner of the Village People – a comic version of the macho style that was being cultivated by gay men in 1979 – alludes also to the nineteenth-century US drive to dominate the subcontinent. 'Go west, this is our destiny', the song runs, using typical imperial motifs; 'Together, we'll find a place/To settle where there's so much space.' The joke depends upon the hybridity of gay culture: the trappings of 'manly' pioneering had become part of the fantasy paraphernalia of the gay leatherman.

The Village People were pastiche: they depended on the thought that even manly gay men are not all that manly. In the tradition of camp self-mockery (at least we know we are silly), they exhibited that thought to the mainstream record-buying public. Yet, at the same time, it was 'coming true', for gay men were redefining the idea of 'going west' – they were making a subcultural colony in the Castro district. 'I couldn't live on one of those gold-and-white prairies alone', the narrator declares in Andrew Holleran's *Nights in Aruba* (1983) – 'The West in the end meant only one thing: San Francisco. Everyone in the little band went to San Francisco.'[48] 'Now if we make a stand,/ We'll find our promised land' ('Go West'). It did look rather like a

ghetto – a sign of ethnic oppression – and legitimate civic represen-
tation proved difficult and dangerous to attain. But in comparison
with living in the *straightgeist* it seemed like a diasporic return. 'There
where the air is free,/We'll be what we want to be.' 'Go West'
celebrated an attainment on the ethnicity-and-rights model, even
while recognizing, through camp self-mockery, that gay men could
not achieve more than a hybrid, self-cancelling, pastiche relation to
the pioneer values that are supposed to constitute 'America'.

The Pet Shop Boys' remake of 'Go West', produced in the
entirely different circumstances of 1993, is fraught with nostalgia.
There is a manly, *Oklahoma*, male chorus, but it is exaggerated only
in the way that such choruses generally are, and it alternates with
Neil Tennant's plangent tones. Suddenly, if you listen, the words all
mean differently. 'Go west, sun in winter time/Go west, we will feel
just fine.' We went west, but it went terribly wrong. Our friends fell
ill and died, and an entirely new phase of stigmatization was legit-
imated. 'Together, we will fly so high,/Together, tell all our friends
goodbye.' In the two voices – the manly choir and Tennant – the
aspirations of the 1970s confront the distress of the AIDS emergency.
This is not my reading alone; it's what Neil Tennant said in an
interview with Andi Peters on BBC2 on 1 October 1993.

Even so, HIV and AIDS in gay districts of San Francisco and
other cities have called forth resources beyond what we had believed
ourselves capable of. 'Together, we will work and strive.' The choir
builds in purposefulness, claiming eventually the heroic dimension
that in 1979 had seemed mere pastiche. 'Together, your hand in my
hand.'

In the Pet Shop Boys' version, the camp disjunction, between
manly, 'American' values and gay style, is redistributed within the
subculture; the hybridity is *within* gay experience and speaks to a
gay agenda. This is how subculture should work. There is an element
of gay affirmation, but 'Go West' – through the typically subcultural
process of reinvesting an earlier textual moment – may evoke for gay
men a difficult part of our experience, inviting us to work through
it again, reassessing complicated and emotive histories, decisions and
affiliations. To be sure, little of that is heard by mainstream record-
buyers, probably, but why should that matter? They may listen if
they wish, but they have plenty of records of their own.

As with another Pet Shop Boys' song, 'Being Boring', I recall
precisely when and where I first heard the remake of 'Go West'. So
you can imagine how angry and betrayed I felt when I saw the video.
This is set outside the Kremlin, with a lot of men marching around
in vaguely kinky 'uniforms', encouraging some listeners to hear in

the music an allusion to the Russian national anthem. Peters, in the television interview, observed that the video 'changes the meaning'. Tennant's response – that Russia is trying to move in a Western, capitalist direction – did not address the implicit question. What I had appreciated as a specifically gay treatment had been abruptly hybridized. Even at the moment when it promises to come out from the protection of the pastiche, gay work is vulnerable to appropriative pressures. Our culture is indeed hybrid, but it is not a source of strength.

Am I being sentimental? Of course the Pet Shop Boys want their record to chart; the effect I have been admiring is expensive to produce, and there is not a gay cultural apparatus capable of circulating it. But then, the Pet Shop Boys have not wanted, as Tennant has put it, to be seen as 'kind of joining a club, the president of which was Jimmy Somerville'; the reason he did not discuss homosexuality publicly before 1994, Tennant says, 'was that it seemed more interesting not to'.[49] Whatever his purposes, we may remark that marginal cultural producers are liable to be seduced by the legitimation of mainstream approbation – a doomed project, since you can't correct the stigma of being gay by being successful as a musician, politician, academic, or whatever *in straight terms*.

Of course, everyone must make their own decisions about where they want to get to and how they are going to do it; the outcome of those decisions is the balance, in the world, between dissidence and incorporation. If the latter tends to prevail, it is facilitated by the hybridity which troubles explicitly gay work in mainstream media. Fortunately, subcultural viability does not depend on the authentic intention of producers: from Plato, through Shakespeare, Wilde, Proust, Tennessee Williams and Freddie Mercury, we are accomplished at (re)appropriating compromised material.

Subcultural work and the post-gay

The argument thus far: lesbians and gay men have understood themselves on the model of ethnicity, but this provides only a doubtful political opportunity and, anyway, ethnic identities are hybrid. This has been regarded as an advantage, but the example of 'Go West' suggests otherwise.

Hybridity may or may not disconcert the system. My case is that being always-already tangled up with it makes it hard for lesbians and gay men to clear a space where we may talk among ourselves. We used to say that we were silenced, invisible, secret. Now, though

our subcultures are still censored, there is intense mainstream invest-
ment in everything that we do, or are imagined as doing. We are
spoken of, written of, and filmed everywhere, but rarely in terms
that we can entirely welcome. In the face of such pressures and
opportunities, my case is that we need various but purposeful subcul-
tural work – with a view neither to disturbing nor pleasing the
straightgeist, but to meeting our own, diverse needs.

The dominant ideology constitutes subjectivities that will find
'natural' its view of the world: hence its dominance (that is an Althus-
serian axiom). Within that framework, lesbians and gay men are,
ineluctably, marginal. 'They had the power to make us see and experi-
ence *ourselves* as "Other" ', Hall remarks of colonial regimes.[50] Sub-
cultures constitute *partially alternative subjectivities*. In that bit of
the world where the subculture runs, you may feel, as we used to
say, that Black is beautiful, gay is good. It is through such sharing –
through interaction with others who are engaged with compatible
preoccupations – that one may cultivate a workable alternative subject
position. In Ken Plummer's formulation, 'As gay persons create a
gay culture cluttered with stories of gay life, gay history and gay
politics, so that very culture helps to define a reality that makes
gay personhood tighter and ever more plausible. And this in turn
strengthens the culture and the politics.'[51]

The nearest equivalent to a queer diasporic experience, Simon
Watney remarks, is 'the sense of relief and safety which a gay man
or lesbian finds in a gay bar or a dyke bar in a strange city in a
foreign country'.[52] Considered as a model for the good society, a gay
bar lacks quite a lot, but for a gay man it is a place where he is in
the majority, where some of his values and assumptions run. Of
course, it is an artificial security, as he knows all too well from the
risk of street aggression as he enters and leaves. But, by so much, it
is a place of reassurance and sharing – and this holds also for all the
trivia of our subcultures.

Subculture is not just good for morale, though; it does not,
particularly, require positive images; and it doesn't occur only, or
specially, in bars and the like. Lesbian and gay subcultures are the
aggregate of what lesbians and gay men do, and that includes music,
fiction, poetry, plays, film and video, cultural commentary. They are
where we may address, in terms that make sense to us, the problems
that confront us. We may work on our confusions, conflicts and
griefs – matters of class, racial and inter-generational exploitation; of
misogyny, bisexuality and sado-masochism; of HIV and AIDS.

For it is dangerous to leave the handling of these matters within
the control of people who, we know, do not like us. Wojnarowitz

and Kramer wanted to catch the attention of the president and the mayor, but it is gay subculture that has taught us about safer sex. Wojnarowicz and Kramer, through their work, have been vastly more use to us than the city or the state. At a poignant moment in Oscar Moore's novel, *A Matter of Life and Sex*, the protagonist proclaims his 'contempt for having to die of a gay disease when he had stood so firmly outside the gay scene, standing on the touchline with his back turned' (he prefers to imagine that being a call-boy is not a part of 'the gay scene').[53] He has it precisely the wrong way around; as Jeffrey Weeks puts it, 'it was the existence of strong lesbian and gay communities and identities which provided the essential context for combating the virus: in providing social networks for support and campaigning, in developing a grammar for safer sex, in promoting a language of resistance and survival'. Watney links the fact that the French have the worst HIV epidemic in Western Europe with the fact that they have no gay press.[54]

Richard Rorty has tried to distinguish a wrong and a right kind of multiculturalism. It is admirable that Black children should learn about Frederick Douglass, Harriet Tubman and W. E. B. Du Bois, he says, but this may lead to 'the dubious recommendation that a black child should be brought up in a special culture, one peculiar to blacks'. Rorty doesn't want Black children to feel that 'their culture is not that of their white schoolmates: that they have no share in the mythic America imagined by the Founders and by Emerson and Whitman, the America partially realized by Lincoln and by King'.[55] Like Wojnarowicz, he is waiting 'for the possibilities to reveal themselves in this shit country'. The consequence of thus crediting the prevailing ideology is that Rorty makes subculture sound like an optional extra. Rather, it is an indispensable resource, for the alternative is the continuing dominance of *straightgeist* accounts of ourselves. In Roth's *Operation Shylock*, despite the sharp look at the state of Israel and the arguments about hybridity, the (somewhat unexpected) conclusion, as I read it, is that Jewish people cannot risk abandoning the last-ditch refuge which Israel represents.

Am I proposing a 'gay ghetto', then, in which we must all think the same? There is no question, in practice, of this. First, working through our differences will produce an enhanced awareness of diversity. For instance, native American gays may be drawing their own thoughts from 'Go West'. A common feature in attacks on gay subculture is a dual denunciation: (1) it makes everyone the same, (2) gays have nothing in common but their sexuality. In between these propositions, any possibility for a political movement seems doubly disqualified: we are, at once, too limited and too various to make

any legitimate common purpose. In fact, I would go further: gay sexuality is not such a great cohesive force either; it too is diverse; there are different kinds of gayness. Our apparent unity is founded in the shared condition of being *not-heterosexual* – compare 'people of colour', whose collocation derives from being not-white. Gayatri Spivak advises a 'strategic essentialism', and Weeks writes of identities as 'necessary fictions', but lesbians and gay men find even an artificial coherence hard to sustain.[56] However, that should not inhibit subcultural work. Not-heterosexual, like not-white, is a real-world political category, and its indeterminacy makes subcultural work the more productive and necessary.

Second, there is no new, allegedly-empty world in which to 'settle where there's so much space'. A gay congressman is still a congressman, a lesbian business still a business; a queer professor is still a professor. Subculture in the West today is not a matter of side-stepping hybridity, but of maintaining any space at all that is not entirely incorporated, in which we may pursue our own conversations. Indeed, it is subordinated groups that have to be bilingual and mainstream groups that need not bother. 'Marginal people know how they live and they know how the dominant culture lives. Dominant culture people only know how they live', Sarah Schulman remarks.[57] Gays need to be able to read the language of straights so we can take evasive action when they get vicious.

The problem, rather, is this: I have been writing 'we'. Insofar as 'we' address 'our' problems today and work through 'our' history and 'our' culture, in the face of inevitable hybridizing pressures, 'we' suppose a minority awareness. Despite all the arguments I assembled initially about the damaging consequences of the ethnicity-and-rights model, a project of subcultural work leads us back towards a version of that model. For, as bell hooks writes, it is with reason that subordinated peoples hold on to ideas of genetic innateness, cultural purity, and other essentialist notions: 'The unwillingness to critique essentialism on the part of many African-Americans is rooted in the fear that it will cause folks to lose sight of the specific history and experience of African-Americans and the unique sensibilities and culture that arise from that experience.'[58] It is to protect my argument from the disadvantages of the ethnicity model that I have been insisting on 'subculture', as opposed to 'identity' or 'community': I envisage it as retaining a strong sense of diversity, of provisionality, of constructedness.

For it should not be supposed that our post-Stonewall lesbian and gay identities, and their heterosexual corollaries, are the last word. In the 1970s and 1980s, to declare yourself 'gay' was such a

strenuous project that to blur the effect by adding that sometimes you were straight after all seemed too difficult, too confusing, and scarcely plausible. Now, though, there are more than a few signs that some young people are not daunted by that kind of pressure; for them (because of the gains of the Stonewall generation), same-sex experience is not such a big deal. And some gay activists, who can hardly be accused of running scared, have been venturing beyond gay identities. To be sure, proclaiming that whatever most of us thought we were doing is passée because it's 'post-' is an easy way for the trend-setter to make a mark. However, we may be entering the period of *the post-gay* – a period when it will not be so necessary to define your sexuality. That's fine by me, but it won't suit a lot of people that I know. How far it is going to get most of us, and how fast, is by no means easy to anticipate (compare 1960s 'melting pot' predictions on race?).

If we cannot afford to abandon minority awareness, then, our subcultural task will have to include a reappraisal of its nature and scope. We have to develop a theory and a politics that will help us to tolerate permeable boundaries. We need to draw upon the experience of elderly gays. We have to maximize opportunities for lesbian and gay alliances, and to explore sexualities that the gay movement has treated as marginal – bisexuality, transvestism, transsexuality. We need to speak with gay people who proclaim themselves to be 'straight-acting' and who demand and promise discretion in contact ads. We must be ready to learn from the different kinds of 'gayness' that are occurring in other parts of the world, and among ethnic and racial minorities in Western societies. For it would be arrogant to suppose that the ways we have 'developed' in parts of North America and Northern Europe of being lesbian and gay constitute the necessary, proper, or ultimate potential for our sexualities.

One inference from anti-essentialist theory should be that we cannot simply throw off our current constructions. We are consequences of our histories – those that have been forced upon us and those that we have made ourselves – and we have to start from there. The notion of gay ethnicity is intuitively powerful and therefore we have to remain in negotiation with it. At the same time, it is because we believe that culture constructs the scope for our identities that we may believe those identities to be contingent and provisional, and therefore may strive to revise our own self-understanding and re-presentation. Subcultural work is our opportunity to support each other in our present conditions, and to work towards transforming those conditions. 'Together, we will learn and teach' – 'Go West'.

Notes

1 Peter Burton, *Gay Times*, 199 (April 1995), p. 24; Dennis Altman, *The Homosexualization of America* (Boston: Beacon Press, 1982), p. 29.

2 Eve Kosofsky Sedgwick, *Epistemology of the Closet* (Hemel Hempstead: Harvester, 1991), p. 85, and pp. 84–90.

3 Steven Epstein, 'Gay politics, ethnic identity', in Edward Stein (ed.), *Forms of Desire* (New York: Routledge, 1992), p. 255; Michael Warner, 'Introduction', in Warner (ed.), *Fear of a Queer Planet* (Minneapolis: Minnesota University Press, 1993), p. xvii. See also Martin Duberman, *About Time*, revised edition (New York: Meridian, 1991), pp. 404–5, 458–9.

4 See Simon LeVay, *The Sexual Brain* (Cambridge, Mass.: MIT Press, 1993); Alan Sinfield, *The Wilde Century* (London: Cassell, and New York: Columbia, 1994), pp. 177–84.

5 Edmund White, 'Gender uncertainties', *The New Yorker*, 17 July 1995, 79–81, reviewing Marjorie Garber, *Vice Versa: Bisexuality and the Eroticism of Everyday Life* (New York: Simon & Schuster, 1995).

6 Didi Herman, 'The politics of law reform: lesbian and gay rights struggles into the 1990s', in Joseph Bristow and Angelia R. Wilson (eds), *Activating Theory* (London: Lawrence & Wishart, 1993), pp. 251–2.

7 Cindy Patton, 'Tremble, hetero swine', in Warner (ed.), *Fear of a Queer Planet*, pp. 173–4.

8 Herman, 'The politics of law reform', in Bristow and Wilson (eds), *Activating Theory*, p. 251.

9 John D'Emilio, *Making Trouble* (New York: Routledge, 1992), p. 12.

10 Warner, 'Introduction', in Warner (ed.), *Fear of a Queer Planet*, p. xxvi.

11 Henry Abelove, 'From Thoreau to queer politics', *Yale Journal of Criticism*, 6, no.2 (Fall, 1993), 17–28, pp. 25–6.

12 See Hans Mayer, *Outsiders*, trans. Denis M. Sweet (Cambridge, Mass.: MIT Press, 1982), p. 18.

13 T. H. Marshall, *Citizenship and Social Class* (Cambridge University Press, 1950), p. 47. See Alan Sinfield, *Literature, Politics and Culture in Postwar Britain* (Oxford: Blackwell, 1989), pp. 13–21.

14 See Alan Sinfield, 'Closet dramas: homosexual representation and class in postwar British theater', *Genders*, 9 (1990), 112–31.

15 Manuel Castells, *The City and the Grassroots* (London: Arnold, 1983), p.163.

16 Steven Epstein, 'Gay politics, ethnic identity', in Stein (ed.), *Forms of Desire*, pp. 279, 282. See Herman, 'The politics of law reform', in Bristow and Wilson (eds), *Activating Theory*, p. 251; Jo Eadie, 'Activating bisexuality: towards a bi/sexual politics', in Bristow and Wilson (eds), *Activating Theory*, pp. 164–5

17 Castells, *The City and the Grassroots*, pp. 162, 138–9.

18 Douglas Crimp with Adam Rolston (eds), *Aids DemoGraphics* (Seattle: Bay Press, 1990), p. 138; Rachel Thomson, 'Unholy alliances: the recent politics of sex education', in Bristow and Wilson (eds), *Activating Theory*, p. 228.

19 Castells, *The City and the Grassroots*, p. 171.

20 David Wojnarowicz, *Close to the Knives* (London: Serpent's Tail, 1992),

p. 81. See Dennis Altman, *AIDS and the New Puritanism* (London: Pluto, 1986), ch. 8: 'A very American epidemic?'.

21 'Happy as Larry', Lisa Power interviewing Larry Kramer, *Gay Times*, 203 (August 1995), p. 49.

22 Bruce Bawer, *A Place at the Table* (New York: Simon & Schuster, 1993), p. 139.

23 Shane Phelan, *Getting Specific* (Minneapolis: Minnesota University Press, 1994), p. 60.

24 Stuart Hall, 'New ethnicities', in James Donald and Ali Rattansi (eds), *'Race', Culture and Difference* (London: Sage, 1992), p. 254.

25 Henry Louis Gates, Jr, *The Signifying Monkey* (New York: Oxford University Press, 1988), p. 237.

26 Stuart Hall, 'Cultural identity and diaspora', in Jonathan Rutherford (ed.), *Identity: Community, Culture, Difference* (London: Lawrence & Wishart, 1990), p. 235; Hall, 'New ethnicities', in Donald and Rattansi (eds), *'Race', Culture and Difference*, p. 258.

27 G. N. Devy, *After Amnesia* (London: Sangam Books, 1992), p. 56.

28 Stuart Hall, 'Deviance, politics, and the media', in Paul Rock and Mary McIntosh (eds), *Deviance and Social Control* (London: Tavistock, 1974), p. 293.

29 Paul Gilroy, *The Black Atlantic* (London: Verso, 1993), p. 4; Gates, *The Signifying Monkey*, p. xxiv.

30 Molefi Kete Asante, *Afrocentricity* (New Jersey: Africa World Press, 1988), p. 27.

31 Hall, 'Cultural identity and diaspora', in Rutherford (ed.), *Identity: Community, Culture, Difference*, p. 226.

32 bell hooks, *Yearning* (London: Turnaround, 1991), p. 29.

33 Gates, *The Signifying Monkey*, pp. xxiii–xxiv.

34 See Alan Sinfield, *Faultlines* (Oxford University Press, 1992), pp. 294–9.

35 Frank Mort, 'Essentialism revisited? Identity politics and late twentieth-century discourses of homosexuality', in Jeffrey Weeks (ed.), *The Lesser Evil and the Greater Good* (London: Rivers Oram, 1994), p. 202; Warner, 'Introduction', in Warner (ed.), *Fear of a Queer Planet*, p. xvii.

36 Paul Monette, *Half-way Home* (New York: Crown, 1991), p. 262. See also Gregory Woods, *This Is No Book* (Nottingham: Mushroom Publications, 1994), p. 79.

37 Nicholson Baker, 'Lost youth', *London Review of Books*, 9 June 1994, p. 6; see Monique Wittig, 'The straight mind', in Wittig, *The Straight Mind and other essays* (Hemel Hempstead: Harvester, 1992), p. 28.

38 Cf. Sagri Dhairyam, 'Racing the lesbian, dodging white critics', in Laura Doan (ed.), *The Lesbian Postmodern* (New York: Columbia University, 1994), p. 31; Avtar Brah, 'Difference, diversity and differentiation', in Donald and Rattansi (eds), *'Race', Culture and Difference*, pp. 128–9; Sedgwick, *Epistemology of the Closet*, pp. 76–82.

39 Jonathan Dollimore, *Sexual Dissidence* (Oxford: Clarendon, 1991), p. 33.

40 Philip Roth, *Operation Shylock* (New York: Simon & Schuster, 1993), p. 157. See Alan Sinfield, *Cultural Politics – Queer Reading* (Philadelphia: University of Pennsylvania and London: Routledge, 1994).

41 Homi Bhabha, 'The third space', in Jonathan Rutherford (ed.), *Identity: Community, Culture, Difference*, p. 211.

42 Bhabha, 'The third space', pp. 216, 211. Cf. Ania Loomba, 'Overworlding

the "Third World" ', *Oxford Literary Review*, 13 (1991), 164–91; Benita Parry, 'Signs of our times: a discussion of Homi Bhabha's *The Location of Culture*', *Third Text* (Winter 1994).

43 Homi K. Bhabha, *The Location of Culture* (London: Routledge, 1994), p. 88, and see pp. 111–21; Judith Butler, *Gender Trouble* (London: Routledge, 1990), p. 137.

44 Karl Marx, *Manifesto of the Communist Party*, in Marx, *The Revolutions of 1848*, ed. David Fernbach (Harmondsworth: Penguin, 1973), p. 70.

45 Kobena Mercer, 'Black hair/style politics', *New Formations*, 3 (Winter 1987), 33–54, p. 49.

46 Danae Clark, 'Commodity lesbianism', in Henry Abelove *et al.* (eds), *The Lesbian and Gay Studies Reader* (New York: Routledge, 1993), p. 199.

47 David Drake, *The Night Larry Kramer Kissed Me* (New York: Anchor, 1994), pp. 29–30. Altman seems to miss the point when he remarks: 'The long-haired androgynous look of the early seventies was now found among straights, and the super-macho image of the Village People disco group seemed to typify the new style perfectly' (Altman, *The Homosexualization of America*, p. 1).

48 Andrew Holleran, *Nights in Aruba* (1983; Harmondsworth: Penguin, 1991), p. 116.

49 Interview in *The Guardian Weekend*, 15 July 1995, p. 17.

50 Hall, 'Cultural identity', in Rutherford (ed.), *Identity: Community, Culture, Difference*, p. 225.

51 Ken Plummer, *Telling Sexual Stories* (London: Routledge, 1995), p. 87. See also Pat Califia, *Public Sex* (Pittsburg: Cleis Press, 1994), p. 21.

52 Simon Watney, 'AIDS and the politics of queer diaspora', in Monica Dorenkamp and Richard Henke (eds), *Negotiating Lesbian and Gay Subjects* (New York: Routledge, 1995), p. 61.

53 Oscar Moore, *A Matter of Sex and Death* (Harmondsworth: Penguin, 1992), p. 234.

54 Jeffrey Weeks, *Invented Moralities* (Cambridge: Polity, 1995), p. 98; Watney, 'AIDS and the politics of queer diaspora', in Dorenkamp and Henke (eds), *Negotiating Lesbian and Gay Subjects*, p. 63.

55 Richard Rorty, 'A leg-up for Oliver North', *London Review of Books*, 20 October 1994, pp. 13, 15.

56 Gayatri Chakravorty Spivak, *In Other Worlds* (New York: Methuen, 1987), p. 205; Weeks, *Invented Moralities*, ch. 3. See Gilroy, *The Black Atlantic*, p. 102, and Chris Woods, *State of the Queer Nation* (London: Cassell, 1995).

57 Sarah Schulman in an interview with Andrea Freud Loewenstein (1990), repr. in Betsy Warland (ed.), *Inversions* (London: Open Letters, 1992), p. 219.

58 hooks, *Yearning*, p. 29. See further Alan Sinfield, ' "The moment of submission": Neil Bartlett in conversation', *Modern Drama*, 39, no. 1 (Spring 1996).

Forms and Meanings

Texts, Performances, and Audiences
from Codex to Computer
Roger Chartier
Chartier examines the relationship
between patronage and the market, and
explores how the form in which a text is
transmitted not only constrains the
production of meaning but defines and
constructs its audience.
144pp, £11.95pb, £27.50hb

Postmodern Apocalypse

Theory and Cultural Practice
at the End
Edited by Richard Dellamora
Richard Dellamora and his contributors
examine apocalypse in contemporary
cultural practice and explore the ways
in which the post-apocalyptic in
contemporary cultural practice
becomes postmodern in the works of
late-twentieth century writers,
filmmakers, and critics.
288pp, 7 b&w illus., £15.95pb, £36.95hb

Television Culture and Women's Lives

thirtysomething and the
Contradictions of Gender
Margaret J. Heide
Explores the complex relationship
between the gender conflicts played
out in the scripts of the popular
television show *thirtysomething* and the
real-life conflicts experienced by
"baby-boomer" women viewers.
192pp, £11.95pb, £27.50hb

Rape on Trial

How the Mass Media Construct
Legal Reform and Social Change
Lisa M. Cuklanz
Provides insights into the different roles
news coverage and fictionalized texts
play in adjudicating between traditional
views of rape and those advanced by
advocates of rape law reform.
160pp, £11.95pb, £27.50hb

Family Plots

The De-Oedipalization of
Popular Culture
Dana Heller
Dana Heller traces the fault lines of the
Freudian family romance and holds that
the "family plot" is very much alive in
post-World War II American culture.
248pp, £13.95pb, £32.95hb

Beyond the Red Notebook

Essays on Paul Auster
Edited by Dennis Barone
This book, the first devoted to the works
of Auster, assembles an international
group of scholars who present twelve
essays that provide a rich and insightful
examination of Auster's writings.
224pp, £16.95pb, £34.95hb

Novel Possibilities

Fiction and the Formation of
Early Victorian Culture
Joseph W. Childers
Childers considers the role of the novel,
especially the social-problem novel of
the 1840s, in interpreting and shaping
the cultures of the early Victorian period.
240pp, £31.50hb

AUPG, 1 Gower Street, London WC1E 6HA (0171) 580 3994

Bryan Cheyette

'Ineffable and usable': towards a diasporic British-Jewish writing

The experience of diaspora can be a blessing or a curse or, more commonly, an uneasy amalgam of the two states. It is not a coincidence that the Hebrew root for exile or diaspora has two distinct connotations. 'Golah' implies residence in a foreign country (where the migrant is in charge of his or her destiny), whereas 'Galut' denotes a tragic sense of displacement (where the migrant is essentially the passive object of an impersonal history).[1] Both words, in current usage, have a pejorative feel about them because they suggest an undesirable exile from an autochthonous 'homeland'. But the distinction between 'Golah' and 'Galut' is worth keeping as it encapsulates a sense of differing historical possibilities in our current idealization of an abstract 'diaspora'.

The word 'diaspora' originally stems from the Greek meaning to scatter or to sow. It was first used in the new testament to indicate the dispersal of the disciples and the spreading of the gospel. In the medieval period, it mainly referred to the resettlement of Jews outside of Israel and, more recently, has been applied to large-scale migrations of populations such as the African diaspora or the diaspora of Irish or Palestinian peoples.[2] Today, however, 'diaspora' has effectively reverted back to its original etymology indicating a universalized state of homelessness that is at the heart of the new gospel of postmodernity.

Postmodern theory, especially as articulated by Philippe Lacoue-Labarthe, Emmanuel Levinas and Jean-François Lyotard, conceives of 'the jew' as the signifier of an ineffable alterity within western metaphysics.[3] Lyotard's *Heidegger and 'the jews'* (1988), for instance, constructs 'the jew' to represent all forms of otherness, heterodoxy and nonconformity. At the beginning of the volume, Lyotard justifies the allegorization of Jews in the following terms:

What is most real about real Jews is that Europe, in any case,

Textual Practice 10(2), 1996, 295–313 © 1996 Routledge 0950–236X

does not know what to do with them: Christians demand their conversion; monarchs expel them; republics assimilate them; Nazis exterminate them. 'The jews' are the object of a dismissal with which Jews, in particular, are afflicted in reality.[4]

While I have relied on the recent translation of Lyotard's text, Geoff Bennington has noted elsewhere that the phrase: ' "The jews" are the object of a dismissal' is more accurately rendered as, ' "The jews" are the object of a *non-lieu*'. This latter term carries a good deal of weight in *Heidegger and 'the jews'* because, as Bennington points out, a *'non-lieu'* is literally a 'non-place' or 'noplace'. This sense of placelessness, of the inability to situate European Jews, above all defines 'the jew' for Lyotard.[5] In this reading, 'the jew's' only place is within quotation-marks as the diasporist *par excellence* and, once again, the eternal victim.

What is ironic about the postmodern embrace of those who would wish 'the jew' to be emblematic once more is that it reproduces the universalizing desire that has, historically, generated the violence that Lyotard is supposed to be writing against. The reconstruction of 'the jew' as an ethnic allegory for postmodern indeterminacy – 'at the end of the end of philosophy' – can be said to aestheticize, reify and dehistoricize 'the other'.[6] That is, the Judaization of the site of 'the other' elides the historical production of 'the jew' within racial discourse. At the same time, Lyotard represents 'real Jews' as nothing more than the effect of a hellenizing Christian culture. His abstracted account of western antisemitism still leaves its trace in *Heidegger and 'the jews'* which, once again, refigures 'the jew' as the ineffable 'other' of European (post)modernity.

One need only glance at Sander Gilman's influential *The Jew's Body* (1991) to see the uncomfortable similarities between 'the jew' as an ethnic allegory within postmodernity and as a racial allegory within modernity. Summarizing the physician-anthropologists of *fin de siècle* Germany, Gilman writes:

> It is circumcision which sets the (male) Jew apartThe Jew in the Diaspora is out of time (having forgotten to vanish like the other ancient peoples); is out of his correct space (where circumcision had validity). His Jewishness (as well as his disease) is inscribed on his penis.[7]

For Lyotard, 'the jew' is out of space and time but this is deemed to make manifest a universalized absence of any grand narratives. At best, diaspora is embraced as an enabling 'golah' or form of exile that contains within it a means of undermining racial and national

absolutes. But, as Gilman demonstrates, Lyotard's ethnic allegory stems from the all too usable racial allegory of 'the jew' as an irrevocable 'other' within western Christian culture. Diaspora, in these terms, is clearly an aspect of 'galut'; the passive (male) body inscribed with an inexorable racial difference.

Diaspora as 'golah' and 'galut', both a blessing and a curse, has been illustrated notably in the influential corpus of Zygmunt Bauman. Bauman is at pains to historicize the 'conceptual Jew' in a number of volumes culminating in his *Life in Fragments: Essays in Postmodern Morality* (1995). In *Life in Fragments*, Bauman rethinks the historiography of antisemitism which he renames 'allosemitism'. The term 'allosemitism' originated in the work of the Polish-Jewish literary historian, Artur Sandauer, who utilized the Greek word for otherness, 'allus', when referring to the practice of representing 'the Jews' as a radically different other.[8] What Bauman argues is that the terms 'antisemitism' and 'philosemitism', which focus on either hostility or sympathy toward 'the Jews', are two relatively distinct aspects of a much broader history of differentiating Jews from other human beings. The danger, for Bauman, is that the conventional historiography continues to essentialize Jews as uniquely timeless, unchanging victims and thereby, as in the case of Lyotard, positions the history of antisemitism outside of the social and political processes which gave rise to this history in the first place.

All Jewish racial representations can, of course, be said to be ultimately 'antisemitic'. But instead of an aberrant hatred or affinity for 'the Jews', Bauman highlights the prevalent constructions of Jewish 'difference' in wider historical terms. For Bauman, the conceptual or notional 'Jew' is not just another case of 'heterophobia' – or the resentment of the different – but is, instead, a case study in 'proteophobia' (the apprehension or anxiety caused by those who do not fall easily into any established categories). Bauman's 'Jew' is 'ambivalence incarnate'; the contradictory *alter ego* marking the orderly spatial and temporal boundaries of Christian civilization.[9]

The diasporic Jew as 'ambivalence incarnate' relates Bauman's work to the representation of 'the Jew' as outside of space and time in Gilman and Lyotard. Like them, Bauman locates modernity as the site *par excellence* which produced the ambivalent 'conceptual Jew'. He maintains that given the ordering, classifying nature of modernity – signified, above all, by the rise of the nation-state – the ambivalent 'Jew' was particularly threatening because s/he made light of all modern social, political and cultural distinctions. In *Modernity and the Holocaust* (1989), Bauman shows that the confusion generated by this ambivalence resulted in a genocidal form of closure. By contrast,

in his *Modernity and Ambivalence* (1991), Bauman locates uncategorizable diasporic Jews, such as Kafka, Freud and Simmel, at the heart of modern culture. The same diasporic ambivalence, in other words, produces both modernist art and culture as well as quintessentially modern forms of racism.[10]

At this point, we can certainly learn from Paul Gilroy's *The Black Atlantic: Modernity and Double Consciousness* (1993) which rejects both the essentializing racial modernity of 'Africentrism' and the postmodern anti-essentialism which reduces black history and culture to the by now familiar universalized alterity. In the last chapter of *The Black Atlantic*, Gilroy gestures towards the many points of connection between black and Jewish diasporic histories.[11] This is not merely to show the similarities between two of the most obvious victims of western modernity. Gilroy also wishes to tease out the pitfalls as well as the utter necessity of making connections across obviously differing histories. By locating black and Jewish history within the diaspora it is therefore possible to move beyond the double bind of essentialism versus anti-essentialism or 'the Jew's Body' versus 'the jew'. As Daniel and Jonathan Boyarin have shown, diaspora is a space which both 'disrupts the very categories of identity' and, at the same time, is the location of particularized histories and cultures.[12] This is also Gilroy's 'anti-anti-essentialism' which enables him to rememorialize and rehistorize black history and culture within the diasporic 'black atlantic'.

*

A few years ago, the American painter R. B. Kitaj (who has been based in London for over three decades) published his *First Diasporist Manifesto* (1989) which encapsulates the creative possibilities for those who are not bounded by a national culture and who are able to locate themselves within a wider history of oppression and displacement. Kitaj is at pains to point out that you need not be a 'Jew to be a diasporist' and, by the same token, not all Jewish writers or artists are 'diasporists'.[13] In this light, he includes all those who are either internal or external exiles. And yet, unlike Lyotard, he does not easily transcend or allegorize his own history as a post-holocaust American-Jew. Kitaj thus enacts the paradox of his 'manifesto': 'Diasporist art is contradictory at its heart, being both internationalist and particularist' (pp. 36–7). What is more, when making a home out of his homelessness, he immediately has to redraw that which becomes 'fixed', 'settled' and 'stable' (p. 37). This is the 'homeless logic' (p. 41) of his 'manifesto' which can only ever be provisional and capricious. For this reason, his Jewishness 'changes all the time'

while, simultaneously, propelling him towards a 'vision of Diasporic art' (p. 49).

Not all British-Jewish writing is, in these terms, diasporist. Kitaj is specifically arguing with what he calls an 'assimilationist modernism' (p. 35) and his aesthetic is, in response to this, rooted in his own particularist life-history. Other writers or painters will have different styles and trajectories. I will argue, for instance, that Harold Pinter precisely reverses Kitaj's formulation and turns aspects of his life-history *into* an assimilationist modernism. In the 1950s, the dramatist, Arnold Wesker, was above all a class warrior who, as Alan Sinfield has argued, attempted to 'proclaim new-left sub-culture as a universal culture'.[14] In the ensuing decades, however, Wesker increasingly substituted ethnicity for class; this led him to rework Shakespeare's *The Merchant of Venice* from Shylock's viewpoint as *The Merchant* (1977). Wesker's conflation of ethnicity with class obviously has a wider historical resonance with the general breakdown of univocal explanations and the location of identity outside of the nation-state.

Most British-Jewish writing, it should be noted from the outset, was written from the perspective of an homogeneous Englishness and, historically, shared the spurious assumptions and suspicions of that national culture. The *fin-de-siècle* writer Israel Zangwill, for example, exemplifies a British-born writer who needed to show that he could both transcend and also control his ethnicity. At the age of 28, Zangwill published his bestselling *Children of the Ghetto: A Story of a Peculiar People* (1892). This was the first fictional account of London's East End Jewish 'ghetto' and quickly established him as a writer with an international readership. But, as well as writing fiction about the East End 'ghetto', Zangwill, for much of his career, chose to publish on what he thought of as more 'universal' subjects.[15]

The high point of Zangwill's universalizing themes was his play *The Melting Pot* (1908) which popularized this term throughout America. President Roosevelt saw this play on its opening night in Washington and reportedly shouted across the theatre, 'that's a great play, Mr. Zangwill'.[16] Zangwill proclaimed America as 'God's crucible, the great Melting Pot, where all the races of Europe are melting and re-forming!' (p. 33). In this brave new world, a Zangwill-like Jewish immigrant from Russia argues that 'God is making the American' and that the 'feuds and vedettas' between Jews and Russians – among many other ethnic groups – will die out eventually in 'God's crucible' (p. 33).

There is, I would want to argue, a strong connection between Zangwill's universal 'melting pot' (which transcended ethnicity) and

his 'ghetto' territorialism (which managed ethnicity). Above all, it was impossible for Zangwill to imagine an Englishness that could in any way accommodate a Jewish past. The severe division between the oblivion of the 'melting pot' and his categorical particularism was, I believe, a product of the restrictive choices allowed within English national culture. As Philip Dodd has noted, Englishness was a product of a peculiarly homogenous unchanging construction of the past. Along with other migrant groups, British-Jews 'were invited to take their place, and become spectators of a culture already complete and represented for them by its trustees'.[17]

Zangwill, in these terms, succumbed to a universalizing Englishness that wanted reassurance from British-Jewish writers that Jewish immigrants would not besmirch a pure national culture. His doctrinaire assimilationism was similarly a response to the threat posed by Jewish ethnicity outside of a distinct Jewish territory (which, for most of his life, he worked to establish). That Zangwill dominated pre-war British-Jewish literature did much to undermine the historical impact of those writers who attempted to construct a usable Jewishness that was to elude the disabling strait-jacket that has been described, *pace* Toni Morrison, as to either 'yiddish up or universal out'.[18] One such writer, Isaac Rosenberg, a contemporary of Zangwill's, is worth focusing on as someone whose poetry offered a radically different, extraterritorial history within British-Jewish writing.

*

Rosenberg sent a copy of his verse-drama *Moses* (1916) to Zangwill who replied to Rosenberg's sister, Annie Wynick, that the poem contains: 'a good many beautiful and powerful lines, but that I hope his experiences of war will give his next book the clarity and simplicity which is somewhat lacking in this'.[19] This retort clearly indicates the differences in approach between the two writers. Whereas Zangwill saw the world in terms of simple, irreducible oppositions, Rosenberg tended to incorporate such antitheses into a more complex and hybrid vision. In one of his best known poems, 'Break of Day in the Trenches' (1916), written when he was a private soldier in the British Army, Rosenberg gives the reader an ironic self-image of someone who is between cultures and who is unable to assimilate, even in wartime, into any one national identity:

> Droll rat, they would shoot you if they knew
> Your cosmopolitan sympathies.
> Now you have touched this English hand

> You will do the same to the German –
> Soon, no doubt, if it be your pleasure
> To cross the sleeping green between.

Rosenberg's poetry, as Adam Phillips has recently shown, is full of such images of subversive mergings across seemingly incongruous domains.[20] The droll, cosmopolitan rat is a creature that is intriguingly given an attractive human consciousness when, more conventionally, the rat is associated negatively with cosmopolitanism and parasitism. These images, needless to say, were in turn used to dehumanize Jews, including Rosenberg, in the British army and beyond.[21] Unlike Zangwill who, in his fiction, attempted to domesticate stereotypes of the Jewish 'alien' or 'pauper' Jew, Rosenberg completely changes the meaning of such stereotypes. If the Jewish past is a realm that must be either colonized or banished for Zangwill, then, for Rosenberg, the past had many subversive possibilities, especially in relation to the chaos of the First World War.

In a letter to the poet R. C. Trevelyan, Rosenberg described his verse-drama *Moses* as 'symbolis[ing] the fierce desire for virility and original action in contrast to slavery of the most abject kind'.[22] This quest for masculine virility, in the face of powerlessness, meant that words themselves made new and indiscriminate relationships in Rosenberg's poetry. Words often took the unlikely form of fecund worms, bees and fleas – as well as the ubiquitous rat – in his imagination.

The opposing dominions of God, man and animal merge in Rosenberg's writing along with the temporal realm of past and present. His reaction to the horrors of trench warfare was to invoke the vibrant figure of Moses who, simultaneously, reinvigorates the slave-like position of diasporic Jews as well as the emasculated working-class soldier in the British army. That Moses was primarily a romantic visionary, not unlike Rosenberg, can be seen from the last lines of the verse-drama. As Moses decides to liberate the Jewish slaves, and thus strangles the hated Egyptian Abinoah, there are unconscious echoes of Rosenberg's own promiscuous poetic method:

> Their hugeness be a driving wedge to a thing,
> Ineffable and usable, as near
> Solidity as human life can be.
> So grandly fashion these rude elements
> Into some newer nature, a consciousness
> Like naked light seizing the all-eyed soul,
> Oppressing with its gorgeous tyranny
> Until they take it thus – or die.

Here the figure of Moses gives the reader a sense of visionary unity which takes place both on a social as well as an aesthetic level. The all-transforming sense of an 'ineffable and usable' Jewish people – 'as near solidity as human life can be' – is not unlike Rosenberg's description of his poetry as being 'understandable and still ungraspable'.[23] The fashioning of 'rude elements/Into some newer nature' exactly relates Rosenberg's poetry to a wider social project. These 'rude elements' crossed time, were between spiritual and physical realms, and were above all not bounded by any one national culture be it 'Jewish' or 'English'. By definition, Moses's wish to fashion a 'newer nature, a consciousness/like naked light seizing the all-eyed soul,/ oppressing with its gorgeous tyranny' cannot be reduced just to the Judaic tradition. At the same time, his evocation of the figure of Moses as a response to his own personal slavery and vilification in the British army shows that it was impossible for him to wholly assimilate into an English poetic tradition.

In his poem 'Chagrin' (1916), Rosenberg utilizes the figure of Absalom, hanging by his hair, to embody his own diasporic condition:

> From the imagined weight
> Of spaces in the sky
> Of mute chagrin, my thoughts
> Hang like branch-clung hair
> To trunks of silence swung,
> With the choked soul weighing down
> Into thick emptiness.

For Rosenberg, 'thoughts', 'silence' and 'emptiness' are weighty as opposed to the weightless 'cloud-boughs' from which Absalom is 'caught and hanging still'. This topsy-turvy poem thus enlarges the levitating figure of Absalom so as to include Rosenberg's fellow soldiers as well as British-Jewry: 'We are lifted of all we know/And hang from implacable bows.' This seemingly endless sense of being caught in mid-air, neither flying nor standing still, was to prefigure much postcolonial and post-holocaust writing about diaspora.

*

Steven Connor has recently distinguished between post-war British writers who write as 'insiders' about a supposedly representable 'condition of England' and those that write from the 'outside in'. Connor refers mainly to postcolonial writers who have previously been deemed to be 'spatially and culturally at a distance' and have 'returned and doubled back' to re-narrate the metropolitan centre.[24] Salman

Rushdie's ideal of an 'imaginary homeland' gives something of the feel of this doubleness and hybridity that is said to characterize the postcolonial diasporic writer:

> Let me suggest that Indian writers in England have access to a second tradition, quite apart from their own racial history. It is the culture and political history of the phenomenon of migration, displacement, life in a minority group. We can quite legitimately claim as our ancestors the Huguenots, the Irish, the Jews; the past to which we belong is an English past, the history of immigrant Britain. Swift, Conrad, Marx are as much our literary forebears as Tagore or Ram Mohan Roy. America, a nation of immigrants, has created a great literature out of the phenomenon of cultural transplantation, out of examining the ways in which people cope with a new world; it may be that by discovering what we have in common with those who preceded us into this country, we can begin to do the same.[25]

The danger with Rushdie's 'imaginary homeland', however, is that one simply aestheticizes the diaspora so that it becomes a 'great tradition' of international writers and thinkers who are beyond any historical or political contingency. By concentrating exclusively on postcolonial writers, on the other hand, Connor illustrates the dangers of ethnicizing the diaspora so that it becomes a part of an all too usable 'black and white' or 'colonial/metropolitan' allegory. Postwar British-Jewish writers can be said equally to write from the 'outside in' about English national culture. But, I want to show, their work challenges both the aestheticization of the diaspora and its potential reduction to an ethnic allegory.

If we turn to the contemporary British-Jewish writer Clive Sinclair, we can see again the ironic creation of a diasporic universe where language carries considerable weight as opposed to history which, in Sinclair's fiction, is merely a function of language. From his earliest collections of short stories, *Hearts of Gold* (1979) and *Bedbugs* (1982), Sinclair has attempted to 'write fiction that owes nothing to any English antecedents' and has, therefore, self-consciously located his 'national' history as a Jew in Israel, America and Eastern Europe. He describes his fiction as a self-consciously failed 'attempt to distill the essence of other places. To make myself temporarily at home'.[26] Continuing this theme in his *Diaspora Blues: A View of Israel* (1987), Sinclair defines himself as an 'insider-outsider' as he has a 'dual loyalty' to 'the language of England and the history of Israel' and argues that, for a writer, there is 'something to be gained from having a language but no history, a history but no language'. Compared

with his alienation from England, his unrequited love-affair with Israel has provided him with a 'narrative' in which to situate himself.[27]

The construction of an extraterritorial 'national' past beyond his English birthplace – which is displaced onto both the Jewish diaspora and Israel – has posed an interesting dilemma for Sinclair. On the one hand, as the story 'Bedbugs' demonstrates, the history of the holocaust is deemed to be outside of the moral purview of his protagonists. When asked to teach First World War poetry to German students, Joshua, Sinclair's persona, fantasies about teaching a parallel course called 'Rosenberg's Revenge' which highlights, above all, Nazi atrocities. Rosenberg's poem, 'Louse Hunting' (1917), is evoked in this story as a metaphor for the holocaust as Joshua and a German student burn the bedbugs which infect their living-quarters. But all of Sinclair's stories are about the dangers of turning such historical metaphors into reality. Joshua, finally, acts as if he has the right to exact 'revenge' on behalf of the Nazi victims but, by the end of the story, he is clearly deranged.

Sinclair's protaganists are often made delirious by their impossible displacement of an 'English' identity onto a Judaized diaspora. In 'Ashkenazia', collected in *Bedbugs*, Sinclair takes such solipsism to its extreme limit by inventing an aestheticized 'imaginary homeland' untouched by genocide. Situated somewhere in central Europe, Ashkenazia, a fictitious Yiddish-speaking country, is defined exclusively as a language-community outside of history:

> Many of my fellow-countrymen do not believe in the existence of God. I am more modest. I do not believe in myself. What proof can I have when no one reads what I write? There you have it; my words are the limit of my world. You will therefore smile at this irony; I have been commissioned by our government to write the official English-language *Guide to Ashkenazia*.
>
> (p. 238)

By the end of the story, all that remains of 'Ashkenazia' is a 'field of wooden skeletons' and Sinclair's demented persona truly becomes bounded by his words, 'Now the world will listen to me, for I am the guide to Ashkenazia. I am Ashkenazia' (p. 248). This conflation of selfhood with nationhood is, on one level, the necessary solipsistic response of an author who displaces the national culture of his birthplace onto a useful fiction. For the post-holocaust writer, however, such aestheticized 'imaginary homelands' cannot just be constituted by words alone. A purely textual 'Ashkenazia' is an act of artistic megalomania precisely because Sinclair's narrator thinks that he can bring these 'skeletons' to life.

Sinclair's two early novels, *Blood Libels* (1985) and *Cosmetic Effects* (1989), take to its logical conclusion the insane union, in his stories, of selfhood with nationhood. Both novels, that is, are personal histories which have national consequences. As in one of Sinclair's later stories, 'Kayn Aynhoreh', hypochondria is the natural condition of those who place the imagination at the centre of nationhood. Jake Silkstone, the *alter ego* in this story, reappears in *Blood Libels* and describes his various Scriptophobic and Dermagraphic ailments as 'the psychosomatic approach to history': 'Just as the mind, knowing the symptoms, has no need of bacillus or virus to counterfeit an illness, so history does not need facts to proceed. What people believe to have happened is more important than what actually did' (p. 188). 'The psychosomatic approach to history' has especially telling consequences in *Blood Libels*, resulting in the emergence of the fascistic 'Children of Albion' in England and the 1982 Israeli invasion of Lebanon. In this novel, Sinclair deliberately undermines the idea of history as the 'pseudo-scientific study of facts' (p. 188) by treating well-known political events in Israel as grotesque fantasy and by turning grotesque fantasy in England into seemingly plausible historical narrative.

In *Cosmetic Effects*, the centrality of the imagination in the creation of historical and political 'facts' becomes the subject of the novel. This can be seen especially in the involvement of Sinclair's protagonist, Jonah Isaacson – a teacher of Film Studies at the University of St Albans – with the making of a Biblical Western in Israel called *The Six Pointed Star*. The producer of this film, Lewis Falcon (based on John Ford), is quite explicit about the fictionality of his 'America':

> Every people has its story . . . which is not the same as its history. It is this story that roots them on the land, that sustains their sense of identity. It may not be the truth, but it is believed. I have lived all my life in the twentieth century, I am not ignorant of the importance of truth, but I am an artist and my first responsibility is to the story – the story of the American people.
>
> (p. 163)

Sinclair's own short story called 'America' anticipated Falcon by showing that the idea of America, based on a series of puns and word-plays, is always liable to inventive reinterpretation. The depiction in *Cosmetic Effects* of 'America' as being not only a nation-state but a 'state of mind' (p. 61), not unlike Sinclair's Israel or 'Albania' (named after St Albans), interestingly shows the dangers of a Lyotardian view of the world based exclusively on language-games. Sinclair's

'America', in *Cosmetic Effects*, is a metaphor that eventually becomes 'real'. Jonah Isaacson recognizes this when he proclaims, 'give my imagination a metaphor and it'll have the *mise-en-scène* worked out in no time' (p. 5). Isaacson, in fact, comes to embody the competing stories which, as he shows, are literally fighting it out to the death in the Middle East:

> Although I have only one arm I really feel like two people – a smooth man and a hairy man – two people in a single body, like the Israelis and the Palestinians are two people in a single land ...
>
> (p. 204)

Cosmetic Effects deals with the possibility of Jonah Isaacson being unwittingly turned into a human bomb by his Palestinian doctor, Said Habash, who fits him with a prosthetic arm. Whether Isaacson is a 'Son of Ishmael' (the name of a Palestinian guerrilla group) or the son of Isaac (an Israeli national hero) is deliberately left open to question. Isaacson loses his memory for much of the novel and thus has a number of competing national stories imposed on him. His animalistic desires and domestic constraints embody this terrorizing or civilizing doubleness but are also part of a conscious narrative 'pluralism' which encourages 'a proliferation of stories and interpretations [so that] the future won't be fascistic' (p. 45). For Sinclair, the imagination 'bind[s] more strongly than kinship' and yet he is careful to locate his diasporic fiction within specific national stories.

In *Augustus Rex* (1992), Sinclair brings August Strindberg back to life, after half a century in the grave, with the Faustian pact that he will once again become an all-powerful writer and unbridled lover of women. The novel is narrated by Beelzebub, Lord of the Flies, who tempts the resurrected Strindberg to overreach himself (he is turned into a fly). Following on from the megalomaniacal storyteller of 'Ashkenazia' – who thinks that he can breath life into Europe's 'skeletons' – *Augustus Rex* sets out to make ironic the supposedly unlimited power of Strindberg's death-defying art. In this way, Sinclair is able to question the limits of an extraterritorial writing, displaced from space and time. His most recent collection of stories, *The Lady with the Laptop* (1996), continues to invent purely imaginary national homelands – such as 'Ishmaliya' in his story, 'The Iceman Cometh' – while simultaneously subjecting his aestheticized diaspora to the contingencies of history.

*

The fiction and poetry of Elaine Feinstein, not unlike Sinclair, also relates the need to escape from history to the desire of British-Jewish

writers to locate themselves beyond a restrictive Englishness. Elaine Feinstein's poetic novels have been especially located in a largely imaginary but historically specific Central Europe. Interestingly enough, when she does write directly about her British antecedents in *The Survivors* (1982), she is unable to go beyond the restrictions inherent in the conventional family saga novel form. In other words, her writing needs an extraterritorial realm so as to eclipse the parochial representations and received images of a domesticated British-Jewry.

When Feinstein's early novels were thought of as a species of contemporary 'Gothic' – along with fiction by Angela Carter, J. G. Ballard and Emma Tennant – she was quick to differentiate herself from what she thought of as this 'steely rejection of humanism, a fashionable resistence to compassion which I believe is as much a luxury of our English innocence as the euphoria of the flower generation'.[28] Her career as a writer has, precisely, gone beyond such 'English innocence'. Only when she became the translator of the poetry of Marina Tsvetayeva and, later, of Margarita Aliger, Yunna Moritz and Bella Akhmadulina, did Feinstein discover her voice as a 'European' writer. In this sense, her writing was self-consciously opposed to an early influential group of Essex University poets (including Lee Harwood and Tom Pickard) who wished to foreground their common 'Englishness' and 'de-Europeanise' themselves.[29]

As a woman, Feinstein has situated 'magical' father-enchanters at the heart of her fiction and has principally historicized the domestic sphere.[30] Feinstein's female *alter egos* resist assimilation into the dominant sexual values of English national culture. By contrast, Rosenberg and Sinclair attempt to masculinize their personae in opposition to the powerlessness of diaspora life. Far from being liberating, Feinstein's father-enchanters are always thoroughly ambiguous, both breathing 'life' into her female protaganists and, at the same time, threatening to make them 'dead with dependence'. In *The Shadow Master* (1978), the seventeenth-century Jewish false messiah, Sabbatai Zevi, is the ultimate historical expression of this double-edged enchantment. By the time of her *The Border* (1984) and *Loving Brecht* (1992), Feinstein has situated Walter Benjamin and Bertolt Brecht in this 'magical' role. If the source of this life-giving 'magic' is the 'music of words' (p. 164), as suggested in *The Circle* (1970), then male writers are a peculiarly disabling embodiment of this imaginative 'refuge' for her women personae.[31]

In *The Border* Walter Benjamin – 'a Marxist who is not a materialist' (p. 57) – is a 'mystical' synthesizing figure which the novel

deliberately deconstructs. Set in Vienna before the *Anschluss*, this work is written as a tryptich in diary and epistolary form and this allows for three equally passionate accounts of an erotic triangle. Far from presenting a single, male consciousness, the multiple, hallucinatory sense of reality in this novel – which turns history into the domestic and the domestic into history – is foregrounded even when the main characters are faced with the threat of Nazism. The Spanish border at Port Bou in 1940, where Benjamin committed suicide, by the end signifies both his tragically fixed place in history and the internal fissures which are writ large in the novel. This is acknowledged in the form of *The Border* which reads an arbitrary version of its own story back from a contemporary perspective.

By situating a great many different kinds of texts in an historical novel Feinstein, like Sinclair, establishes the possibility of re-imagining a European past in terms of ineffable 'magical' word-play as well as making usable the insurmountable 'borders' of history. But this is not, as Mark Shechner has argued, merely a 'journey of self-integration' into the European past for the Jewish novelist.[32] On the contrary, it is the lack of a sense of 'integration' into another history which these British-Jewish writers highlight in their fiction. In other words, all of these writers evoke an indeterminate Jewishness precisely to help us rethink the presumed certainties of the present.

*

By bringing together a disparate group of writers, and categorizing them as 'British-Jewish', there is clearly a danger of reducing these writers to a monolithic ethnicity. In the first full-length study of its kind, Ephraim Sicher has categorized British-Jewish writers in terms of their relation to the 'East End' and 'North West' of London.[33] Writers who are not easily confined by these city limits, such as Elaine Feinstein, are simply excluded from his ethnic realm. But, even those writers who are deemed to belong to the 'East End' or 'North West' districts of London are severely reduced by such territorial boundaries. One cannot understand a writer such as Harold Pinter or Anita Brookner in terms of this metropolitanism as they both write from the 'outside in' and interrogate the received cultural boundaries of Englishness. For this reason, virtually every post-war British-Jewish writer has located a good deal of their fiction or drama either on the Continent of Europe or in Israel or America. If a Jewish past has been written out of British national culture, then British-Jewish writers have invariably looked to the diaspora for their sites of Jewishness.

Pinter and Brookner are worth referring to in this context pre-

cisely because of their assumed position at the centre of English national culture. Both of these writers, paradoxically, established themselves at the heart of the English canon by locating their writing and their Jewishness in a largely unspecified European diaspora. This European dimension has often been read as the essential supplement to their writing as it seems to invigorate an increasingly moribund Englishness. Even Pinter's most autobiographical work, *The Dwarfs: A Novel* (1990), written originally between 1952 and 1956, belies its East End origins. European literature and philosophy overwhelm this youthful *Bildungsroman* which shows the extent to which, from the beginning, Pinter wished to render ineffable both his Englishness and Jewishness.[34] While the novel is dotted throughout with Yiddish jokes, references to the Talmud and 'the gaschamber' (p. 112), Pinter does not attempt merely to document the social and cultural milieu of Hackney or London's East End. Given that much of the Jewish East End was destroyed during the war, his modernist sense of deracination does have an historical resonance. *The Dwarfs* thus gives something of the flavour of Pinter's background without simply being reduced to that background.

In *The Birthday Party* (1958), produced soon after *The Dwarfs* was written, Goldberg, Pinter's most unequivocal Jewish figure, simultaneously articulates both an unreal and nostalgic Englishness as well as a fixed Jewishness. On the one hand, he extols the virtues of 'a little Austin, tea in Fullers, a library book from Boots' (p. 86) in a self-consciously parodic construction of an idealized English past. But, within a few lines, he acts as if Stanley's grotesque 'birthday party' is not unlike a British-Jewish family celebration or Simchah: 'Stanley, my heartfelt congratulations. I wish you, on behalf of us all, a happy birthday. I'm sure you've never been a prouder man than you are today. Mazeltov! And may we only meet at Simchahs!' (p. 86).

Englishness and Jewishness are, crucially, brought together by Goldberg in relation to a contrived and illusory sense of community. This is because, for Pinter, Goldberg's underlying menace goes hand in hand with his sentimentalized sense of belonging. A British-Jewish insider will know that the phrase 'may we only meet at Simchahs' is rather ominous as it is normally said at funerals. Throughout the play, Goldberg's blatant inconsistencies concerning his upbringing expose both his Englishness and Jewishness as specious fabrications, a refusal to come to terms with his own lack of identity. His multiple identities are, on the one hand, fully displayed and, at the same time, ineffable and enigmatic. Ultimately, Goldberg's deranged sense of an all-embracing community threatens to overwhelm Stanley's precari-

ous sense of self which explains, in part, Stanley's breakdown in the final scenes of the play.

Anita Brookner, while writing in a more conventional mode of realism than Pinter, also undermines received images of both Englishness and Jewishness. As John Skinner has argued, although Brookner writes 'stylistically' as an English 'insider', her predominantly female protagonists are 'mentally, if not ethnically, outsiders'.[35] Brookner's precarious position – as neither an 'insider' nor an 'outsider', neither 'Jewish' nor 'English' – can, in this regard, be related to Pinter. After *The Birthday Party* Pinter, not unlike Brookner, universalized his Jewishness so as to make it unrepresentable. Until *A Family Romance* (1993), Brookner similarly refused to portray her characters explicitly as Jewish outsiders although this does not apply to her self-representation in her interviews.[36]

As her novel *The Latecomers* (1988) demonstrates, Brookner's reluctance to make her Jewishness usable in her fiction was, above all, a self-conscious strategy. In an article on contemporary British-Jewry, she defines 'latecomers' as 1930s German-Jewish émigrés to Britain. Two such 'latecomers', Thomas Hartmann and Thomas Fibich, are at the heart of Brookner's eighth novel.[37] The status of Hartmann and Fibich, however, remains teasingly inexact in this work. If Hartmann and Fibich are 'latecomers' to England, then this assumes a line of earlier arrivals, but this is an immigrant story which Brookner pointedly refuses to tell. Brookner's narrative method has, in this sense, been rightly described as a 'refusal of emplotment'.[38] Hartmann and Fibich are both child refugees from Nazism, who lost their families during the holocaust, but Brookner uses the word 'Jew' only once in her novel. Not unlike the painfully incomplete story-telling of Aharon Appelfeld, what is left unsaid in *The Latecomers* becomes the subject of the novel. To this extent, both Brookner and Pinter have made usable the ineffability which surrounds Jewishness within English national culture.

*

What is interesting about the extraterritorial realm, which distinguishes much British-Jewish literature, is that it neither universalizes Jewishness out of existence nor strait-jackets it in preconceived images. This sense of being unsettled both in a spurious English universalism, as well as an overly monolithic Jewish particularism, has been a feature of much British-Jewish writing in recent years. At their best, however, the writers under discussion have not replaced their sense of homelessness with fixed or received images of Jewish identity. Instead, their self-conscious extraterritoriality – neither Eng-

lish nor Jewish – enables them to question the misconceived certain-
ties embedded in both an English as well as a Jewish past. This sense
of both a 'usable *and* ineffable' textuality has been contrasted with
the purely ineffable 'jew' within postmodern theory and the all too
usable 'Jew's body' within our current conceptions of modernity.

That the 'Golah' might be embraced and celebrated by Jews is,
as R. B. Kitaj shows, now a reality. But the danger, as I have argued,
is that this diasporic realm might either be overly aestheticized or
reductively particularized. George Steiner has recently republished
his defining essay, 'Our Homeland, the Text', which contends that
the 'dwelling... ascribed to Israel is the House of the Book' and
that the 'centrality of the book does coincide with and enact the
condition of exile'.[39] Here Steiner is close to Rushdie's 'imaginary
homeland' but, unlike Rushdie, he makes explicit the struggle
between his extraterritorial homeland and the myth of autochthony
which Steiner thinks of as 'the dialectical relations between an un-
housed at-homeness in the text... and the territorial mystery of the
native ground, of the promised strip of land' (p. 305). In the end, as
Daniel and Jonathan Boyarin have argued, the Jewish diaspora was
not historically synonymous with the 'Galut' or the forced product
of war and destruction. On the contrary, the 'Golah' was often a
voluntary state of existence that provided a model for 'cultural speci-
ficity but in the context of deeply felt and enacted human solidarity'.[40]
One can only hope that diasporic culture can once again live up to
these ideals.

Queen Mary and Westfield College, University of London

Notes

My thanks to Susan Cooklin, Laura Marcus, Max Silverman, Louise
Sylvester and Leon Yudkin for help on this piece.

1 Phil Cohen, *Home Rules: Some Reflections on Racism and Nationalism
 in Everyday Life* (London: University of East London Press, 1993), p. 34.
2 I am grateful to an earlier unpublished draft of *Home Rules* for this
 etymology.
3 Gillian Rose, *Judaism and Modernity: Philosophical Essays* (Oxford:
 Blackwell, 1993), pp. 1–24 and 241–57 for this argument in full. See also
 Max Silverman, 'Re-figuring "the Jew" in France' in Bryan Cheyette and
 Laura Marcus (eds), *Modernity, Culture and 'the Jew'* (Berkeley: Univer-
 sity of California Press, forthcoming).
4 Jean-François Lyotard, *Heidegger and 'the jews'*, trans. Andreas Michel

and Mark S. Roberts (Minneapolis: University of Minnesota Press, 1990), p. 3.

5 Geoff Bennington, 'Lyotard and "the Jews"', in Marcus and Cheyette (eds), op. cit.

6 Rose, op. cit., pp. 5–10, 13.

7 Sander Gilman, *The Jew's Body* (Routledge: London and New York, 1991), p. 91.

8 Zygmunt Bauman, *Life in Fragments: Essays in Postmodern Morality* (Oxford: Blackwell, 1995), pp. 207 and 206–22. Bauman continues this argument in Marcus and Cheyette (eds), op. cit.

9 ibid., pp. 208, 211–12.

10 Bauman, *Postmodern Ethics* (Oxford: Blackwell, 1993) for a possible way out of this doubleness.

11 Paul Gilroy, *The Black Atlantic: Modernity and Double Consciousness* (London: Verso, 1993), pp. 205–23.

12 Daniel and Jonathan Boyarin, 'Diaspora: generation and the ground of Jewish identity', *Critical Inquiry*, 19 (Summer 1993), pp. 721 and 693–725.

13 R. B. Kitaj, *First Diasporist Manifesto* (London: Thames & Hudson, 1989). Further references to this work will be in parentheses in the text.

14 Alan Sinfield, *Literature, Politics and Culture in Postwar Britain* (Oxford: Blackwell, 1989), p. 264.

15 Joseph Udelson, *Dreamer of the Ghetto: The Life and Works of Israel Zangwill* (Tuscaloosa: University of Alabama Press, 1990) for a recent account of Zangwill in these terms.

16 Neil Larry Shumsky, 'Zangwill's *The Melting Pot*: ethnic tensions on stage', *American Quarterly*, 27, (March 1975), p. 29. Further references to Israel Zangwill, *The Melting Pot* (London: Globe Publishing Co., 1925) will be in parentheses in the text.

17 Philip Dodd, 'Englishness and the national culture', in Robert Colls and Philip Dodd (eds), *Englishness and Culture 1880–1920* (London: Croom Helm, 1986), p. 22.

18 Cohen, op. cit., p. 34. Cohen echoes Morrison's *Tar Baby* (London and New York: Chatto & Windus, 1981) which enacts the lives of those who are forced to 'black up or universal out'.

19 Letter, 12 June 1916, in Joseph Cohen, *Journey to the Trenches: The Life of Isaac Rosenberg, 1890–1918* (London: Robson Books, 1975), p. 149.

20 Adam Phillips, *On Flirtation* (London: Faber & Faber, 1994), pp. 175–95.

21 Cohen, op. cit., pp. 127–8 discusses the level of antisemitism in the British army. See also Bryan Cheyette, *Constructions of 'the Jew' in English Literature and Society: Racial Representations, 1875–1945* (Cambridge: Cambridge University Press, 1993).

22 Letter, 15 June 1916, to R. C. Trevelyan, in Ian Parsons (ed.), *The Collected Works of Isaac Rosenberg*, (London: Chatto & Windus, 1979), p. 235 and Phillips, op. cit., p. 193.

23 Letter, 23 July 1916, to Gordon Bottomley, in Parsons, op. cit., p. 238.

24 Steven Connor, *The English Novel in History* (London and New York: Routledge, 1996), p. 85.

25 Salman Rushdie, 'Imaginary Homelands' (1982), in *Imaginary Homelands: Essays and Criticism 1981–1991* (London: Granta Books, 1991), pp. 20 and 9–21.

26 ' "On the Edge of the Imagination": Clive Sinclair interviewed by Bryan

Cheyette', *Jewish Quarterly*, 3–4 (1984), pp. 26–9. See also the entry on Sinclair in *World Authors: 1985–1990* (New York: H. W. Wilson & Co., 1995), pp. 818 and 818–20. Sinclair's stories have been republished as *For Good or Evil: Collected Stories* (London: Penguin, 1991). Further references to this work will be in parentheses in the text.

27 Clive Sinclair, *Diaspora Blues: A View of Israel* (London: Heinemann, 1987), pp. 50–3, 65 and 202. Sinclair's *Blood Libels* (London: Allison & Busby, 1985), *Cosmetic Effects* (London: André Deutsch, 1989) and *Augustus Rex* (London: André Deutsch, 1992) will be referred to in parentheses in the text.

28 Peter Conradi, 'Elaine Feinstein: life and novels', *Literary Review* (April, 1982), pp. 24–5.

29 ibid., pp. 24–5.

30 Olga Kenyon, *Writing Women: Contemporary Women Novelists* (London: Pluto Press, 1991), pp. 39–50 for this argument.

31 Jay L. Halio (ed.), *British Novelists Since 1960* (Detroit: Gale Research Co., 1983) for this argument and Glenda Abramson (ed.), *The Blackwell Companion to Jewish Culture* (Oxford: Blackwell, 1989). References to Feinstein's *The Border* (London: Hutchinson, 1984) will be in parentheses in the text.

32 Mark Shechner, *The Conversion of the Jews and Other Essays* (London: Macmillan, 1990), p. 100.

33 Ephraim Sicher, *Beyond Marginality: Anglo-Jewish Literature after the Holocaust* (New York: State University of New York Press, 1985).

34 Martin Esslin, *Pinter: The Playwright* (London: Methuen, 1982), pp. 121–30. I will be referring to Pinter's *The Dwarfs: A Novel* (London: Faber & Faber, 1990) and Margaret Rose (ed.), *The Birthday Party* (London: Faber & Faber, 1993) in parentheses in the text.

35 John Skinner, *The Fictions of Anita Brookner* (London: Macmillan, 1992), p. 6.

36 See, for example, John Haffenden, *Novelists in Interview* (London: Methuen, 1985), p. 60 where Brookner describes the Polish-Jewish background of her parents.

37 Anita Brookner, 'Aches and pains of assimilation', *The Observer*, April 23 (1989), p. 44.

38 Skinner, op. cit., p. 137.

39 Steiner, 'Our Homeland, the text' (1985), in *No Passion Spent: Essays 1978–1995* (London: Faber & Faber, 1996) pp. 305 and 304–27. Further references to this essay and *Proofs and Three Parables* (London: Faber & Faber, 1992) will be in parentheses in the text.

40 Boyarin, op.cit., p. 720.

Sojourners

The Return of German Jews
and the Question of Identity
**John Borneman and
Jeffrey M. Peck**

"A firsthand confrontation with
the inner fears and the outer
realities of [German Jews] as
they themselves reflect post-
Shoah history and experi-
ence."—Sander L. Gilman
£38 hb

Prismatic Thought

Theodor W. Adorno
Peter Uwe Hohendahl

A brilliant tour of Adorno's
work, with special emphasis on
his aesthetic writings.
£32.95 hb

Emerson's Literary Criticism

Ralph Waldo Emerson
Edited with a new introduction
by Eric W. Carlson

"Carlson has performed a
valuable service in publishing
these important critical
statements in one convenient,
thoroughly documented
sourcebook."—*Choice*
£9.50 pb

Toward a Theory of Radical Origin

Essays on Modern
German Thought
John Pizer

"[John Pizer] provides
illuminating readings of five of
this century's most influential
thinkers."—Martin Jay, author of
Marxism and Totality. The five
influential thinkers are
Nietzsche, Benjamin,
Rosenzweig, Heidegger, and
Adorno.
£32.95 hb

The Powers of Speech

The Politics of Culture in
the GDR
David Bathrick

"Bathrick's study is potentially
the most important book on
GDR culture to appear in the
English language."—Patricia A.
Herminghouse, editor of *Frauen
im Mittelpunkt*
£38 hb

University of Nebraska Press
c/o Academic & University Publishers Group 1 Gower St. • London WC1E 6HA

Romita Choudhury

'Is there a ghost, a zombie there?' Postcolonial intertextuality and Jean Rhys's *Wide Sargasso Sea*

I

Intertextuality, understood not only as a dimension shared by all texts but also as a deliberate, self-conscious reply of one text to another, has significant implications for the discourse of postcolonialism. Defined as 'dominated literatures' and recognized by its elements of difference, defiance, identity and opposition, postcolonial literatures are seen to tend inevitably towards 'writing back to the centre'.[1] It is felt that 'a study of the subversive strategies employed by postcolonial writers would reveal both the configurations of domination and the imaginative and creative responses to this condition'.[2] In the formulation of postcolonial intertextuality as framed by domination and subversion, the possibilities of diverse forms and content and the heterogeneities in specific configurations of colonization and decolonization, even as they are acknowledged, ultimately converge towards a unified domain of true and nameless resistance.

The idea of intertextuality most elaborated and extended in successive theorizations is also its basic one, namely that any text is a confluence of sources, each separate and losing itself in the process of intermingling. No text is self-contained. Neither is it an obedient follower of its predecessors. The conception of meaning as produced through repetition and difference has become an important base for challenging hierarchical notions of the unity, authorship, authority and sanctity of the literary text.[3] In the case of the postcolonial text, the dual imperatives of being different and accessible impose peculiar sanctions, making it push the boundaries of English literary interpretation while remaining solidly a subsidiary of it.[4] English language texts from the postcolonial world and their ideological intersections with those of the centre are thus invested with a representativeness sought in the general idea of postcoloniality: '[t]he use of english

Textual Practice 10(2), 1996, 315–327

inserts itself as a political discourse in postcolonial writing, and the use of english variants of all kinds captures that metonymic moment between the culture affirmed on the one hand as "indigenous" or "national", and that characterized on the other as "imperialist", "metropolitan", etc.'⁵ So, English becomes *the* postcolonial language of an 'emergent' literature and culture that affords the critical middle ground separable from indigeneity and imitation. Both in its identity and otherness, it is required to engage in *ambivalent* dialogue with colonialism. Concomitantly, the more varied and innovative the manifestations of this ambivalence, the richer, more heterogeneous and sophisticated, postcolonial literature is decreed to be. Furthermore, the subject whose language can engage the discourses of dominance in such a way and can be interpreted by them acquires an exorbitant role.

The different texts of postcolonialism, joined by the already known intertext of colonialism, are assigned a third space in which dialogue can be conducted. This is the space of cross-culturalism, described in the writing back scenario as 'the potential termination point of an apparently endless human history of conquest'.⁶ The triangulated discourse of cross-culturalism, postcolonialism and colonialism constitutes a politics of reading, which, while introducing a critique of colonialism into the restricted territory of English Literature, organizes and manages this critique within a framework of postcolonial subjectivity. This politics of reading functions like a command, a 'duress', under which the rethinking of identity and difference, of cultural self-representation takes place.⁷ It prefigures a particular kind of reader of the colonial and/or postcolonial scene, responding with a certain type of competence to the series of epistemic transformations – most effective in literature – that have produced the colonial subject. The intricate complicities and negotiations of this production along the lines of gender, class, colour and language are absorbed in a category of postcolonial literature which remains in its accessible language and different articulation of identities a *supplement* of the dominant culture's history.

According to Ross Chambers, double negativity is the sign of a literary text's imbrication in a specific cultural history within which its critical activity becomes most meaningful:

> For 'literarity', as the mode of irony that defines text as the *not not-I* with respect to social discourses – that is both to the canonised intertext and to its own textual discourse – is itself dependent on the social phenomenon of its being recognized by a readership, and I mean 'recognized' in the sense of 'noticed' and in the sense

of 'accepted'. There can be no intertextuality (constitutive of the literary system) except as it is produced by a reader in the act of perceiving the textual discourse as part of the literary system; and it is in thus recognizing the text as belonging to a form of discourse historically produced as subject to 'interpretation', that the reader constitutes the text as an *'alter ego'* with respect to itself, that is as meaning 'more', or rather *other*, than it says.[8]

The recognition of oppositional gestures then corresponds to the text's placement *within* the literary system and its history of oppositionality and/or affirmation. *How* a text is made to mean more or other than its apparent enunciations and *how* its reworkings will be addressed or found readable is a function of that particular location. It is what ensures 'the ongoingness of literary history' through 'the impossibility of saying something different, . . . an equal impossibility inherent in the attempt to say something same'.[9] Hence, the fluidity of discourses that the notion of intertextuality seems to denote and the re-positioning of reading practices that it is seen to effect[10] have to be seen within a field of determinations surrounding the text and its various positionings in relation to that field.

In spite of the multiple possibilities of reference a text may evoke, it is possible to discern centralizing/stabilizing forces at work in establishing intertextual relations.[11] Having situated the text within a world of counter-hegemonic displacements, we have to continue to deal with the question of power and *its sources* in deciphering and explaining textual politics. Because of the very fact that we can now see the relation between margins of discourse as *constructed* in temporary and partial ways, it is important to ask what political imperatives govern the referentiality among texts. Postcolonial intertextuality demands such a recognition. For, over and beyond the general dimension of intertextuality attributed to all texts from the postcolonial world, whose postcoloniality is seen to originate in their 'difference' from the Imperial Center, there is the question of how the centre is being figured and where the text is being placed in relation to the text of the Center. The organizing principles of this relationship are so important because intertextuality is often the mark of a struggle to 'unhinge' the narratives of domination by reclaiming the colonized, subjugated spaces.

II

Jean Rhys's *Wide Sargasso Sea* is well known for its overt intertex-
tuality, its attempt to re-write the story of the mad Creole woman
locked up in Charlotte Brontë's novel, *Jane Eyre*. Rhys's text is tied to
the 'original' narrative by its ensemble of similarities and differences.
Among the range of responses to *Wide Sargasso Sea*, very few deny
that the recreated Bertha Mason/Antoinette Cosway is a far more
challenging character than her nineteenth-century version. And she
has arisen from the ashes of a violent conflagration to tell her story.
Yet, much as the independence of this story is recognized, its enrich-
ment of the repressed with exclusive knowledge and an impregnable
inner world hailed, *Wide Sargasso Sea* owes the volume of its critical
readings to its reference to the literary tradition against which it
defines its existence. Its reclamation of a marginalized subjectivity
therefore provokes a crisis that is assigned to a discursive space
created by an *informed* re-reading of the classical text.[12] Through
the rupture of temporalities, reversal of effects, identifications and
doublings – those devices of subversion that mark its difference –
Wide Sargasso Sea ends up completing *and* problematizing the
canonical text.[13] Whether it is the place from where the challenge has
come or the strength of its enunciation as judged by the hierarchies of
discourse, Rhys's text shows that without the framework of reversal
undergoing radical transformation, the full possibility of the trans-
gressive text cannot be realized. In other words, if the critical act of
postcolonial intertextuality must always mark its origin, its reconcep-
tualizations of the colonial subject must remain the effect of different
readings of that origin.

The intertextual activity of *Wide Sargasso Sea* has made available
a kind of historical knowledge that *solves* the mystery of Bertha
Mason's madness. She emerges as the lonely, tormented and restless
fellow victim of Jane Eyre: 'each woman, in her own way, resists
temptation, rejects "swans and roses", and wrests her identity from
the patriarchal hypocrisy of "happily ever after" '.[14] As a result two
very different texts are collapsed in an inclusionary gaze that turns
the prisonhouse of 'civilization' into a mutually beneficial space of
enlightenment. In this space 'the parallels between Antoinette and
Jane' are celebrated and made more significant than the virtually pre-
ordained suicide of Antoinette. In order to see Jane and Antoinette
as sisters, *Wide Sargasso Sea* is read as a development of the mad
Bertha, a realization of her potential for complexity and her subli-
mation into the higher domain of her superior sister.[15] Also, the deep
chasms of race and class that constitute the terrain of Rhys's protag-

onist and the narration of her relatively privileged subjectivity are ignored.

In order to install Bertha Mason as Jane Eyre's '*alter ego*', her colonial history must be incorporated into the discourse of selfhood as one stage only, activated at the appropriate conjuncture of domination and resistance. The prolonged, diffuse and unnameable conditions of Antoinette will have to be periodized accordingly, where disidentification is the necessary prerequisite of maturation. Antoinette Cosway's act of torching Thornfield Hall is thus explained as a representative moment of her 'identification with her West Indian heritage' and the 'recover[y] of her childhood, her identity.'[16] Questions such as what this West Indian heritage means relationally, in terms of the two texts, or how the suicidal burning down of an English manor house should signify West Indianness, remain unanswered. The combination of nostalgia and annihilation, resonant with stereotypical presuppositions about the West Indies as place of magic and madness, signals the later dissipation of Antoinette Cosway. Thus the rupture that *Wide Sargasso Sea* inserts into the context of Jane Eyre is sealed, reinstating the innate capacity of the canonical English text to absorb new meanings and remain virtually intact.

Brontë's text has charted a diverse critical history, from the outraged responses of its time to the feminist readings of our times.[17] Within these diverse and disparate readings, the space of colonial marginality has remained the most malleable one. It is accessible to everyone. It can be repositioned and reprojected anywhere. Either as Jane's recalcitrant self in battle with her soul or as Rochester's guilty heart of darkness, the Creole woman serves as the instrument for all sorts of recuperative measures. What is more, these transpositions function as markers of the anti-hegemonic, anti-closure stance of the text.

Brontë, of course, does not seek to obfuscate the dividing line between the two women, for the legitimation of her discourse of 'feminist individualism'[18] depends on the contrast between the meditative Jane and the wild Bertha. Consider Rochester's dual function of justifying the larger project of domination and laying out the qualifications of a civilizing feminine consciousness:

> ... look at the difference! Compare these clear eyes with the red balls yonder – this face with that mask – this form with that bulk.
>
> (p. 297)

Further,

> I was rich enough now – Yet poor to hideous indigence: a nature
> the most gross, impure, depraved I ever saw, was associated with
> mine ... I could not rid myself of it by any legal proceedings.
>
> (p. 310)

But,

> There was a pleasurable illumination in your eye occasionally, a
> soft excitement in your aspect, which told of no bitter, bilious,
> hypochondriac brooding.
>
> (p. 317)

The negativity of Bertha gives 'form' to the potential goodness of
Jane and the burden of Rochester's past. It is the binary foundation,
the history, the truth upon which the dynamism of the protagonists
resides.

Franco Moretti describes the *Bildungsroman* as the symbolic
form of modernity because it encompasses two contradictory prin-
ciples in the approach to modernity:

> Under the classification principle, ... a story is more meaningful
> the more truly it manages to suppress itself as story. Under the
> transformation principle ... the opposite is true: what makes a
> story meaningful is its narrativity, its being an open-ended process.
> Meaning is the result not of a fulfilled teleology, but rather, ... of
> the total rejection of such a solution. [T]he two models express
> opposite attitudes towards modernity: caged and exorcised by the
> principle of classification, it is exasperated and made hypnotic by
> that of transformation.[19]

The metonymic captivity that links Jane and Bertha enclosing them
within the boundaries of uncontaminated goodness and evilness dis-
solves itself in due time with Jane's transformation, her moral and
intellectual readiness for autonomy, for 'breaking the sequence' of
effects. Armed with the self-determination acquired through her
experience of this captivity, Jane is finally able to override the impli-
cations of Rochester's patronizing discourse with the assertion of her
sense of self. Rochester had made the following observations on
her predicament: 'I see ... a curious sort of bird through the close-
set bars of the cage: a vivid, restless, resolute captive is there; were it
but free, it would soar cloud-high' (p. 140). Unsettling his idealized
and conciliatory interpretation of her condition, Jane is able to answer
him back at the right moment and with the *proper* amount of restraint:
'I am no bird; and no net ensnares me: I am a free human being with

an independent will; which I now exert to leave you' (p. 256). The status of the imperial text of modernity and its performance of Englishness are both contributory factors in the authority with which Jane is made to represent and embody the values of democracy, will, sincerity and justice – the values of her class and the values of universal humanity. Bertha Mason also undergoes transformation but strictly in her movement between two poles of being: from vicious lunatic to dazzling, majestic beauty and back again to hideous and coarse nature.

The West Indian text of *Jane Eyre* constitutes a category that exists only within its discourse of imperialism from where it enables the self-perception of its principal characters. Toni Morrison, in her study of the Africanist presence created by the 'founding fathers' of American literature, draws attention to a similar textual dynamic arising out of another violent racial encounter. In order to investigate the functions of this presence, she finds she must focus not on the 'dark, abiding' object but on the subjectivity and agency of Americanness that this object made possible: 'Africanism is the vehicle by which the American self knows itself as not enslaved, but free; not repulsive, but desirable; not helpless, but licensed and powerful; not a blind accident of evolution, but a progressive fulfillment of destiny.'[20]

Bertha Mason, neither black nor white, an outcast in Jamaica and a contaminating presence in England, performs the discourse of irrationality, degeneracy and malice that releases the consensual Truth upon which Jane's story can be written. Even if her indeterminate otherness is seen to stand in as a grotesque reflection of Jane's othering by the morals and assumptions of a feudal-patriarchal culture, that link is clearly broken when the protagonist has established her identity. With Rochester's account of his marriage to Bertha, the Creole woman is returned to where she belongs: 'hurricanes', 'the air . . . like sulphur-steams', 'the moon . . . like a hot cannonball' and generally, 'a world quivering with the ferment of tempest' (p. 312). When Rhys uses the same figure of otherness to construct the Jamaican side as opposed to the 'English side',[21] in the gaps and mutedness of the master text, the project reveals that the voice and story of her paradigmatic figure of hybridity does not automatically re-imagine and re-centre history. Not only are her whiteness and her femaleness traversed by 'whiteness, as a masculinized epistemology', and a 'femaleness which is aligned with blackness and historylessness',[22] but her resistances and collusions in this grid of significations are contained by the urgency of finding a language and a context in which *at least* the ghost of Bertha Mason could speak.

Wide Sargasso Sea attempts to extricate Bertha Mason and the West Indies from their discursive bondage to the formation of

England and Englishness. Through the figure of Antoinette Cosway, Rhys's text speaks to the unquestioned ideology of imperialism permeating the dominant discourse and canonicity of Brontë's text. In *Wide Sargasso Sea*, Brontë's mad Creole object finds a voice, however tremulous and disjunctive; she finds a space agitated by racial and class conflicts, by identification and alienation. In short, she finds a *story*. This story does not topple the Manichean structures of domination in the master narrative by conjoining the separate histories and locations of Jane and Bertha in the interests of a transnational, transcultural discourse of feminine identity. On the contrary, it produces a difficulty in re-accommodating the Jamaican Antoinette alias Bertha within Thornfield Hall. Without Bertha's barbaric, malignant, and treacherous capacities, Jane cannot activate and consolidate her 'soul-making' process; Europe cannot render itself the 'grave and quiet' spectator of the 'demonic gambols' of its Other.

Wide Sargasso Sea, in its separateness, *almost* makes *Jane Eyre* an impossibility. On the other hand, it is also a testimony to the power and authority of the English text through which it seeks to negotiate a different possibility for Antoinette Cosway, for the Caribbean text is as concerned with revealing the bases of power and authority in the English text as it is with its own newness. Rhys's re-location of Bertha/Antoinette, however, brings into relief the precariousness of her identity. Englishness, whether it comes in such tidy packages as the 'geography book map', pictures of 'lovely English girls', imitation English houses, tall, fine English husbands, or the scattered remains of the slaveowners' legacy, encodes irrevocably her white Creole experience. Choosing, as Antoinette does, to find herself within the modes of knowing, seeing and performing that have othered her, unable to find her 'own' path as it were, Antoinette plunges back into the anterior text, and, with agonizing clarity, repeats the act of self-destruction she is so well known for.

The text opens with Antoinette's narration which at the very outset voices the problem of self-positioning: 'They say when trouble comes close ranks, and so the white people did. But we were not in their ranks. The Jamaican ladies had never approved of my mother, "because she pretty like pretty self" Christophine said' (p. 1). In her relationship with Rochester, Antoinette, unlike Jane Eyre, can make sense of her experiences only through a ceaseless chain of negations. Before she can assert herself she must engage in a long and losing battle to make Rochester unlearn what he already knows about her. She says, 'My name is not Bertha; why do you call me Bertha?' 'Because I think of you as Bertha', she is told (p. 111). Not Bertha, not mad, not white nigger – Antoinette's stubborn attempts to break the

link in the sequence of identities fail to afford any resolution to her crisis of self-definition, fail to free her from its relentless markings. Rochester needs to re-name Antoinette as Bertha to ensure the continuity of his own beginnings. Otherwise the surroundings that make him so indubitably conscious of his alienation, that make him feel 'like a child spelling out the letters of a word which he cannot read' will forever remain outside his control (p. 113). Rochester's power resides exactly at this point when self-reflexivity intersects with the larger political and economic establishment that makes English presence possible in Jamaica; individual unease aligns with political and economic certainty to grant him central authority in 'reading' Antoinette's experiences and prescribing the 'proper' course of action. In correspondence with this process of usurpation, Antoinette's textual space gradually diminishes and her interpretive control over her story fades.

The 'rosy' and fearful text of Englishness invades Antoinette's dreams. The scene is always the same, that of a hunt. In the dream of her childhood, Antoinette 'hear[s] heavy footsteps' and 'though [she] struggled and screamed [she] could not move' (p. 23). In a later version, just before her marriage to Rochester, the pursuit takes the form of seduction. She is following a voice, that of a man beckoning her to approach him. This time the sense of paralysis is more well-defined, being articulated almost as action. As always, there is the foreboding sense of imminent violence actualized in the enclosed landscape, the felt surveillance of the man and his palpable ubiquity: 'I follow him sick with fear but I make no effort to save myself; if anyone were to try to save me, I would refuse. This must happen' (p. 50). The language of the dream projects a containment between the inability to act (so petrified is Antoinette) and an active refusal of intervention (so inexorable seem the happenings). By infusing the experience of fear, desire and acceptance with interchangeability, Rhys hints at a more complex interplay of forces as grounding the exercise of power than is suggested by the singular person of Rochester. Antoinette herself revokes her decision not to marry Rochester, rejects Christophine's advice to go away and re-evaluate her options, breaks her relationship with Sandi and sails off to England with Rochester. She returns from every route of escape back to him.

A curious resemblance is discernible in the predicament of Antoinette and Rochester, who is himself beset with fear. To him the 'magic' of the place is 'wild but menacing' (p. 58), its beauty always touched with 'an alien, disturbing, secret loveliness' (p. 73) and the night itself alive 'watching, listening... outside' (p. 106). Rhys is obviously not interested in substituting Brontë's Bertha Mason with

Rochester in *Wide Sargasso Sea*. She is more concerned with the effects of dis-ease and alienation in a 'hostile' world. Like Antoinette in her own dream, Rochester gets drawn into the forest. What he finds there reverberates with Antoinette's dream sequence: 'I was lost and afraid among these enemy trees, so certain of danger that when I heard footsteps and a shout I did not answer' (p. 87).

Rochester and Antoinette share the same kind of fear and insecurity. Both have also inherited directly and indirectly a whole epistemic apparatus that exceeds the influences of place. Its objects and patterns of enquiry, its expectations, are expressed in the power to name and interrogate. When Rochester is lost in the woods and finally found by Baptiste, he seeks the answers he seems already to know:

> 'A child passed', I said. 'She seemed very frightened when she saw me. Is there something wrong with the place?' He shrugged his shoulders.
> 'Is there a ghost, a zombie there?' I persisted.
> 'Don't know nothing about all that foolishness.'
> 'There was a road here sometime.'
> 'No road,' he repeated obstinately.
>
> (p. 88)

Rochester clings to his confidence in his powers of deduction and knowledge by association, but Antoinette has realized the futility of it all: '[The place] has nothing to do with either of us ... it is something else. I found that out long ago when I was a child' (p.107). Antoinette's own knowledge of this place and its secrets are laughed off by Christophine as 'tim-tim story ... all foolishness and folly' (p. 93).

The 'tim-tim' stories persist in Antoinette's memories and Rochester's books. Although no authenticity is attributed to either, a world parallel to and inconceivable by outsiders is obviously evoked by images of zombies, ghosts and obeah. While the lawlessness of these practices does imbue Antoinette's dogged recourse to them with a certain amount of subversiveness, Rhys ultimately translates obeah in the idiom of midsummer night 'madness'. As Rhys herself has written in a letter to Francis Wyndham, 'A Zombie is a dead person raised up by the Obeah woman, it's usually a woman I think, and a zombie can take the appearance of anyone. Or anything ... But I did not write it that way and I'm glad, for it would have been a bit creepy! And probably, certainly I think, beyond me.'[23] The disaster brought about by the love potion gone wrong does not provoke laughter, however. It allows Rochester to break Antoinette and turn

her into 'a ghost in the grey daylight' (p. 140), a 'zombie', like the one described in *his* source book, *The Glittering Coronet of the Isles*: 'A zombie is a dead person who seems to be alive or a living spirit who is dead. A zombie can also be the spirit of a place usually malignant' (p. 88). References to zombification abound in *Wide Sargasso Sea* replete with the aura of mystery and fear. Antoinette's mother has 'eyes like zombie and [Antoinette's] eyes like zombie too' (p. 42). Rochester is mocked by Amelie for looking 'like he see zombie' (p. 83).

This world that Antoinette Cosway *de facto* turns away from haunts the fractured textuality of her dreams. As Wilson Harris so succinctly puts it, the dream of the forest voices Antoinette's 'indebtedness to the black soil'.[24] This soil is forbidden because, alive with a fierce energy like Christophine's, it can pull her away into its supposed darkness. Harris reminds us that when Antoinette enters the forest in her dreams, she 'do[es] not try to hold up [her] dress, it trails in the dirt, [her] beautiful dress' (p. 60). The black presence is heralded as ubiquitous, powerful and enigmatic, but not a uniform collective subjectivity. In Antoinette's narrative, we are told that Christophine's 'songs were not like Jamaican songs, and she was not like the other women . . . she was much blackerShe had only one friend – a woman called Maillotte, and Maillotte was not a Jamaican' (p. 20). Amelie is a 'half-caste servant' who looks like Antoinette. Overall, this world remains outside Antoinette's reach, and its many voices, although intuitively recognized and acknowledged by author and narrator, proclaim its absence.

In the final segment, Rhys reinstates Antoinette Cosway at the very centre of the narrative. She speaks from the scene of her own obliteration. Even as predispositions to the meaning of development/ awakening, as represented by the nineteenth-century British *Bildungsroman* are here challenged, re-formulated and parodied, Rhys effects an uneasy balance between the transformative potential of the intertextual space and the new set of social contradictions it confronts. This balance is symbolized in the sudden and sweeping accretion of hybrid Jamaican images in the final segment culminating in the vision of the black girl Tia and a single, terrified utterance of her name. It is as if Antoinette has glimpsed the failed possibility of achieving a composite identity. In this moment of exteriority, it cannot be forgotten that she has once before seen her own bruised and bloody face in that of Tia, 'like in a looking glass' (p. 38). Noticeably, this time 'there is no looking glass', nothing at all 'between us – hard, cold and misted over with my breath' (p. 147). All differences and dissonances have been transmuted into oneness. In the simultaneity of this

dreamed coalescence and the burning down of the 'cardboard house', Rhys attempts to metamorphose the individual, frenzied act of Bertha Mason into the contextualized and grounded revolt of Antoinette Cosway and her eventual turn homeward. Yet, given the inexorable logic and circumstances of the journey itself, this return can only function as the substitution of one form of alienation by another and the destination itself as a disturbing paradox of homeland and prison.

If expected to fill the gaps left by Manichean colonialism in Europe and America's cultural progress, postcolonial intertextuality can be little more than a magnifying glass held to the ambivalences and slippages in dominant discourses. Its revisionings and rewritings will be haunted by the always present agenda of restitution. As zombification is not simply passivity or an inability to think, but an inability to think differently, so de-zombification is not the emptying out of the mind but the confrontation of a heavily inscribed terrain criss-crossed by histories. Rhys's text poses the problems in the extrication of language and thought from the dominating structures of colonial culture. As such, it anticipates newer narratives that address this problematic not only from an urge to correct canonical norms and approaches, but from the imperatives of the struggle to construct an alternative history of the colonial subject.

University of Alberta

Notes

1 Bill Ashcroft, Gareth Griffiths and Helen Tiffin (eds), *The Empire Writes Back: Theory and Practice in Post-Colonial Literatures* (London: Routledge, 1989).
2 ibid., p. 33.
3 'Introduction' to Michael Worton and Judith Still (eds), *Intertextuality: Theories and Practices* (Manchester and New York: Manchester University Press, 1990), pp. 1–44.
4 Ashcroft *et al.*, p. 53.
5 See Roland Barthes, 'From work to art', in Stephen Heath trans., *Image Music Text* (Glasgow: Fontana, 1977). It would be useful to keep the following definition in mind while considering the implications of postcolonial intertextuality and its problematic relationship to beginnings, critical or otherwise: 'the intertextual in which every text is held, it itself being the text between of another text, is not to be confused with some origin of the text: to try to find the "sources", the "influences" of a work is to fall in the myth of filiation. The citations which go to make up a text are anonymous, untraceable, and yet already read: they are quotations without inverted commas' (p. 160).
6 Ashcroft *et al.*, p. 36.
7 See Gayatri Chakravorty Spivak 'The burden of English', in Rajeswari

Sunder Rajan (ed.), *The Lie of the Land: English Literary Studies in India* (Delhi: Oxford University Press, 1992), pp. 275–99.

8 Ross Chambers, 'Alter ego: intertextuality, irony and the politics of reading', in Michael Worton and Judith Still (eds), *Intertextuality: Theories and Practices* (Manchester and New York: Manchester University Press, 1990), p. 144.

9 Barbara Johnson, 'Les fleurs du mal arme: some reflections on intertextuality', in *A World of Difference* (Baltimore and London: Johns Hopkins University Press, 1987).

10 See Julia Kristeva, 'Word, dialogue and novel', in Toril Moi (ed.), *The Kristeva Reader* (Oxford: Basil Blackwell, 1986).

11 John Frow, 'Intertextuality and ontology', in Worton and Still (eds), *Intertextuality: Theories and Practices*. See also Ruth Frankenberg and Lata Mani, 'Crosscurrents, crosstalk: race, "postcoloniality" and the politics of location', *Cultural Studies*, 7.2 (1993), pp. 292–310.

12 Gayatri Chakravorty Spivak, 'Poststructuralism, marginality, postcoloniality and value', in Peter Collier and Helga Geyer-Ryan (eds), *Literary Theory Today* (Cambridge: Cambridge University Press, 1991), pp. 219–44. See also Thomas King, 'Godzilla vs. Post-Colonial', *World Literature Written in English*, 30.2 (1990), pp. 10–16.

13 Elizabeth Baer, 'The sisterhood of Jane Eyre and Antoinette Cosway', in Elizabeth Abel *et al.* (eds), *The Voyage In: Fictions of Female Development*, (NH: University Press of New England, 1983); see Ellen G. Friedman, 'Breaking the master narrative: Jean Rhys's Wide Sargasso Sea', in Ellen G. Friedman and Miriam Fuchs (eds), *Breaking the Sequence: Women's Experimental Fiction* (Princeton, New Jersey: Princeton University Press, 1989); Rachel Blau Duplessis, *Writing Beyond the Ending: Narrative Strategies of Twentieth Century Women Writers* (Bloomington: Indiana University Press, 1985).

14 Elizabeth Baer, p. 147.

15 I have borrowed this notion of displacement from Peter Stallybrass and Allon White, *The Politics and Poetics of Transgression* (London: Methuen, 1986), p. 198.

16 Baer, pp. 134, 147.

17 'A dialogue of self and soul: plain Jane's progress', in Sandra M. Gilbert and Susan Gubar, *The Madwoman in the Attic: The Woman Writer and the Nineteenth Century Literary Imagination* (New Haven and London: Yale University Press, 1979).

18 Gayatri Chakravorty Spivak, 'Three women's texts and a critique of imperialism', *Critical Inquiry*, 12 (1985): p. 252.

19 Franco Moretti, *The Way of the World: The Bildungsroman in European Culture* (London: Verso, 1987), p. 8.

20 *Playing in the Dark: Whiteness and the Literary Imagination* (Cambridge, Mass.: Harvard University Press, 1992), p. 52.

21 See Ellen G. Friedman, p. 120.

22 Belinda Edmondson, 'Race, privilege, and the politics of re(writing) history', *Callaloo*, 16.1 (1993), p. 184.

23 Francis Wyndham and Diana Melly (eds), *Jean Rhys: Letters, 1931–1966* (London: Andre Deutsch, 1984) pp. 262–63.

24 *The Womb of Space: The Cross Cultural Imagination* (Westport, Connecticut: Greenwood Press, 1983), p. 53.

David Norbrook

The Emperor's new body? *Richard II*, Ernst Kantorowicz, and the politics of Shakespeare criticism

At the end of the fourth act of *Richard II*, the deposed king calls for a mirror and breaks it. For Richard, a formerly unified world has been shattered: mirrors no longer reflect reality, the real king has become a mere play-actor. For many critics, this moment has become crucial for understanding not just this play but the whole political culture of early modern England. The play, we are told, dramatizes the doctrine of the 'king's two bodies'. One of these bodies is natural and mortal, the other artificial, mystical and immortal. In the ideal state of things, the king brings those bodies together just as the sacramental host brings together Christ's divine and earthly substances. This doctrine has often been seen as a keystone of Elizabethan theories of language and representation, which sought to establish a natural unity of sign and thing signified, though such unity was becoming increasingly difficult to sustain, and was thus projected on to a medieval past. *Richard II* presents the tragic consequences of the breakdown of political and, more broadly, of semiotic unity.

The 'king's two bodies' concept is by now so familiar that it has been absorbed into productions of *Richard II* and has become the common currency of literary criticism. It is hard to remember that it was almost unknown until the publication in 1957 of Ernst Kantorowicz's massive treatise, *The King's Two Bodies*. This book enjoys ever-increasing celebrity, having been translated into Spanish, French and Italian. The speed with which the concept of the two bodies was taken up reflects growing interest in the role of the body in history, and it is in this context that Kantorowicz's work has become so enormously influential.[1] Michel Foucault gave a kind of canonical status to *The King's Two Bodies* when he presented it as a counterpart to his own *Discipline and Punish*: Foucault dealt with the body in

Textual Practice 10(2), 1996, 329–357

pain where Kantorowicz had dealt with the body in ceremonial triumph.[2]

The common concern in much recent writing on the body is to excavate a pre-Enlightenment mentality in which modern oppositions between mind or soul and body had not yet emerged. The role played by *The King's Two Bodies* in that project is not accidental, for the book has a deeply-rooted sub-text that belongs to an earlier stage of this century's counter-Enlightenment theorizing. The fact that this point has not been widely noticed indicates the markedly short time-scale in which recent debates about historicisms old and new have tended to operate. In what has become a standard narrative, an old, unthinkingly positivist and apolitical historicism has been superseded by a new historicism that has become aware for the first time that historical writing is not unproblematically and apolitically objective. Kantorowicz's case is a reminder of how many political and historical problems have been elided by that kind of narrative. The revolt against 'old' historicisms tends to be seen as an emancipatory move against an intrinsically conservative methodology. But the 'King's Two Bodies' concept, as it has tended to circulate in recent critical discourse, has roots in an earlier phase of counter-Enlightenment discourse which was closely linked with the politics of the extreme right.

'Frederick II': the imperial body and the George circle

Kantorowicz himself was very reluctant to acknowledge that *The King's Two Bodies* might carry any political force:

> It would go much too far ... to assume that the author felt tempted to investigate the emergence of some of the idols of modern political religions merely on account of the horrifying experience of our own time in which whole nations, the largest and the smallest, fell prey to the weirdest dogmas and in which political theologisms became genuine obsessions defying in many cases the rudiments of human and political reason. Admittedly, the author was not unaware of the later aberrations; in fact, he became the more conscious of certain ideological gossamers the more he expanded and deepened his knowledge of the early development. It seems necessary, however, to stress the fact that considerations of that kind belonged to afterthoughts, resulting from the present investigation and not causing it or determining its course.[3]

This denial of contemporary motivation may seem to be carried to a nervous extreme: it is not unusual for even the most ascetically positivistic scholar to acknowledge some kind of personal pressure behind a book. Kantorowicz, however, goes out of his way to insist that he had completed the five hundred-plus pages of this *magnum opus* before it fully struck him that it might have had some bearing on the present.

This passage acquires much more complicated meanings when we set the book in a longer-term context. Kantorowicz had in fact himself played a very significant role in the emergence of precisely the modern kinds of political mysticism and theology that he here condemns.[4] In 1927 he had published a rapturously idolatrous biography of the Holy Roman Emperor Frederick II Hohenstaufen (1194-1250).[5] As Kantorowicz repeatedly reminded his readers, Frederick had a place in German legend as a great ruler who would one day return and restore glory to the German people: his body was in that sense immortal. Kantorowicz celebrates Frederick as a genius ahead of his time, a man who broke free of the church's superstitions and tried to establish a unified absolute state across Italy and Germany, 'ruled by the iron will of the Italian Super-Tyrant' (p. 487). Historical circumstances were unpropitious for Frederick, but Kantorowicz leaves no doubt about the need for a new man of iron who will complete the task.

The distinctive feature of Frederick's rule as presented by Kantorowicz is the complete lack of the phenomenon he was to analyse in his later book: a dissociation between body natural and body mystic, between person and office. As Holy Roman Emperor, he represented 'the corpus mysticum of the "German-as-a-Whole", which Frederick II justifiably identified with his own body' (p. 387). In his absolute rule in Sicily, Frederick *was* the state, and the laws were simply his will at a particular moment (p. 218). Frederick was fascinated by eastern cults of ruler-worship and created his own political religion. He was 'the first whose soul was saved by the Sacrament of the State' (p. 256). His body became a divine entity, linking the state with a transcendental order: he lent Christ 'bodily existence in his own flesh' (p. 611). Yet he did not suffer from the anti-worldly dualism peddled by the church. Frederick had been much admired by Nietzsche, and Kantorowicz finds in him a this-worldliness comparable to Nietzsche's. He claims that it was the cult of Frederick that made secular art possible for the first time: in portraying the emperor's body, sculptors were portraying at once a man and a divine world-ruler fused in one entity (p. 528). Much attention is paid to Frederick's bodily characteristics. Kantorowicz is anxious to reassure his readers

that there 'was nothing soft about Frederick for all his intellect', and tells how during a battle he ripped open an enemy's side with his bare feet. His eyes exercised a snake-like fascination (pp. 366–7).

In order to safeguard his unity, Frederick ruthlessly suppressed all opposition: what he needed, Kantorowicz tells us, was obedience, 'unquestioning devotion, and the mass-strength of a people' (p. 217). To counter 'degeneracy of race' he forbade Sicilian women to marry foreigners and made Jews wear yellow patches (pp. 291–2, 121). He was 'probably the most intolerant Emperor that ever the West begot' – but then, a tolerant judge 'is like luke-warm fire' (p. 270). Kantorowicz plays close attention to his relations with the northern city-states, which were trying to break away from imperial authority and were pioneering the republican ideology that was to be described by an exile with a very different world-view, Hans Baron, as civic humanism. Frederick was determined to nip this malign development in the bud from the very start. He had 'an instinctive constitutional hate against rebels... Such abysmal hate, such lust for vengeance, admits no argument. It is simply a fact to be reckoned with' (p. 150). His 'alliance of monarchs to combat the principle of freedom from authority... constituted the first SECULAR OECUMENICAL ACTION FOR POLITICAL ENDS in history: a forerunner of the coalitions of hereditary monarchs against the Jacobins' (p. 463). Frederick offers a model for all future strong rulers who want to eliminate democratic and republican movements. He is constantly compared to Caesar, the foe of the Roman republic, and to Napoleon, who superseded the French republic; but the comparison is to their disadvantage:

> The total impression, in spite of its broad-necked power and steel-like strength, is one of something lyrical and inspiring... a German trait to which neither a Caesar nor a Napoleon could lay claim.
>
> (p. 368)

Frederick's Teutonic body carries with it a potential which only German rulers can fully realize.

It is also sexually overwhelming. As one who demanded unqualified submission in all spheres, Frederick naturally regarded his wives as subordinate beings: 'There was no room around Frederick in which a woman could strike root.... In the rarefied atmosphere of these brilliant heights no human being but himself could thrive.... All his wives died after a few years of marriage' (p. 408) – presumably consumed, Semele-like, by his divine potency.[6]

It is not surprising that this book, which quickly became a best-seller, should later have been seen as a prophecy of Hitler's rule. Its

last sections in retrospect seem prophetic of his fall; the tone grows darker as increasing resistance to Frederick pushes him into ever more desperate measures. The transition is marked with a striking paragraph:

> 'Now I shall be hammer!' This was the characteristic cry which led Nietzsche to hail Frederick of Hohenstaufen as 'one of my nearest kin'. Nietzsche, the first German to breathe the same air as Frederick, took up the cry and echoed it. Frederick had struck a new note, and passed into a supernatural world in which no law was valid save his own need.

> (p. 603)

Frederick now compared himself to the Antichrist and to Attila the Hun as he embarked on an increasingly cruel and savage war to suppress opposition. Kantorowicz does not condemn these cruelties, however; rather he notes that even they had a kind of creative joy, and puts the main blame on the enemies who forced him into them by failing to recognize that his superhuman genius transcended all common human standards.

Yet at the time when *Frederick II* appeared, Hitler's Nazis were a relatively insignificant element in the broad currents of right-wing politics, and the book's intellectual affinities were undoubtedly distinct from those of Nazism. It belongs to a group of biographies of great men which were published by the circle of the poet Stefan George. George's work is full of longing for visionary rulers, and one of his poems invoked the spirit of Frederick II, but he always claimed to be concerned with inner, spiritual empire, not with the vulgar literalism of the Nazis.[7] George was heavily influenced by French Symbolism, and one of his recurrent concerns was that the modern world had robbed symbols of their deeper spiritual meaning. He surrounded himself with a hieratic atmosphere: incense was burned at readings of his poems. Such rituals point to the tension Adorno discerned in George's work: he sought to resist the commodification of language through an elevated, formal, prosodically weighty idiom, yet there was always a danger that the genuine achievement would lapse into kitsch.[8] Similar considerations apply to Kantorowicz's 'poetic' style of history. The positivists who attacked him for introducing poetry to history did indeed have a very narrow conception of history. Kantorowicz retorted with some force that historical research (*Forschung*) always involved narrative representation (*Darstellung*): to put it in more recent terms, history writing has a performative as well as a cognitive dimension. But history which tries

to become poetry may favour a kind of poetry that has forgotten its responsibility to history.

In his later years, George searched with increasing urgency for some kind of public embodiment for the world of symbols. He shared Nietzsche's exaltation of the body against its devaluation by Christianity and rationalism. He compared his disciples to medieval knights whose role was to keep Nature to her task of making the body divine and the divine into body, 'Den leib vergottet und den gott verleibt'.⁹ In his quest for embodiment of the divine, he looked not to political leaders but to a fourteen-year-old boy, Maximilian, who had the same effect on him as Beatrice on Dante, as a manifestation of divinity in human flesh. The George circle valued poets and seers – in particular Shakespeare, Goethe, Nietzsche – as much as men of action. Political change was to come about from a process of educating a spiritual elite, not from a mass movement. The circle was strongly opposed to the Prussian ethos. George came from the Rhineland and insisted that German culture needed a Latin tempering, which he extended to replacing the traditional Gothic script by a specially designed Roman script in the circle's publications. Many Jews, Kantorowicz amongst them, belonged to the circle. The cult of the human-divine body offered a release from the waves of antisemitic propaganda against the deformities of the Jewish body, as well as from a narrowly conventional sexual ethic.¹⁰ From an early stage Kantorowicz's biography of Frederick II attracted the criticism that it was more of a work of poetry than of scholarship, and it would be possible to argue on those grounds that it stands aloof from politics.

Yet treating the state as if it were a work of art, a passive medium acted on by a dominant personality, itself has political implications. Kantorowicz's book was a kind of 'prequel' to Jacob Burckhardt's *The Civilization of the Renaissance in Italy*, and engages in a comparable aestheticization of politics.¹¹ His book confirms Walter Benjamin's argument that that process has totalitarian tendencies.¹² Kantorowicz shows how Frederick laid the foundations for the Italian despotisms that Burckhardt described. He shares Burckhardt's repudiation of republican historiography, and he alludes to, though going beyond, Burckhardt's comparison of the state to a work of art:

> we must review the whole magnificent structure of his State – like every work of art, a unityThis State was a 'work of art' not because of its skilful administrative methods, but because the union of the laws of God, Man, and Nature made it an approximation to an ideal original.

(pp. 254-55)

Frederick is ultimately an artist, a poet of political forms:

> Now seemed the time to give permanence to the beautiful
> Roman-German form that had been just evolved, to help it to a
> still finer perfection, to weld the whole into a conscious unity:
> princes and races into one people. To strengthen and harden into
> an enduring state, as sculptors then were fashioning enduring
> monuments of stone, this German growth ... by persistently
> inspiring princes and races with the thought and the spirit of
> state-building.
>
> (p. 409)

It was Frederick who single-handedly invented Italian literature by
adapting the Sicilian dialect for court poetry. He did not follow
the conventional course of patronizing poets: instead, his officials
themselves became poets:

> Frederick made no man a state official because he happened to be
> a poet, but the 'compelling necessity of things' evoked political
> skill from the officials of this Emperor ... the laws of a State
> cannot be altered without altering those also of the Muses.
>
> (p. 329)

A recurrent point of reference is Dante, whose cult of the emperor
in *De Monarchia* and the *Divine Comedy* was inspired by Frederick's
example; but Kantorowicz sets up a clear hierarchy by declaring that
'Dante only proclaims what Frederick II had lived' (p. 668). What
fascinates him about Frederick is the way in which he makes the
whole state a living poem.

And Kantorowicz's book becomes part of that poetry. If early
reviewers attacked it as a work of imagination rather than historical
scholarship, Kantorowicz's whole point is that such distinctions may
serve in a debased, bourgeois, Enlightenment order, but can be tran-
scended with the advent of a higher organic unity under a great leader.
The revolt against positivism in the George circle was militantly anti-
progressive.[13] Kantorowicz's book offers itself as a model of the way
in which an alienated intellectual whose imagination is cut off from
the public world can again become part of a living public process. In
his paean to the youthful Frederick II, George's cult of the young
male body acquires an eerie political allure:

> An atmosphere of magic played round this Hohenstaufen, some
> wholly-German Germanic emanation which Napoleon for
> instance conspicuously lacked, an immeasurably dangerous ema-
> nation, as of a Mephisto free of horn and cloven hoof, who moves

among men disguised as a golden-haired Apulian boy, winning
his bloodless victories with weapons stolen from the Gods.

(p. 102)

The narrative voice of *Frederick II* takes on some of the Emperor's
own numinosity: the voice of the dispassionate historian blends with
the impersonal voices of the prophecies woven around the Emperor
until it becomes at once anonymous and the voice of a whole people
seeking an inspired vessel for its expression. The poetry of history
becomes a powerful vicarious politics.

And Kantorowicz himself had been prepared to step outside the
study when it was time for political action. After his service in
the Great War he had taken up arms with the Freikorps, a militia
which fought against the republican and communist risings which
had broken out in several different parts of Germany, and which was
responsible for the murder of Rosa Luxemburg. In Munich he had
been shoulder to shoulder with several future Nazis in taking aim at
the regrettably unmystical bodies of the communists. His enthusiasm
for the eternal imperial body was a right-wing counterpart to the
cult of Lenin's mummified body which was emerging in the Soviet
Union.

Kantorowicz's circle took up an ambivalent attitude toward Hit-
ler's rise to power. Kantorowicz himself was strongly opposed to the
Nazis and his career suffered as a result. His university post was
immediately threatened and his lectures were subjected to Nazi har-
assment until it was impossible for him to continue. In 1933 he wrote
to George that words like 'Hero' and 'Führer' which had filled their
lives with the most secret and highest meaning had become degrad-
ingly secularized under Hitler.[15] The swastika had been a favourite
symbol of the George circle, as of other avant garde groups, before
it was appropriated by the Nazis.[16] The reference to secret meaning
recalls the concept of a 'Secret Germany', a kind of spiritual elect
whose time would come in the future, to which George had devoted
a poem. In his prefatory note to his *Frederick II*, Kantorowicz had
recorded the laying of a wreath to his memory in 1924, inscribed 'To
its emperors and heroes, the Secret Germany' (p. vii). In a letter of
the same year he had greeted with derision the idea that Mussolini
could possibly be the modern fulfilment of such ideals; Frederick's
empire had to be revived in the spiritual and intellectual life.[17] A
member of the circle, Claus von Stauffenberg, was a leading agent in
the assassination plot against Hitler. For Kantorowicz, with Hitler's
advent to power this 'secret Germany' whose internationalist values
might be hoped to inform the public world finally became cut off

from the outward Germany. Already before 1933 he had begun work on a sequel to *Frederick II* which would deal with the interregnum after his death, a period when the values he had embodied were tragically shattered and in the absence of a strong enlightened ruler a narrower nationalism emerged.[18] One of Kantorowicz's last lectures before he was driven out of the university ended with a quotation from one of George's poems; he would fight the Nazis' Germany with the truer one.[19]

Firmly as figures like Kantorowicz and von Stauffenberg opposed Hitler, however, their conservatism did place limits on the nature of their opposition. While hostile to the dictator's vulgar populism, von Stauffenberg declared in his final manifesto: 'We despise the lie that all are equal and we submit to rank ordained by nature'.[20] Not everyone could maintain a strict separation between the ideal spiritual emperor longed for by the George circle and the admittedly inadequate candidate being put forward by the Nazis. Kantorowicz's preface had noted that even in a day when there were no more Kaisers, enthusiasm was astir for the great German rulers of the past. And when he and his circle spoke with enthusiasm of the suppression of modern liberal and democratic ideas, they deprived themselves of room for manoeuvre when Hitler set about that task with such vigour. When questioned during the 1930s about whether the Frederick biography did not inculcate Nazi values, Kantorowicz replied that 'brutality based on metaphysics was better than brutality for its own sake'.[21] Resistance to Hitler based on the need to add metaphysics to brutality was unlikely to gain mass support.

Kantorowicz did resist in his own way, but the unrelenting idealism of the George circle's stance sometimes became hard to distinguish from complicity in the dictatorship. George himself greeted Hitler's advent to power by self-exile, yet he still refused to descend to the vulgar material plane of saying whether he supported him or not. His circle therefore divided. Much to Kantorowicz's concern, the dedicatee of *Frederick II*, Woldemar Count Uxkull-Gyllenband, who had also fought in the Freikorps, gave a lecture on 'the revolutionary ethos in Stefan George', seeing the poet as a prophet against the triple evils of rationalism, capitalism and science.[22] George is reported to have remarked in 1933 that, in the end, the Jewish question was not so important to him – a comment all the more chilling since it came from a man with many loyal Jewish followers.[23] Before long, however, some Nazis were attacking him and his circle for a decadent 'humanism'.

The legacy of Kantorowicz's *Frederick II* was likewise politically ambiguous. The intense interest in the continuing power of medieval

royal symbolism that had motivated Kantorowicz's researches helped to carry his friend and fellow-medievalist Percy Ernst Schramm into open support for Hitler, who could be seen as the best means of restoring a quasi-Frederickian empire. Schramm's history of the English coronation, which appeared in 1937 and made links between medieval and Nazi rituals, may have been one factor in turning Kantorowicz's interests towards the symbolism of royal bodies in England.[24] Hitler himself is said to have read *Frederick II* twice; he looked back to Frederick's struggle against the Catholic Church as a model for his own. Göring presented a copy to Mussolini with a personal dedication.[25] Kantorowicz's situation had become painfully paradoxical. His writings could be appropriated by the Nazis, and yet the vigour with which he had affirmed his own identity with Germanic culture did not prevent them from identifying his person with the non-Aryan Other. If in one sense *Frederick II* was an expression of a devotion amounting to love for the Teutonic body, it was a love that was disappointed in the cruellest and most tragic way. Kantorowicz had written from the point of view of an insider, leaving no rhetorical space for being suddenly reclassified as an outsider. In 1938 he left first for England and then for America. His mother was to die in a concentration camp.

Kantorowicz's American career: the fissured body

In this new, American phase of his career, the old reactionary ardour was no longer in evidence, and it is this post-war Kantorowicz who has become celebrated, his earlier phase normally regarded as an embarrassing irrelevance. He did make some attempt to create an equivalent of the George circle. His lectures on medieval history inspired the poet Robert Duncan to make plans to undertake research in Germany. For Duncan, however, it was the mystique of the poetic rather than the royal office that counted.[26] When the University of California ordered faculty members to swear an oath of political loyalty and anti-communism, Kantorowicz took a strong oppositional stand. There was a consistency here with a George-circle vindication of academic hierarchies,[27] but also a desire for political reparation: he expressed his regret that in his earlier political activities he had 'prepared, if indirectly and against my intention, the road leading to National-Socialism and its rise to power'.[28] Kantorowicz lost his position at Berkeley and moved to Princeton. *The King's Two Bodies* is the crowning work of this later phase, and it marks a decided shift in tone and political outlook; as if to signal the break,

Kantorowicz emphasizes right at the beginning that the book orig-
inated in 1945. For many years Kantorowicz resisted strong pressure
to have *Frederick II* reprinted in Germany for fear that it might lend
comfort to Nazi sympathizers, and was deeply disturbed just before
his death when he formed the impression that this might be hap-
pening.[29]

It may then seem misleading or worse to present the earlier
work as any kind of context for the later. I shall try to show, however,
that the persistence of vestiges of the highly conservative assumptions
of his earlier writings can alert us to certain idiosyncrasies of the
later work which have tended to escape notice. Indeed, Kantorowicz's
own moral wrestling over the republication of *Frederick II* indicated
the difficulty of positing a total break between his German and
American phases. He went ahead with the publication, after long
delay, precisely because he did not want to seem to be breaking faith
with his long-formed bonds of allegiance with the George circle: he
insisted that the original dedication with its evocation of 'Secret
Germany' be retained.[30] And something of that earlier romantic mys-
ticism of kingship lingered in the later writing.

When he moved to a republican America whose academies were
dominated by a strongly positivist historiography, Kantorowicz was
encountering a radically new world of discourse. One connection
came via the writings of the great English constitutional historian
Frederick Maitland. Here theories of mystical bodies were chronicled
with the sarcastic common sense of the English empirical tradition.[31]
Kantorowicz set himself to counter that sarcasm and to restore a
proper dignity and reverence to these concepts. The language of
political mysticism, he writes in his opening paragraph,

> unless resounding within its own magic or mystic circle, will
> often appear poor and even slightly foolish, and its most baffling
> metaphors and highflown images, when deprived of their iri-
> descent wings, may easily resemble the pathetic and pitiful sight
> of Baudelaire's Albatross.[32]

Kantorowicz returns here for a moment to the concerns of the sym-
bolist George circle – 'The Albatross' stood second in George's trans-
lations of Baudelaire's *Les fleurs du mal*. Kantorowicz's aim is to
show that these mystical fancies, far from being marginal to the
English constitutional tradition, are central to it.[33] Kantorowicz's
earlier view of English culture had not been favourable: under
'England, English: traits of', readers of *Frederick II* were referred to
the following catalogue: 'a frugality bordering on parsimony ... an
amazing lack of education, a poverty of intellect' (p. 65). In his more

muted post-war accent, he wryly observed of the contrast between Frederick II's followers and Bracton that to 'accept domination by an abstract idea has never been a weakness of England'.[34] In now addressing an anglophone audience he tried to show how that prosaic poverty of intellect had in the past been supplemented by a rich European symbolic language, a poetics of monarchy and of the royal 'superbody'.[35]

Kantorowicz's boldest strategy in his opening chapter is to argue that even that central moment of the Whig-liberal tradition, Parliament's declaration of war against King Charles in 1642, was in fact a product rather than a repudiation of absolutist mysticism. The Parliamentarians, he tells us, were defending Charles's politic body against his natural body, and the act of 'fighting the king to defend the King' would have been 'next to impossible' without the doctrine of the two bodies. Like Schramm, Kantorowicz insisted on the deep-rooted continuity of English monarchism. He even claimed that the republicans in 1649 executed 'solely the king's body natural without affecting seriously or doing irreparable harm to the King's body politic'.[36] The George circle's idealism triumphantly emerges here in the claim that on a higher metaphysical plane the English Revolution never actually happened.

This opening chapter provides continuity between his earlier work and the republican world into which he had moved. Admittedly there is none of the old rapture in celebrating the mysteries of kingship. The incense swirling round the Frederick II biography has given way to a much drier tone, though this is sometimes relieved by an urbane wit. Although there is a long section devoted to Frederick II, Kantorowicz makes only very curt references to his own biography. The overall structures of the two books are also sharply distinct. Both books, indeed, share a common reaction against nineteenth-century paradigms of linear progress: Frederick II's career is viewed against a series of mythical archetypes which are felt to be potentially available at any moment of history. Yet there is also a delight in the process by which that divine element is embodied in linear time; the book has a powerful dramatic sense, with the narrator trying to emulate the emperor's own daring and sense of timing. *The King's Two Bodies*, chronicling the failure of such embodiment, abandons any attempt at linear sequence in a 'retreat from monumentality', overlaying the argument with a density of references so thick as to obscure the overall structure.[37]

Shakespeare and the fissured body

If the main part of the book represses the earlier biography's narrative energy, a certain poetic element does surface in the strategically-placed chapters on Shakespeare and Dante. At first sight the positioning of the chapter on *Richard II* seems baffling: it comes immediately after the introductory chapter and is followed by a jump back to the twelfth century. On one level, however, it does regain for the book that old poetry of power which for Kantorowicz has been lost in his adaptation to a different political world; and the chapter itself becomes something of an elegy for that lost world. His *Frederick II* had celebrated a monarch for whom mystical and natural bodies were inseparable, who himself embodied the abstract being of the state: 'Person and office began to merge in one' in his absolute rule of Sicily (p. 107). *The King's Two Bodies* charts a steady eclipse of that unity, as the royal body becomes fissured and reified in ceremonial emblems. Kantorowicz repeatedly points out that the splitting off of the king's office as an impersonal body is linked with the unusual dominance of Parliament in English history. The Civil War, in which Parliament took up arms against the king's natural body, is the culmination of that process. And by linking Charles's execution with Richard's deposition, Kantorowicz insists that the process is tragic. The deposition scene, he writes with a nod to Walter Pater, 'leaves the spectator breathless. It is a scene of sacramental solemnity'.[38] Kantorowicz reads *Richard II* as the tragedy of the emerging split between the king's two bodies, a shift from realism to nominalism as Richard's divine lustre dwindles to an empty name. Richard's deposition is an inverted coronation. Stage by stage his sacramental unity becomes violently severed until in the deposition scene his body becomes 'a *physis* now devoid of any metaphysis whatsoever'.[39] His tragedy is that of a fall from absolute difference from his fellow-men into a banal common humanity: he becomes a mere player-king. This reading of the play as a Fall from unity draws heavily on the edition by John Dover Wilson, who comments that 'the sun image . . . dominates the play as the swastika dominates a Nazi gathering'.[40] One can imagine some of the conflicts which these words would have aroused in Kantorowicz, the title-page of whose *Frederick II* had borne a swastika, albeit as emblem of the George circle rather than of Nazism.

Kantorowicz did not need to turn to English critics for such a reading of the Histories, however; in German criticism there was a long tradition of interpreting Shakespeare as a legitimist, and it was maintained in the George circle. George himself was mainly interested in the *Sonnets*, which he translated, and which linked

closely with his cult of the young male body. But his close associate Friedrich Gundolf translated many of the plays and had no doubt that Shakespeare shared also the circle's admiration for virile men of action. In his biography of Caesar, which appeared in the same series as Kantorowicz's *Frederick II*, Gundolf wrote that *Julius Caesar* revealed Shakespeare's strong monarchism: 'The quality most absent in Shakespeare is any trace of republicanism or moral opposition'.[41] What can be reconstructed of the younger Kantorowicz's reading of Shakespeare seems consistent with that viewpoint. During the 1930s, when he was already distancing himself from the political standpoint of *Frederick II*, he invoked Shakespeare to criticize the Nazis: when Maurice Bowra attended a performance of *Julius Caesar* at Stratford with him, Kantorowicz was heard to mutter 'Dr Goebbels' during the forum scene. That would not, however, necessarily be incompatible with an admiration for Caesar and a suspicion of the turbulence of democratic rhetoric. Bowra also records that he regarded English politics, such as the abdication of Edward VIII, 'as if they came straight out of Shakespeare . . . an actual play in which everyone played a part without knowing that it was one'.[42] Though Kantorowicz is unlikely to have known it, Edward's removal had been caused at least as much by his Nazi leanings as by his marital imprudence. It was however clear enough that this had been a revolution from above, deftly removing a ruler who was considered unacceptable while retaining the traditional mystique of royal institutions. That was the model of political change and agency that Kantorowicz was to explore in *The King's Two Bodies*.

The two bodies in politics: opposition or absolutism?

Kantorowicz's reading of *Richard II* was rooted in a long tradition of counter-revolutionary discourse. And that paradigm of a fall from unified organic symbols into chaos forms a sub-text in the discussion of English history in *The King's Two Bodies*, working in tension with its deference to Whiggish views of the triumph of Parliamentary sovereignty. Critics who have drawn heavily on Kantorowicz have therefore unwittingly inherited a set of assumptions which they might be reluctant to endorse explicitly. To be fair, this is not altogether Kantorowicz's responsibility: he could not have imagined that a study which aimed to give a slyly disruptive twist to a historical orthodoxy should have been uncritically accepted as the basis of a new orthodoxy. His own political stance did make him sensitive to areas that had been neglected in the Whig tradition, and the title of this essay

is not intended to suggest that the ideal imperial body did not exist at all. But it has acquired a mystic status out of proportion to its historical significance.

The 'two bodies' theory certainly was current in the early modern period; Marie Axton has developed Kantorowicz's research a great deal further and established the theory's emergence in debates over the succession to Queen Elizabeth.[43] When it comes to her discussions of the succession in the drama, however, it is far from clear that the theory of the two bodies is being specifically alluded to. And Axton herself shows that the theory was far from being the only available political discourse in the period. Its sacramental overtones did indeed have a particular appeal to Catholics who wanted Mary Stuart to succeed – Plowden, who pioneered the 'two bodies' idea, was a Catholic. But Axton shows that the mystical elements were played down when it was invoked in printed texts.[44] Those who invoked the theory at this time tended to want the succession to be determined without Parliament, following the strict principle of primogeniture and avoiding any kind of interregnum, while advocates of Parliamentary participation looked to other kinds of claim. Axton argues that Elizabeth 'must have seen that the Stuart mystique of blood royal could not stand the harsh reality of the Lower House'.[45] It is therefore difficult to see the theory as a major origin of the English Revolution. In Scotland, the opposition to Mary was led most vociferously by the poet and historian George Buchanan, who was to become very popular with English Parliamentarians, and who derived his justification of popular sovereignty from classical republican and constitutional sources. The man who as tutor to James VI 'whipped the arse of the Lord's anointed' did not have a Kantorowiczian reverence for royal bodies.[46] In England, even leading royal servants were tinged by what Patrick Collinson has termed a monarchical republicanism, a strong sense of the independence of the state from the monarch's person which owed more to classical thought than to two-body theory.

When James did succeed to the English throne, the 'two bodies' theory acquired prominence for a time, but in more problematic terms than Kantorowicz allows. The union of the crowns had brought two states together under one man, and James was anxious to insist that both English and Scottish subjects owed their allegiance to him in person rather than to their respective nations in the abstract. Opponents of fuller union do seem to have insisted on a separation between the king's person and his office in a way that might be cast in the Kantorowiczian two bodies terminology; though, as is often the case with oppositional arguments, the evidence is far more frag-

mentary than for the volley of statements of the official position.[48] Yet the body was also strongly invoked by the defenders of the royal prerogative, in the test case of 1607 that became known as 'Calvin's Case', and which Kantorowicz cites again and again. In this particular instance Sir Francis Bacon and Sir Edward Coke, who normally took very different views of the royal prerogative, were uncharacteristically united – to a point which led a mid-century Parliamentarian to complain that Coke had been led astray by Bacon's 'gilded *oratorie*', becoming 'fit *metal* for any *stamp royal*'.[49] And indeed on this occasion Coke used the body metaphor not to challenge but to reinforce the royal prerogative, by insisting on the indissolubility of the king's natural and politic bodies.[50] It is true that Lord Chancellor Ellesmere, who was more consistently high-flying in politics, did have doubts about the language of two bodies, which he saw as giving a dangerous hostage to fortune; his speech launched into a bitter attack on classical republicans.[51] Yet the mystical, sacramental potential of the body image also helped to hold off too radical a separation between monarch and state. As it was decided, Calvin's Case, so far from legitimizing Parliament's rebellion against the king, worked against it. In the later 1640s it was frequently invoked by the imprisoned royalist David Jenkins in his campaign against Parliament; he compared Parliament's leaders to the Spencers in the reign of Edward II who had wickedly tried to separate natural and politic bodies. Parliament's leading theorist, Henry Parker, conspicuously failed to refer to two-body theory in his replies.[52] Another Parliamentarian, Robert Austin, recognized that Calvin's Case was liable to 'raise a scruple' with his side and felt it necessary to publish a lengthy reinterpretation before he could arrive at the formulation that 'wee fight not against our King, but for him'.[53] The fullest development of the body metaphor at the time of the Union debate, by Edward Forset, was uncompromisingly absolutist in stance, declaring that the royal prerogative 'admitteth no questioning disputes'.[54]

Calvin's Case, then, indicates the need for caution in invoking the two-bodies theory. While Kantorowicz was right to observe that it could point in constitutionally dangerous directions, and Ellesmere censured it on those grounds, the very act of personifying the state in corporeal, sacramental terms tended to work against a more radically abstract concept of the state. Those who were uneasy about the exaltation of the royal prerogative tended to look for other kinds of rationale for resistance. The distinction between the king's person and his office could be formulated in ways that were quite independent of 'mystical body' theory; there were, for example, ample precedents in

classical republicanism for a distinction between the public interest of the state and the private interest of an imperial dynasty.

James's reign perhaps marked the high point of official interest in royal bodies, for the king had elaborate monuments constructed for Mary Stuart and Elizabeth I. How widely his subjects shared such interests, however, remains open to debate. Royal funerals did dramatize the distinction between person and office: royal corpses were embalmed, and effigies were constructed to which honour had to be paid – a practice continued even on the death of Oliver Cromwell. Kantorowicz points further to the custom of representing both the body in its full lifetime costume and a decaying corpse on some monuments. Here, he suggests, is a sculptural embodiment of the two-bodies theory.[55] Other explanations can, however, be offered for this custom: might not observers less attuned than Kantorowicz to imperial glory have read such sculptures as revealing the transience and fragility of human pomp rather than the magnificent immortality of office? There is the further problem that the examples he gives are mostly of non-regal monuments. According to Nigel Llewellyn, Sir Robert Cecil's two-tier tomb shows that he was 'well versed' in the idea of the King's Two Bodies. But it is then odd that twinned bodies should have been represented on the tomb of the commoner Cecil but not on those of the monarchs Elizabeth and Mary. Moreover, contrary to what might have been expected, building monuments for royal bodies was the exception rather than the rule in early modern England. Though an elaborate tomb was constructed for Henry VII, Henry VIII's monument was never finished, while Edward VI, Mary Tudor, James, his wife, and his immensely-popular son Henry went uncommemorated, and no monument was built for Charles I even after the Restoration. Llewellyn suggests that relative degrees of dynastic stability may have been a factor, but his main explanation for the failure to build a monument for James I is that 'certain Political Bodies are simply too massive to be imagined, and in these cases the death ritual is restricted to the Natural Body'.[56] When the theory of the King's Two Bodies becomes an explanation for the shortage of evidence for the theory, the models seem to need revising.

When we come to the impact of two-body theory on the outbreak of the Civil War, caution is again in order. Kantorowicz's much-repeated claim is that the Puritans' rallying-cry was: ' "We fight the *king* to defend the *King*" '; but that particular formulation was much less widespread than his readers have come to suppose.[57] He cites as evidence for the dominance of the 'two bodies' theory a Declaration of the Lords and Commons of 27 May 1642 which proclaimed that Parliamentarians who took up arms against the king

still carried the stamp of royal authority.[58] But though readers may gain the impression that phrases like 'King body politic' and 'king body natural' are cited from this document, they represent Kantorowicz's paraphrase in consonance with his own particular interests – as their somewhat unidiomatic phrasing might indicate. These phrases are in fact nowhere to be found in this or, as far as I can determine, in any of the major declarations on the Parliamentary side.[59] The coin inscription which Kantorowicz cites to demonstrate the theory – PRO RELIGIONE. LEGE. REGE. ET. PARLIAMENTO – sets up a hierarchy of aims rather than a mystical synthesis, and a clear order of precedence in which the king comes only third.[60] Where the word 'body' occurred, it was to declare not the king but Parliament as 'the representative body of the Kingdome'.[61]

In fact, the reduction of Parliamentarian principles to the paradox of fighting against the king to save him became a favourite topic of royalist satirists precisely because it sounded absurd. When Kantorowicz offers a specific source, he turns out in fact to be referring to a royalist satire; in the amply-documented mottoes of Parliamentarian soldiers, the king does not figure as prominently as abstract ideals such as religion, truth, liberty or law.[62] It is true that Parliamentary declarations retained statements of devotion to the king, since it was generally assumed that he would be restored to some kind of sharply limited authority, but they seldom made much of the king's body. The most voluminous statement of the cause, by William Prynne, used corporeal analogies only briefly in hundreds of pages. For him, Parliament was 'THE HEAD AND BODY OF ALL THE REALME', and he claimed the precedent of the justified deposition of Richard II.[63]

Prynne and the Parliamentary mainstream remained committed to some form of monarchical government, but there was a significant if small current of specifically republican thought which had even less difficulty in conceiving of the national interest independently of images of royal bodies. One Leveller tract distinguished not between the king's two bodies but between 'two Bodies of the people, the representative and the represented', the shadow and the substance, which 'together make up the body of the Common-wealth'.[64] It was deeply embarrassing for a committed republican like Henry Marten to be saddled with the idea of fighting for the king; he roundly declared that to claim to be loyal to the king's office while fighting his person was to 'cant'.[65] Like Parliament's earlier propagandists, Marten returned to the story of the opposition to Richard II, again viewing it through terms very different from those of two-bodies theory. His pamphlet ended with an account of how Richard's opponents had compromised with royal power and had ended up by

being destroyed. He did not need to point the moral: the execution of Charles I finally redeemed the failure of the Ricardian rebels to limit royal aspirations strongly enough. For Marten, then, the regicide was a happy ending to the tragic story of Richard's reign – the conception of what counts as tragic of course being very different from the Kantorowiczian view.

We can indeed find the two-bodies theory being deployed in the debates over the regicide, but again the situation was more complex than Kantorowicz implies. He describes the issue in 1649 as 'the charge of high treason committed by the *k*ing against the *K*ing'.[66] In fact the core of the charge was the 'upholding of the personal interest of will and power and pretended prerogative to himself and his family against the public interest, common right, liberty, justice, and peace of the people of this nation'.[67] What was at issue was a defence of a common, public interest against the private, mystical world of the monarch and his favourites. The prosecution asserted that the king was a man like any other, insisting on his common humanity. They therefore had little interest in couching their arguments in the imagery of mystical bodies, which imparted to the king's person the kind of sacramental magic which they strongly opposed. It was therefore opponents of the regicide who made most reference to the doctrine of the two bodies. In the most celebrated polemic against the regicides, Salmasius dwelt on the idea of separating the natural from the politic body precisely in order to demonstrate how monstrous and absurd it was to do so.[68] He borrowed the two-body idea from Jenkins's attack on the Parliamentary leaders but developed the body metaphor further in an absolutist direction. Salmasius's political position was extreme by the standards of seventeenth-century English discourse. He emphatically rejected the Fortescuean idea that the king ruled in a 'political' as well as 'regal' way, consulting with his subjects as well as simply giving orders. Salmasius insisted that the king's power was purely regal, not political, and he was able to give force to this extreme claim by presenting any alternative view as a violent mutilation of a unified body, a proliferation of monsters.[69] In his defence of the republic, Milton ridiculed Salmasius's imagery of the body, including his usages of 'persona' to mean 'person' or 'body', as a kind of murder of proper Latin equivalent to the murder he denounced.[70] He would have been surprised to find the two-bodies theory, which as Kantorowicz declares in his final chapter had no classical origins, regarded as the main inspiration of mid-century classical republicanism.

Historical drama and the two bodies

Over-emphasis on mystical bodies has given a quite misleading account of Parliamentary agency as a tragic fissuring of an organic body politic. And that distortion has also affected understanding of the political connotations of Shakespeare's play. In his much-praised reading of Shakespeare's *Richard II*, Kantorowicz's sympathies are one-sidedly with Richard. In summarizing the historical charges against the king, he indignantly declares that one of 'Richard's so-called "tyrannies" ', his claim that the laws of the realm were in his head, in fact 'merely referred to a well known maxim of Roman and Canon Laws'.[71] His accusers, then, were betraying their provincial ignorance. The whole orientation of the reading assumes that Richard is a 'unified' figure in the first part of the play and that his descent into disunity is wholly tragic. The king's failure ever to acknowledge any degree of error or of responsibility for the kingdom's plight is apparently for Kantorowicz a sign of his sublimity. This reading is not very far removed from the mental world of the *Frederick II* biography. Or indeed of Salmasius's sacramental absolutism.

And yet Kantorowicz himself mentions a factor that seems to run quite counter to his reading: the play staged by some supporters of the Earl of Essex just before their rebellion against Elizabeth seems to have been Shakespeare's. How can they have derived inspiration for rebellion from a play that dramatizes the tragic consequences of fissuring the delicate unity of the king's two bodies? We cannot in fact be sure that the play in question was Shakespeare's – though it is hard to provide a convincing alternative. The possibility of that performance does, however, at least open up different ways of reading the play, once we see beyond royal bodies and take account of the strength by the 1590s of differing currents of constitutionalist and republican thought. Two of the ringleaders in the Essexian staging were members of the Percy dynasty, whose leaders the Earls of Northumberland were in a consistently oppositional relationship right down to the civil war, when the tenth Earl sided with Parliament. He allegedly opposed the punishment of those responsible for the execution of Charles I in 1649, declaring that 'the example might be more useful and profitable to kings, by deterring them from such exorbitances'.[72] His nephew, Algernon Sidney, was a leading theorist of republicanism.

With the aid of the chronicles, especially Holinshed,[73] the Percies looked back to the medieval past not as a lost world of symbolic unity but as the scene of a continual struggle between aristocratic and constitutional liberties and a monarchy that kept trying to appropriate

public resources for its private interests. There is evidence that such views were linked with Shakespeare's histories by the third Earl of Essex, the son of the rebel of 1601. The third Earl became commander of Parliament's forces against the king: as Kantorowicz noted, his face displaced the king's on Parliamentary medals. In August 1641, when the Parliamentarians were tentatively exploring the extent of their military support, the Earl ruefully commented: 'We may say well, as Hotspur said, our members love the commonwealth well; but their own barns better.' In organizing Parliament's resistance to Charles, Essex was instinctively looking back to Shakespeare's presentation of the fiery young Percy. He is likely to have been aware of the link between Shakespeare and his father's rebellion.[74] It is interesting that what Essex added to Shakespeare (1 *Henry IV* ii.4.4-5) was the word 'commonwealth': he casts his political actions in terms of serving the common good, not of elevating the king's body. It is probable that members of the Northumberland and Percy dynasties – to say nothing of other readers – would have viewed Richard's high-flying speeches as exemplars of an absolutist discourse that threatened aristocratic liberties. For them, such a discourse was not part of a lamentably lost past, it was a threatening menace in the present.

The dominant understanding of the Elizabethans' view of history, however, remains within an absolutist paradigm. *The King's Two Bodies* appeared at a time of renewed critical interest in iconography, often with a very strong courtly cast, and later more radical readings of the Renaissance have often taken over more of that courtly frame of reference than they fully realize.[75] Again and again, critics who attack Tillyard and Dover Wilson for their reactionary stance nevertheless reproduce assumptions very close to theirs. In the essay that gave the phrase 'new historicism' wide currency, Stephen Greenblatt took as his instance of an older historicism a lecture on Shakespeare's histories given by Dover Wilson at Berlin in 1939. We should, says Greenblatt, examine critical discourse in its political context, and 'look closely at the relation between Dover Wilson's reading of *Richard II* – a reading that discovers Shakespeare's fears of chaos and his consequent support for legitimate if weak authority over the claims of a ruthless usurper – and the eerie occasion of his lecture'.[76] The present essay is in many ways an attempt to carry out that project and take it further. And yet Greenblatt's own critique of Dover Wilson also echoes some of his ideas and phrases, and the same applies to later new new historicist criticism which draws heavily on Kantorowicz. For Kantorowicz's analysis had much in common with Dover Wilson, whose edition of *Richard II* he praised as 'a model

of literary criticism'.[77] More nuanced accounts of the Elizabethan political mentality have always been available – and not easily divided into 'old' and 'new' historicisms; and work by Graham Holderness, Richard McCoy, Annabel Patterson and others is recovering the dimension of political resistance.[78] What is surprising is the extent to which it has been lost.

The rebirth of the body: some conclusions

It is tempting to parallel the rhetorical effect of *The King's Two Bodies* to that of Richard's reaching for the mirror, which prevented him from having to read the thirty-three articles. It has encouraged critics to turn from the more discursive aspects of early modern political culture and to focus unrepresentatively on theories of reflexivity and on royal ritual. The theory of the king's two bodies has arguably gained more widespread currency in recent decades than it ever enjoyed in the 1590s – just as many portraits of the queen that would have been unknown to more than a small circle of courtiers have a far wider audience now than they ever had at the time.

Why has the idea of the two bodies been so appealing? It is not, evidently, that its recent exponents share either Kantorowicz's early reactionary fervour or his later detachment. Indeed, his ideas have been warmly welcomed by the kind of people whom in his youth he might have felt obliged to shoot. But there are threads running through his work that anticipate more recent historicisms. What seems 'new' about Kantorowicz's historicism can in some ways be linked with a materialist agenda. The body has become a central focus of so much anthropological and deconstructive criticism because it is an alternative locus to dissociated, timeless abstractions. Kantorowicz's interest in royal ritual forms part of a larger return to areas of symbolism and non-discursive communication which had been neglected in some modes of historical writing. And there were certainly connections between Kantorowicz's interest in the body and his Nietzschean hostility towards the claims of some historians to achieve a context-free, disembodied, neutral truth.

What emerges so strikingly from his career, however, is how easily these apparently materialist emphases can turn into a particularly strong form of idealism. The 'two bodies' theory has appealed in part because it seems to counter older grand narratives of the steady progress of ideals of liberty. The result has been, however, that the major ideological agency behind the English Revolution has been quite implausibly transferred to a small group of court panegyr-

ists. As a model of political coherence, the body has a long tradition of association with hierarchy and opposition to democracy, and it often played that role in the early modern period. As for the Kantorowiczian and new historicist hostility towards positivism, here again the results have been ambiguous. The claim that a critic's or historian's work will always be informed by political ideology has become axiomatic, and it is taken for granted in the present study. But the tendency simply to collapse the cognitive into the performative, history into rhetoric, tends to undermine the space for critical assessment.

By now, however, the argument of this essay may seem to have come close to refuting itself. Does not the eagerness with which Kantorowicz's ideas have been taken up, considerably beyond the available evidence, indicate the very overwhelming power of royal symbols which I have tried to question? One reply is that such power tends to be strongest when opposing modes of political discourse are in eclipse. The strength of the reaction against any forms of objectivism or positivism in the current climate of literary theory, and the systematic erasure of older 'grand narratives' in the quest for an Other to an Enlightenment viewed as purely repressive, has tended to erode alternatives. It has been widely assumed that the triumph of a one-dimensional Enlightenment humanism was the almost unavoidable goal of history, and its contestation the intellectual's main task. As the century nears its end, however, with militant nationalism leading to the steady rehabilitation of long-repressed discourses – and a growing trade in royal bodies in the former communist world – that strategy may seem to have its own complacency. Kantorowicz's early absolutist discourse had been greatly tempered by the time it was becalmed in post-war American academia; and he himself became uneasy about its possible resurgence. Yet his later writings retain something of the elegiac pathos with which the George circle had surrounded the lost symbols of autocratic power. If that pathos was ever appropriate, it is the less so at a moment when Mephisto is stirring again.

Magdalen College, Oxford

Notes

1 For a recent instance see Sergio Bertelli, *Il corpo del re: Sacralità del potere nell'Europa medievale e moderna* (Florence: Ponte alle Grazie, 1990). I am grateful to Darleen Prydds for this and other references.
2 See Michel Foucault, *Surveiller et punir: naissance de la prison* (Paris: Gallimard, 1975), pp. 33–4.

3 Ernst H. Kantorowicz, *The King's Two Bodies: A Study in Mediaeval Political Theology* (Princeton: Princeton University Press, 1957), p. viii.

4 Discussions of Kantorowicz's career include Yakov Malkiel, 'Ernst H. Kantorowicz', in Arthur Evans, Jr (ed.), *On Four Modern Humanists: Hofmannsthal, Gundolf, Curtius, Kantorowicz* (Princeton: Princeton University Press, 1970), pp. 146–219; Alain Boureau, *Histoires d'un historien: Kantorowicz* (Paris: Gallimard, 1990); Norman F. Cantor's strongly hostile 'The Nazi twins: Percy Ernst Schramm and Ernst Hartwig Kantorowicz', in *Inventing the Middle Ages: The Lives, Works, and Ideas of the Great Medievalists of the Twentieth Century* (Cambridge: Lutterworth Press, 1991), pp. 79–117. Professor Robert Lerner is working on a full biography; see his 'Ernst Kantorowicz and Theodor E. Mommsen', in Hartmut Lehmann and James J. Sheehan (eds), *An Interrupted Past: German-Speaking Refugee Historians in the United States after 1933* (Washington: German Historical Institute and Cambridge: Cambridge University Press, 1991), pp. 188-205, and 'Ernst H. Kantorowicz (1895–1963)', in Helen Damico and Joseph B. Zavadil (eds), *Medieval Scholarship: Biographical Studies on the Formation of a Discipline, vol. 1: History* (New York and London: Garland Publishing Inc., 1995), pp. 263–76. I am grateful to Professor Lerner for pointing out a number of errors in an earlier version of this paper, though there is more than conventional force in the disclaimer that he is in no way associated with the views here expressed.

5 Ernst Kantorowicz, *Frederick the Second 1194–1250*, trans. E. O. Lorimer (London: Constable & Co, 1931). References in parentheses are to this translation. The German edition was published at Berlin by Georg Bondi in 1927.

6 Boureau, *Histoires d'un historien*, pp. 42ff., notes that spiritual succession from one male to another without any female intermediary is a unifying theme of Kantorowicz's work.

7 On Frederick II see 'Die Gräber in Speier', in *Stefan George: Werke*, 2 vols (Munich and Düsseldorf: Helmut Küpper, 1958), 1: 237–8.

8 Theodor W. Adorno, 'The George-Hofmannsthal Correspondence', in *Prisms*, trans. Samuel and Shierry Weber (London: Neville Spearman, 1967), pp. 187–226; for a highly qualified defence see also 'Stefan George', in *Notes to Literature*, ed. Rolf Tiedemann, trans. Shierry Weber Nicholsen, 2 vols (New York: Columbia University Press, 1991–92), 2, pp. 178–92.

9 'Templer', *Werke* 1: 256.

10 Sander Gilman, *The Jew's Body* (New York and London: Routledge, 1991), p. 179: 'The Jew's experience of his or her own body was so deeply impacted by anti-Semitic rhetoric that even when that body met the expectations for perfection in the community in which the Jew lived, the Jew experienced his or her own body as flawed, diseased'. Boureau, *Histoires d'un historien*, pp. 78ff., 156, writes informatively about the further split in Kantorowicz between Polish and German identities.

11 On aestheticization of politics in Burckhardt, see David Norbrook, 'Life and death of Renaissance man', *Raritan* 8:4 (Spring 1989), pp. 89–110. Kantorowicz discusses historical parallels between poet and ruler in 'The sovereignty of the artist: a note on legal maxims and Renaissance theories of art', in *Selected Studies*, ed. Michael Cherniavsky and Ralph E. Giesey (Locust Valley: J. J. Augustin, 1965), pp. 352–65.

12 Walter Benjamin, 'The work of art in the age of mechanical reproduction', in *Illuminations*, trans. Harry Zohn (London: Jonathan Cape, 1970), p. 244. On the tendency of the German right to turn poetry into a substitute religion, see Peter Gay, *Weimar Culture: The Outsider as Insider* (New York: Harper and Row, 1968), pp. 68–9. In Gay's view (p. 68, see also pp. 52–53), Kantorowicz 'regressed by turning scientific questions into myths'.

13 On the other hand, Albert Brackmann, the positivist historian who led the onslaught on Kantorowicz, was a nationalist in the Rankean tradition and strongly supported Hitler's rise to power: political positions cannot be easily read off epistemological positions. It can be argued that positivism is more likely to create the illusion of transcending its own time and place and hence to become blind to its own prejudices, a fault of which the young Kantorowicz certainly cannot be accused.

14 See Nina Tumarkin, *Lenin Lives: The Lenin Cult in Soviet Russia* (Cambridge, Mass.: Harvard University Press, 1983).

15 Eckhart Grünewald, *Ernst Kantorowicz und Stefan George: Beiträge zur Biographie des Historikers bis zum Jahre 1938* (Wiesbaden: Franz Steiner, 1982; hereafter Grünewald), p. 121.

16 In 1928 Georg Bondi, who had just published *Frederick II*, explicitly denied any connection between the emblem used on his book and the Nazi swastika: Grünewald, p. 151 n. 11.

17 Grünewald, p. 165.

18 Grünewald, p. 111.

19 Grünewald, pp. 127–8.

20 Richard J. Evans, review of Michael Baigent and Richard Leigh, *Secret Germany: Claus von Stauffenberg and the Mystical Crusade Against Hitler* (London: Cape, 1994), *Times Literary Supplement*, 5 August 1994, p. 10.

21 C. M. Bowra, *Memories 1898–1939* (London: Weidenfeld & Nicholson, 1966), p. 294.

22 Claude David, *Stefan George: Sein Dichterisches Werk*, trans. Alexa Remmen and Karl Thiemer (1952; Munich: Carl Hanser Verlag, 1967), p. 385.

23 Malkel, 'Ernst H. Kantorowicz', p. 197.

24 For discussion of the symbolism of the body both in the Middle Ages and in its current renewal under fascism, see Percy Ernst Schramm, *A History of the English Coronation*, trans. Leopold G. Wickham Legg (Oxford: Clarendon Press, 1937), pp. 10–11, 230–1. Boureau, *Histoires d'un historien*, pp. 163ff., notes that the term 'political theology', which occurs in the subtitle of *The King's Two Bodies*, seems to go back to Carl Schmitt, the Nazis' most intellectually impressive defender.

25 Grünewald, p. 165 n.36. The biography was reprinted in 1936.

26 Jack R. Cohn and Thomas J. O'Donnell, 'An interview with Robert Duncan', *Contemporary Literature* 21:4 (Autumn 1980), pp. 513–48 (522); Ekbert Faas, *Young Robert Duncan: Portrait of the Poet as Homosexual in Society* (Santa Barbara: Black Sparrow Press, 1983), pp. 225, 230, 273, 281. I am grateful to Peter Middleton for drawing my attention to Kantorowicz's influence on American poets.

27 Boureau, *Histoires d'un historien*, pp. 132–3.

28 Lerner, 'Ernst H. Kantorowicz', p. 268.

29 Grünewald, pp. 158ff.
30 Grünewald, p. 163.
31 F. W. Maitland, *Selected Essays*, ed. H. D. Hazeltine, G. Lapsley and P. H. Winfield (Cambridge: Cambridge University Press, 1936), pp. 104ff.
32 Kantorowicz, *The King's Two Bodies*, p. 3.
33 Cantor, 'The Nazi twins', p. 114.
34 Kantorowicz, *The King's Two Bodies*, p. 147.
35 ibid., p. 13.
36 ibid., pp. 21, 23.
37 Malkel, 'Ernst H. Kantorowicz', p. 215. Lerner, 'Ernst Kantorowicz and Theodor E. Mommsen', p. 198, writes of the book's 'lack of a sustained argument. I know of commentators who presume to identify the book's thesis, but I know of no two who seem to agree on what it is'.
38 Kantorowicz, *The King's Two Bodies*, p. 35.
39 Kantorowicz, *The King's Two Bodies*, p. 40.
40 *Richard II*, ed. John Dover Wilson, (1939; 2nd edn, Cambridge: Cambridge University Press, 1957), p. xii.
41 Friedrich Gundolf, *The Mantle of Caesar*, trans. Jacob Wittmer Hartmann (London: Grant Richards & Humphrey Toulmin, 1929), p. 206, contrasting Shakespeare's sympathies with those of the Plutarchan account which had been an inspiration to republicans. The 1927 edition of the Frederick II biography carried advertisements for Gundolf's Shakespeare translations. He did not himself translate *Richard II*, but he commented on the play in *Shakespeare: Sein Wesen und Werk* (Berlin: Georg Bondi, 1928), pp. 249–76. Gundolf sees the play as registering a split between mystical and secular conceptions of power, and emphasizes that Richard's mysticism would have been more sympathetic to Shakespeare than to modern readers.
42 Bowra, *Memories*, pp. 286–7.
43 Marie Axton, *The Queen's Two Bodies: Drama and the Elizabethan Succession* (London: Royal Historical Society, 1977).
44 Marie Axton, 'The influence of Edmund Plowden's Sucession Treatise', *Huntington Library Quarterly*, 37 (1973–74), pp. 209–26, *The Queen's Two Bodies*, pp. 20ff.
45 Axton, *The Queen's Two Bodies*, p. 134.
46 On Buchanan's influence in England, and possibly on Shakespeare, see David Norbrook, '*Macbeth* and the politics of historiography', in Kevin Sharpe and Steven Zwicker (eds), *Politics of Discourse* (Berkeley, Los Angeles and London: University of California Press, 1987), pp. 78–116, and Alan Sinfield, '*Macbeth*: history, ideology and intellectuals', *Critical Quarterly*, 28 (Spring/Summer 1986), pp. 63-77, reprinted in Ivo Kamps (ed.), *Materialist Shakespeare: A History* (London and New York: Verso, 1995), pp. 93–107.
47 Patrick Collinson, 'The Elizabethan Exclusion Crisis', *Proceedings of the British Academy*, 84 (1993), pp. 51–92. Collinson mentions the 'two bodies' theory but gives few examples of its use. It is, however, true that after Mary's death, when the Protestant James VI was a probable successor, we can find Puritans like Peter Wentworth rehearsing some of arguments earlier used by Mary's supporters (Axton, *The Queen's Two Bodies*, pp. 89–91).
48 Bruce Galloway, *The Union of England and Scotland, 1603–1608*

(Edinburgh: John Donald, 1986), p. 151, notes the fragmentariness of the sources for opposition to the Union. I am grateful to Martin Butler and David Ibbetson for discussion of the constitutional and legal debates though they are in no way responsible for my conclusions.

49 Arthur Wilson, *The History of Great Britain* (London, 1653), p. 41.

50 On the unusual nature of Coke's stance in this case, see Glenn Burgess, *The Politics of the Ancient Constitution: An Introduction to English Political Thought, 1603–1642* (London: Macmillan, 1992), pp. 128–9.

51 Louis A. Knafla, *Law and Politics in Jacobean England: The Tracts of Lord Chancellor Ellesmere* (Cambridge: Cambridge University Press, 1977), pp. 66, 202–53. Justice Fleming had similar reservations, see Galloway, *The Union of England and Scotland*, p. 154.

52 David Jenkins, *The Vindication of Judge Jenkins* (London: 1647; Thomason Tract no. E386.6), pp. 5–6, and ensuing controversy with Henry Parker. In *The Contra-Replicant* (London, 1643; E87.5), pp. 25–6, Parker strongly vindicated the deposition of Richard II and wished that the spirit of Henry IV could be revived to give advice to Charles. His biographer notes the family connection of his patron the third earl of Essex, whom he proposed for the office of Dictator, with Shakespeare's play: Michael Mendle, *Henry Parker and the English Civil War: The Political Thought of the Public's 'Privado'* (Cambridge: Cambridge University Press, 1995), pp. 119–20.

53 Robert Austin, *Allegiance Not Impeached* (London: 1644; E42.12), sig. A2v, pp. 7, 10; extracts in Andrew Sharp, *Political Ideas of the English Civil Wars 1641–1649* (London: Longman, 1983), pp. 43–5.

54 Edward Forset, *A Comparative Discourse of the Bodies Natural and Politique* (London: 1606), pp. 20–1. Forset himself complained that attempts to draw analogies between the bodies were being undermined by 'makebates' with their 'humor of crossing with dissimilitudes' (sig. A1r), and acknowledged that he might be criticized for using hackneyed comparisons (p. 37). On Elizabethan awareness of the limits of analogy see David Norbrook, 'Rhetoric, ideology, and the Elizabethan world picture', in Peter Mack (ed.), *Renaissance Rhetoric* (London: Macmillan, 1994), pp. 140–64.

55 Kantorowicz, *The King's Two Bodies*, pp. 419ff.

56 Nigel Llewellyn, 'The Royal Body: monuments to the dead, for the living', in Lucy Gent and Nigel Llewellyn (eds), *Renaissance Bodies: The Human Figure in English Culture c. 1540–1660* (London: Reaktion Books, 1990), pp. 218–40 (221, 240).

57 Kantorowicz, *The King's Two Bodies*, p. 18.

58 Kantorowicz, *The King's Two Bodies*, p. 21.

59 R. W. Southern, review of *The King's Two Bodies, Journal of Ecclesiastical History*, 10 (1959), p. 106; see also the somewhat critical review in the *Times Literary Supplement*, 13 November 1959, p. 665. Kantorowicz provides an authority for the leading 'revisionist' historian of the Civil War, Conrad Russell. In *The Fall of the British Monarchies 1637–1642* (Oxford: Clarendon Press, 1991), pp. 505ff., Russell argues that declarations which Whig historians had seen as assertions of Parliamentary sovereignty merely affirmed 'the doctrine of the King's Two Bodies', while apparent anticipations of more modern theories were 'almost unconscious' (p. 508). While these declarations may indeed be 'rudimen-

tary' as theories of the state (p. 507), they nowhere mention twinned bodies, and the Kantorowiczian label perhaps gives a misleading impression of a coherent 'doctrine'. Of the sources Russell discusses, it is a royal declaration, of 18 June 1642, that explicitly alludes to the two-body concept, invoking Calvin's Case to denounce the Parliamentary leadership.

60 Kantorowicz, *The King's Two Bodies*, p. 22.

61 *A Remonstrance or Declaration of the Lords and Commons ... 26 of May 1642* (London: 1642; E148(23)), pp. 19-20.

62 John Prestwich, *Prestwich's Respublica* (London: 1787), gives an exhaustive catalogue. Perhaps the most indicative motto is the following: 'Pro Deo pugnamus, pro rege oramus, pro patria moriamur' ('We fight for God, we pray for the king, we die for our country', p. 23).

63 William Prynne, *The Soveraigne Power of Parliaments and Kingdomes* (London: 1643), Part I, p. 80, Part III, p. 43.

64 Anon, *England's Miserie and Remedie* (London: 1645), p. 1.

65 Henry Marten, *A Word to Master William Prynne* (London: 1649; E537(16)), p. 9.

66 Kantorowicz, *The King's Two Bodies*, p. 39.

67 *The Trial of Charles I: A Documentary History*, ed. David Lagomarsino and Charles T. Wood (Hanover and London: University Press of New England, 1989), p. 63.

68 On the ways in which a distinction, but not a separation, between person and office could work against resistance theory, see Conal Condren, *George Lawson's 'Politica' and the English Revolution* (Cambridge: Cambridge University Press, 1989), p. 131.

69 [Claude de Saumaise], *Defensio Regia* (n. pl., 1649), pp. 283–7.

70 Milton, *A Defence of the People of England*, in *The Complete Prose Works of John Milton*, ed. Don M. Wolfe *et al.*, 8 vols. (New Haven: Yale University Press, 1953-82), 4: 1: 309-10 and n., 488–9. Don M. Wolfe points out, 4: 1: 106, that Salmasius belongs to a Continental absolutist tradition and that 'even the most ardent English royalist did not make the claims for kingship that Salmasius set forth so easily'. Bertelli, *Il corpo del re*, p. 243, cites Salmasius's use of the two bodies theory to show that divine kingship was still alive in intellectual circles even if Milton and others were beginning to undermine its foundations. Yet Salmasius only glances at the theory in a few pages of a massive tome, and Milton is able to muster such vitriol in part because he sees Salmasius as betraying a tradition of humanist demystification which goes back to figures like Erasmus and Buchanan.

71 Kantorowicz, *The King's Two Bodies*, p. 28 n.5.

72 Jonathan Scott, *Algernon Sidney and the English Republic 1623–1677* (Cambridge: Cambridge University Press, 1988), p. 44.

73 Annabel M. Patterson, *Reading Holinshed's 'Chronicles'* (Chicago and London: University of Chicago Press, 1994), pp. 112–17, discusses Holinshed's pro-Parliamentary account of Richard II's deposition. It would be rash to claim that the doctrine of the king's two bodies is nowhere to be found in Holinshed's massive tome, but there seems to be no trace of it in the politically loaded chronicles of Edward II and Richard II.

74 Letter of 30 August 1641, cited in J. S. A. Adamson, 'Chivalry and political culture in Caroline England', in Kevin Sharpe and Peter Lake

(eds), *Culture and Politics in Early Stuart England* (London: Macmillan, 1994), pp. 161–97 (185).

75 Frank Kermode, a critic always alert to new developments, took up Kantorowicz's ideas in several essays: see *Shakespeare, Spenser, Donne* (London: Routledge & Kegan Paul, 1971), pp. 59, 190.

76 Stephen Greenblatt, 'Introduction' to *The Power of Forms in the English Renaissance* (Norman, Oklahoma: Pilgrim Books, 1982), pp. 3–6, discussing John Dover Wilson, 'The political background of Shakespeare's *Richard II* and *Henry IV*', *Shakespeare Jahrbuch* 75 (1939), pp. 36–51. See the remarkably insouciant account of his Berlin visit in John Dover Wilson, *Milestones on the Dover Road* (London: Faber & Faber, 1969), pp. 215ff. On the politics of Dover Wilson's Shakespeare criticism see also Terence Hawkes, *That Shakespeherian Rag: Essays on a Critical Process* (London and New York: Methuen, 1986), pp. 101ff.

77 Kantorowicz, *The King's Two Bodies*, p. 27 n.12. For invocations of the royal body as completely central to the Elizabethan political mentality see e.g. Francis Barker, *The Tremulous Private Body: Essays on Subjection* (London: Methuen, 1984); Leonard Tennenhouse, *Power on Display: The Politics of Shakespeare's Genres* (New York and London: Methuen, 1986); and for a critique, see David Aers, 'Reflections on Current Histories of the Subject', *Literature and History*, 2nd series, 2:2 (Autumn 1991), pp. 20–34.

78 See Graham Holderness, *Shakespeare's History* (Dublin: Gill & Macmillan, New York: St. Martin's Press, 1985); Richard C. McCoy, *The Rites of Knighthood: The Literature and Politics of Elizabethan Chivalry* (Berkeley, Los Angeles and London: University of California Press, 1989), ch. 4; David Norbrook, ' "A Liberal Tongue": language and rebellion in Richard II', in J. M. Mucciolo (ed.), *Shakespeare's Universe: Renaissance Ideas and Conventions. Essays for W. R. Elton* (London: Scolar Press, forthcoming). Ernest W. Talbert, *The Problem of Order: Elizabethan Political Commonplaces and an Example of Shakespeare's Art* (Chapel Hill, NC: University of North Carolina Press, 1962), offers a more nuanced account than many later studies. In a book which came to my attention after the present article was completed, Richard F. Hardin has questioned the Kantorowiczian paradigm: *Civil Idolatry: Desacralizing and Monarchy in Spenser, Shakespeare, and Milton* (Newark: University of Delaware Press and London and Toronto: Associated University Presses, 1992), pp. 22–8 (I owe this reference to Richard McCoy).

Reviews

Tyrus Miller

Massimo Cacciari, *Architecture and Nihilism: On the Philosophy of Modern Architecture*, trans. Stephen Sartarelli (New Haven: Yale University Press, 1993), lvi + 248 pp., $35 (hardback)

Massimo Cacciari, *The Necessary Angel*, trans. Miguel E. Vatter (Albany: State University of New York Press, 1993), vi + 124 pp., $14.95 (paperback)

I

The work of Massimo Cacciari is unfamiliar to most British and North American readers, even to philosophers, cultural theorists, and scholars of modernist culture, who should find much in it to challenge and interest them. Up to the recent publication of these two translations, only one essay by Cacciari had appeared in English: 'Eupalinos or Architecture', in the now-defunct architectural journal *Oppositions*.[1] Yet in Italy, Cacciari has been a major figure in philosophy and left politics for over twenty-five years – as the co-editor of the Marxist political journal *Contropiano* (originally with Antonio Negri and Alberto Asor Rosa), as the author of numerous books and essays, as a professor at the University of Venice, as a Communist party deputy in the parliament, and, most recently, as the independent left-progressive mayor of the city of Venice. Although translations in French and German as well as in English have begun to give Cacciari's work a hearing outside of Italy, and while such delays in the broader dissemination of ideas are inevitable, the striking contrast between the breadth of Cacciari's intellectual activity and the narrow ambit of his work's reception does testify to Italy's problematic place in the

Textual Practice 10(2), 1996, 359–415

cultural life of Europe. In an essay tellingly entitled 'The Italian silence', Robert Harrison remarked ten years ago on the status of Italian intellectuals as *incogniti*: 'Who are the Italians engaged in critical thinking today? It almost takes an Italianist to answer.'[2] Harrison goes on to suggest that this problem runs deeper than one of publicity, that it recalls an historical division of labour nascent in the Middle Ages, between France as the centre of scholastic philosophy and Italy as the focal point of poetic innovation. '[T]he intellectual surge of the Middle Ages,' Harrison concludes, 'left its lasting mark in Italy not on the local scholastics but rather on the poets' (ibid.).

Be that as it may, Italy has certainly emerged since the late sixties as an intense site of philosophical inquiry. The renewal of Italian philosophy, impelled by both the challenge of German post-metaphysical thought (above all, Nietzsche, Heidegger, and Benjamin) and the re-reading of classical and medieval philosophy, has nonetheless only gradually made itself known beyond Italy's borders – and still more slowly in the United States than in Europe. Viewed from another angle, it remains unfortunately true that in the United States at least, the monolingualism characteristic not only of the popular readership, but of the academic elite as well, actively works to limit the range and impact of new voices from abroad. This stubborn entrenchment within a single language and the ongoing cutbacks in foreign language studies burden translators with a crucial mediatory role, the difficult job of awakening English speakers from the sleep of monolingual culture. One can only be thankful, then, for the recent English translations of Cacciari, as well as of works by Giorgio Agamben, Gianni Vattimo, Antonio Negri, Franco Rella, and even Antonio Gramsci; they should spark new interest in the political and philosophical culture of twentieth-century Italy. Indeed, they might even help to reinvigorate Italian studies itself, which up to now has perfectly mirrored the general parochialism of the American academy.

Given this context of general monolingualism, the choices – and chances – of translation will no doubt contribute to a certain skewing of Cacciari in the mind's eye of the English-language reader, for they place in the starkest relief the perspective shifts in Cacciari's thought over twenty-five years. These years saw both the precipitous growth and the equally impressive decline of the Italian left; they ushered in the Italian Communists' 'historic compromise' and the dissolution of the Soviet Communist bloc from which the Italian road to socialism was meant to veer; finally, they compelled a profound rethinking of Marxism by left intellectuals and their large-scale defection from it once it had been 'rethought' beyond repair. It may well be that the continuity and sheer volume of Cacciari's work served in the

Italian context to buffer the historical shock that jars the English-language reader of *Architecture and Nihilism* and *The Necessary Angel*. This reader must traverse the militant Marxian and Nietzschean idiom of the 'Metropolis' essay in the first book, as well as the later book's earnest philosophical exegesis of angelology from neo-Platonism and Gnostic Christianity to Walter Benjamin, Paul Klee, and Rainer Maria Rilke; and s/he is confronted, within the *Architecture of Nihilism* volume itself, by distinct, even opposed interpretations of the Viennese architect Adolf Loos. Cacciari's willingness to republish his earlier work, at the cost, perhaps, of a certain philosophical embarrassment, is commendable, for, in doing so, he implicitly accepts the historicity of the positions he has taken in his career and lets their contradictions play themselves out on the present horizon. While his recent meditations on the crisis of the European *nomos*, published as *Geo-filosofia dell'Europa* (1994), and his massive study of metaphysics and theology, *Dell'Inizio* (1990), reveal Cacciari to be very much a 'living' philosopher, the sum of his previous writings, of which the English translations are a truncated image, nonetheless stands as a kind of death's head over the years since 1968: a sobering allegory of a terminated history, scattered signs only partly legible in their original significance, and – at their best – a spur to commitment to the interminable task of thinking the life that follows from that history.

II

Architecture and Nihilism encompasses three major works: the essay portion of *Metropolis* (1973), which originally also included Italian translations of a number of works of German sociology; the essay 'Loos-Wien' from *Oikos* (1975); and the essay 'Loos and His Angel' (1981). In addition, there are exerpts from *Walter Rathenau e il suo ambiente* (*Walter Rathenau and His Context*, 1979), short essays from *Dallo Steinhof: Prospettive viennesi dell'inizio del secolo* (*From the Steinhof: Viennese Perspectives from the Turn of the Century* 1980), and an epilogue composed for the translation, 'On the architecture of nihilism'. The first section articulates a philosophical concept of 'Metropolis' through an interrogation of key texts of sociology, cultural theory, philosophy, and architectural thought. Georg Simmel, Max and Alfred Weber, Friedrich Tönnies, Werner Sombart, Walter Rathenau, and Walter Benjamin form, along with Friedrich Nietzsche, the nodal points of Cacciari's investigation. With his concept of 'Metropolis', Cacciari attempts to link Georg Simmel's evocation

in 'Metropolis and mental life' of an intensified 'nervous life' in the
Großstadt to Max Weber's concept of rationalization, the collective
reorganization of traditional institutions to intensify and expand poli-
tico-economic power. The Metropolis, which Cacciari defines as 'the
general form assumed by the process of the rationalization of social
relations' (p. 4), confronts the individual as his or her negation.
Moreover, such negativity is not merely occasional to rationalization,
but is the very heart of this process; rationalization *is* the organization
of conflict to the ends of collective power.

Cacciari evaluates German social thought – from Simmel to
Benjamin – as a chain of responses to the sheer negative facticity of
the Metropolis. His standard of judgement is set by Nietzsche's tragic
acknowledgement of the Metropolis (in Cacciari's reading of Part III
of *Zarathustra*) and by Max Weber's coolheaded lucidity when ana-
lysing the reorganization of state and economic power in Germany
before the Second World War. Any response that sought to deny the
tragic *'Es muß sein!'* that the Metropolis spoke (in a cacophony of
languages), any response that fell short of Nietzsche's and Weber's
tragic recognition of the new metropolitan condition, whether this
denial took the form of regressive nostalgia for community or utopian
longings for redemption, was doomed from the outset to absurdity
and sheer impotence. The failures of the Succession movements, with
their often anti-capitalist, but manifestly aestheticizing traits; of the
social-democratic movements, whose leaders utterly failed to grasp
the new dynamics of capitalist power;[3] and finally of the architectural
utopias, whether avant-garde constructions or socialist housing-pro-
jects[4] – all these failures can, in Cacciari's view, be traced back to a
refusal to draw the proper political, aesthetic, and philosophical (in
short, tragic) conclusions from the Metropolis as the manifest form
of rationalized social relations.

If the Metropolis is the concrete social form of rationalization,
its appropriate theoretical discourse is 'negative thought'. With this
term, Cacciari designates a philosophical thought that had accepted
and internalized the crisis of dialectical thought, that had rejected the
very idea of synthesis in favour of an organized 'composition' of
conflicts and contradictions: 'To give an order to the absence of syn-
thesis – to posit this absence and explore its implications to the end
– was the real "mandate", and the real question' (p. 37). To try to
think the Metropolis outside the *'absence* of synthesis', outside the
functionalized orchestration of irreducible languages, was to reduce
the Metropolis to social forms already smashed in the process of
rationalization: 'city, family, organism, and individuality' (p. 37). Yet
if the origins of 'negative thought' can be traced to the Metropolis,

negative thought may in turn intervene in the very texture of Metropolis, through the person of the architect, who had traditionally tied architecture to the notions of 'city, family, organism, and individuality'. In Cacciari's view, it was the Viennese *Baumeister* Adolf Loos who most fully left these traditional notions behind and grasped the implications of negative thought for architecture.

It is in Cacciari's lengthy discussion of Loos, however, that strains emerge in his notion of 'negative thought', as the tragic thought of 'rationalization'. In the context of this review, I can only briefly suggest the crux of the problem, which lies in an apparent contradiction between Cacciari's earlier and later essays on Loos, 'Loos-Wien' and 'Loos and His Angel'. It is not my point here to argue for one or the other interpretation, but to suggest that taken together, both are, literally, *questionable*. This in-coherence at a crucial point in Cacciari's argument, indeed, reveals what is truly *fragwürdig* in Loos's architectural thought and practice, and, in turn, it reiterates the very problem that took Cacciari back to Loos for another attempt at understanding him. Precisely because Loos so fully realized the implications of his times, and set himself to labour in the *Werkstatt Nihilismus* of the Metropolis, he resists philosophical interpretation, even a strictly 'negative' one. Yet surely it must be the attempt to interpret the 'immediate negative' manifest in Loos's practice or in Nietzsche's writing which forms the burden of 'negative thought': to unfold the tragic predicament of *composing* and *keeping composed* in the face of insuperable conflicts.

In the first of the two Loos essays, which is conceptually linked to Cacciari's discussion of Metropolis, Loos appears as the active, 'tragic' nihilist:

> Loos opposes style with his *Nihilismus*.... All anti-expressive, anti-synthetical, anti-natural composition is nihilistic.... Style is *organic* language – composition is depth and historic contradictoriness, *primary* plurality ... technique-discipline, no new ornament, no nostalgia, no 'recuperation'.
>
> (pp. 111–12)

The general stance of Cacciari's Loos is set by Nietzsche, while the impulse towards analysis and formalization is akin to Loos's friend Wittgenstein, the early Wittgenstein of the *Tractaus*. Cacciari makes this latter analogy clear by referring to Loos's ' "logico-philosophical" critique of the Werkbund and the Werkstätte' (p. 111). In 'Loos and His Angel', however, Cacciari's philosophical coordinates have shifted significantly. It is no longer 'rationalization' and 'tragedy' which are the central concepts, but praxis, tradition, and the multiplicity of

language games. And precisely here, the organicism that Cacciari earlier claimed Loos had firmly rejected creeps back into Cacciari's analysis:

> The tectonic lies not in striking roots in mythical 'land', but in *striking roots* in the process of the thought-game of which one is part, in operating with it, relating to the material and *its body* as to *an organism* that can never be reduced to a mere instrument of construction, seeing in the material a compositional factor, and defining, in this same operation, one's own rules, seeking to define them.
>
> (p. 164, my emphases)

Here it is no longer Nietzsche and the early Wittgenstein who lay the ground for Cacciari's reading of Loos, but rather the post-*Kehre* Heidegger and the Wittgenstein of the *Philosophical Investigations*. Even if we leave Heidegger aside and focus only on Wittgenstein, however, we should not be surprised at these organic notes in Cacciari's more recent analysis. For the central notion of Wittgenstein's later 'investigations', the 'language game', defined as a 'form of life' (*Lebensform*), itself carries strongly organicist connotations.[5]

Moreover, it is striking that another central metaphor that Wittgenstein uses to describe the plurality and relation of language-games also stands over and against the idea of the Metropolis, the famous metaphor of the 'ancient city' of paragraph 18: 'Our languages can be seen as an ancient city: a maze of little streets and squares, of old and new houses, with additions from various periods; and this surrounded by a multitude of new boroughs (*Vororte*: suburbs) with straight regular streets and uniform houses' (p. 8e; p. 246). Shortly before this passage, Wittgenstein also compares rationalized, mathematized languages to 'suburbs' (*Vorstädte*). If we follow out the metaphor, thus, the negativity that originally served for Cacciari as the link between the Metropolis and negative thought has been dispersed in a new spatial image of potentially unlimited extensivity. The Metropolis represented the intensive restructuring of social relations, the orchestration of crisis at the heart of the system. In Wittgenstein's city of language games, in contrast, rationalized and unrationalized languages touch only at their peripheries. Rationalization need not have *any* implication for the older form, since the old and new games may go on living side by side. No longer need rationalization compose crises within the 'urban' process, since rationalized languages may add themselves on to the existing city as suburbs. What Wittgenstein proposes is something far less akin to Haussmannization, the classic form of Metropolitan intervention, than to suburban

sprawl; and, for better or worse, Wittgenstein (of Cambridge, not Vienna) is the authentic philosopher of a post-metropolitan pluralism. In this new, dispersive order, rationalization is not intensive, but extensive. It amounts to the laying out of one *Trabantenstadt* (satellite city) after another along the lines of the *Autobahn*, which leads us ever further out of the 'ancient city'.

III

Of the two books, however, the more recondite is certainly *The Necessary Angel*. Written originally in 1986 and revised in the 1988 French edition, this book followed up on the theological and literary investigations of Cacciari's 1985 study, *Icone della Legge* (*Icons of the Law*), which includes a chapter entitled 'L'angelo sigillato'. The word 'sigillated', which means both 'sealed' and 'impressed with a seal' (a 'sigil' is an impressed sign or more generally an occult mark), offers an excellent characterization of Cacciari's meditations on angels in the later book as well. *The Necessary Angel* is a 'sealed' book, in a dual sense: closed, yet also replete with outward signs of a message it seems hesitant to enunciate. Ostensibly a philosophical study of angelology, supported by an erudite battery of citations, it treats such classic philosophical and theological issues as the nature of time, fate, free will, representation, and salvation. In a more historical dimension, Cacciari also considers the problematic association of angels and demons and the iconographic connection of angelology with pagan zodiacs. Yet this book's ambition is at once more far-reaching and other than can be conveyed by a summary of content. Throughout it, indeed, one senses an idiosyncratic attempt by its author to mimic angelic speech, to achieve a purely 'intelligible' idiom, which, like the angel's tongue, seeks communication but is bound to and by the supersensual.

For Cacciari, the 'Angel' inherited from Judaic, Christian, and Islamic theology represents philosophy's impossible sublimation, its unreachable summit in 'pure theory', in which the philosopher may comprehend the angel as the figure of supersensual truth: 'The forms of angelic communication differ in principle from those of sensible apprehension and sight. The Angel witnesses the mystery as mystery, transmits the invisible as invisible, without "betraying" it to the senses . . . It *figures* the living presence of the mystery – but only for the gaze of pure *theory*' (p. 2). Yet Cacciari is in no wise suggesting a theologico-theoretical revival of ancient myths of passage through the successive archons of wisdom, drawn upwards by the angelic

psychopomp to the highest modes of contemplation. On the contrary, after positing this image of the angel, he turns it around, downwards, towards descent. The Angel's purity, and hence the purity of the gaze that can see it as the figure of unsayable truth, is only the point from which this descent towards a worldly existence begins.

It is this purity as yet untouched by descent, this angelic subli-mation, this theoretical atopicity, that torments the angels of contem-porary Berlin in Wim Wenders' film *Wings of Desire* (which appeared after Cacciari's book) – and thus Wenders' film can serve us here as a kind of practical opening onto the problems that occupy Cacciari in *The Necessary Angel*. Wenders' angelic drama plays itself out at the exasperated extreme of metropolitan *Ent-ortung* (de-placing, dis-placing) – Berlin after the fall of the Wall – and as a meditation on the nihilistic synthesis implicit in the idea of 're-unification'. In presenting the German myth *par excellence*, the myth of unity, as the consummation of the postmodern *Großstadt*, Wenders uncovers the profound elective affinities between architecture, nihilism, and angels. From the murky '*Himmel über Berlin*' (Should *Himmel* be translated as 'heaven' or 'sky'? A *krisis* for angels ...), Wenders' angels confront their innate inability to empathize with creatures consigned to the life of the body, time, and death – to history. They endure in the impossibility of their being *seen* by the same eyes that look at, without really seeing, the life of the postmodern, post-ideological Metropolis. And their endurance is properly philosophical in its import, for it is the measure of the utter incompatibility of this ultra-Metropolis with the philosophical dream of pure theory, the exclusion of anything 'unsayable' from this horizon of nihilism.

Are Wenders' angels, then, ultimately nothing more than the patter of wings of a human, all-too-human desire, the click of the mechanically reproduced image in the machinery of projection, an ironic realization of Rilke's 'vibration in the void which now transports us and comforts and helps' ('First Duino Elegy')? Perhaps, but perhaps too these beings are still allowed one narrow possibility of authentic encounter. For as Cacciari notes of Rilke's Angel, 'The end of the order of the *mundus imaginalis* does not mean the end of all encounters with the Angel – it means that every encounter will now have to begin by putting ourselves at risk. In the word that implores there resounds the wait for what saves, for a kind of sal-vation that comes from beyond the misery of the creature' (p. 11).

The risk of oneself lies in the very invocation of the Angel, for the invocation takes the form of a wager of one's self. It is this wager, or invocation, which Cacciari's book, its autobiographical interior concealed behind an expressionless facade of questions and quo-

tations, seeks to represent, to circumscribe, to *name*. His wager is to speak a deeply attenuated speech, made up of impoverished and *outmoded* words, in a philosophical idiom proper to what we can now call a *descendent* theology and metaphysics: 'to say in such a way that the ex-pression is praise of the invisible, without expecting anything from it, without provoking anything in it. Such saying re-edifies in the heart, the thing' (p. 11). The risk of invoking the Angel calls forth, in It (as in us, who may overhear it as readers) profound astonishment. The messenger-Angel is startled at the abyss between its own 'angelic' unsayable truth and human speech, which takes the ephemeral things of the world into 'the invisible' tending of the word. Astonishment – the astonishment of encounter within absolute difference, elsewhere crucial to Cacciari's current political thought[6] – undoes the traditional purity of the Angel, drawing it close to the human, making it *descend*. 'The pathos that moves man toward the name-symbol is therefore shared by the Angel', writes Cacciari. 'Its figure resembles more that of a companion caught in our own vicissitudes than that of the hermetic-gnostic Pyschopomp. The Angel *follows* man; it desires to be named by man's desire for the name' (p. 48).

Indeed – as both Wenders and Cacciari suggest – this Angel, the *angelus novus*, longs to be for us the very *wings* of that desire, to fly downward, to descend and accompany us in our search. It would like to stay, but it is carried upward by the drafts of our cries for consolation, which catch in its wings like a storm. Its sole happiness lies in the rhythm of our coming and going, in hearing the antiphon of our questioning – in feeling itself drawn down towards us and being made to lament our abandonment of it. Angelus, that being fated to sing; 'yet it could not help it if its lament sounded so beautiful' (Kafka).

Yale University

Notes

1 Massimo Cacciari, 'Eupalinos or architecture', trans. Stephen Sartarelli, *Oppositions*, 21 (Summer 1980), pp. 06–16.

2 Robert Harrison, 'The Italian silence', *Critical Inquiry*, 13 (Autumn 1986), p. 81.

3 Cf. Cacciari's analysis of German Social-Democracy in several of the essays in *Pensiero Negativo e Razionalizzazione* (Venice: Marsalio, 1977), above all, 'Sul problema dell'organizzazione. Germania 1917–1921', pp. 85–145; also the section entitled 'Böhm-Bawerk e Hilferding: il dibattito sulla "trasformazione"' in chapter 1 of *Krisis: Saggio sulla crisi del pensiero negativo da Nietzsche a Wittgenstein* (Milan: Feltrinelli, 1976), pp. 11–29.

4 This view was central to the critique of architecture developed by Cacciari's teacher and senior colleague, the historian Manfredo Tafuri. Already by the late sixties, Tafuri was developing this view in Cacciari's journal *Contropiano*: Tafuri, 'Socialdemocrazia e città nella Repubblica di Weimar', *Contropiano*, 1 (1971), pp. 207–23; 'Austromarxismo e città: "Das rote Wien"', *Contropiano*, 2 (1971), pp. 259–311. Cf. Tafuri, *Architecture and Utopia: Design and Capitalist Development*, trans. Barbara Luigia La Penta (Cambridge, Mass.: MIT Press, 1976).

5 Ludwig Wittgenstein, paragraph 19 of *Philosophical Investigations*, trans. G. E. M. Anscombe (New York: Macmillan, 1958), p. 8e; *Philosophische Untersuchungen* in *Werkausgabe*, Bd. 1 (Frankfurt a/m: Suhrkamp, 1984), p. 246. On the organicism of Wittgenstein's thought, see Joachim Schulte's comparison of Goethe's 'morphology', developed in his botanical writings, with Wittgenstein's 'morphological' approach to language use: 'Chor und Gesetz. Zur "morphologischen Methode" bei Goethe und Wittgenstein' in Schulte, *Chor und Gesetz: Wittgenstein im Kontext* (Frankfurt a/M: Suhrkamp, 1990), pp. 11–42.

6 Massimo Cacciari, *Geo-filosofia dell'Europa* (Milan: Adelphi, 1994), especially the last chapter, 'La Patria Assente' and the epilogue, pp. 131–70.

David Siar

The Dematerialisation of Karl Marx: Literature and Marxist Theory Leonard Jackson (London and New York: Longman, 1994), ix + 312 pp., $58.95 (hardback), $28.50 (paperback).

One might wonder why a 'non-Marxist' – as Leonard Jackson describes himself – would offer a tough-minded, book-length defence of 'one of the main principles of Marxism': namely, 'the principle that human culture and cultural history are mainly determined by their economic basis' (p. 1). No matter, *somebody* needed to write this book, and I am just as glad that it was Jackson since his distance from socialist politics gives this project a certain objectivity to which no Marxist writer could lay claim in the eyes of an increasingly anti-Marxist world. That objectivity, however, leads him to challenge certain other principles that most orthodox Marxists have maintained since the publication of *Capital*, including the labour theory of value and the concept of surplus value, both of which, the writer argues, are less scientific than 'metaphysical'. Yet the main target of *The Dematerialisation of Karl Marx* is not the alleged weaknesses in Marxist economic theory but, rather, the philosophical idealism implicit and/or explicit in much of the so-called materialist literary theory of the past twenty years.

According to Jackson, the angry young (and not-so-young) men

The Body in Late-Capitalist USA

Donald M. Lowe
"Lowe has produced an impressive agrument about the transformation of the body in recent society."
—Mark Poster 224pp, £14.95pb

Magical Realism

Theory, History, Community
Lois Parkinson Zamora and Wendy B. Faris, editors
This critical anthology, the first of its kind, shows magical realism to be an international movement with a wide-ranging history and a significant influence among the literatures of the world. 592pp, 11 illus., £21.95pb

Early Postmodernism

Foundational Essays
Paul A. Bové, editor
A collection of basic texts in the history of postmodernism.
336pp, £16.95pb

Orientalism and Modernism

The Legacy of China in Pound and Williams
Zhaoming Qian
Developing a new interpretation of important work by Pound and Williams, Qian fills a significant gap in accounts of American Modernism.
216pp, 32 illus., £14.95pb

The Uses of Literary History

Marshall Brown, editor
Brown has gathered essays by twenty leading scholars and critics to appraise the current state of literary history. 290pp, 4 illus., £15.95pb

All Is True

The Claims and Strategies of Realist Fiction
Lilian R. Furst
A major statement on one of the most enduring forms in cultural history, this book promises to alter not only our view of realist fiction but our understanding of how we read it.
256pp, £15.95pb

Universal Grammar and Narrative Form

David Herman
In a major rethinking of the functions, methods, and aims of narrative poetics, Herman exposes important links between modernist and postmodernist literary experimentation and contemporary language theory. 320pp, £18.95pb

Socialist Realism without Shores

Thomas Lahusen and Evgeny Dobrenko, editors
A collection of essays of international perspective, covering a wide variety of genres and places, on socialist realism. 297pp, £9.50pb

Pinter in Play

Critical Strategies and the Plays of Harold Pinter
Susan Hollis Merritt
With a new preface by the author
Provides a survey of diverse readings of the Pinter canon organized around and presented in terms of the major critical schools of the past twenty-five years. 376pp, £16.95pb

Duke University Press, AUPG, 1 Gower St., London WC1E 6HA (0171) 580 3994

D U K E U N I V E R S I T Y P R E S S

AIDS TV

Identity, Community, and
Alternative Video
Alexandra Juhasz
With a Videography by
Catherine Saalfield
"[*AIDS TV*] combines broad social
analysis and a culturally informed
feminist politics with the work of
producing AIDS video."
—Paula Treichler
352pp, 22 b&w illus., £16.95pb

The Ruling Passion

British Colonial Allegory and the
Paradox of Homosexual Desire
Christopher Lane
"Lane's work displays a quite
astonishing intellect. . . a work of
considerable academic stature."
—Joseph Bristow 344pp, £15.95pb

Technologies of the Gendered Body

Reading Cyborg Women
Anne Balsamo
"Balsamo takes us further into cyborg
territory than any intelligent book
has done."—Andrew Ross
272pp, 29 b&w photos, £16.95pb

Shame and Its Sisters

A Silvan Tomkins Reader
*Eve Kosofsky Sedgwick and
Adam Frank, editors*
"[This book] will have a major impact
on the study of culture in the coming
years and on several fronts."
—W. J. T. Mitchell
312pp, 3 illus., £14.95pb

Skin Shows

Gothic Horror and the
Technology of Monsters
Judith Halberstam
"*Skin Shows* is the Gothic book that
many of us have been waiting for
and it is every bit as smart as we
had hoped it would be."
—George E. Haggerty
240pp, 6 b&w photos, £14.95pb

Race and the Education of Desire

Foucault's *History of Sexuality* and
the Colonial Order of Things
Ann Laura Stoler
"Stoler has given us an ingenious and
compelling reading of the apparent
absence of race and colonialism in
Foucault's account of modern
power."—Partha Chatterjee
248pp, £14.95pb

Our America

Nativism, Modernism, Pluralism
Walter Benn Michaels
Offers a new way of understanding
current debates over the meaning of
race, identity, and multiculturalism,
and pluralism. 216pp, £23.50hb

Containment Cultures

American Narratives, Post-
modernism, and the Atomic Age
Alan Nadel
Nadel provides a unique analysis of
the rise of American postmodernism
by viewing it as a breakdown of
Cold War cultural narratives of
containment. 336pp, £16.95pb

Keywords

Postcolonialism; intertextuality; canonicity; Englishness; self-positioning; zombification

David Norbrook

The Emperor's new body? *Richard II*, Ernst Kantorowicz, and the politics of Shakespeare criticism

The idea that the king had 'two bodies', one natural and one politic, and that their dissolution would have fatal consequences for the state, is widely assumed to have been a leading paradigm of early modern political thought and a major influence on the work of Shakespeare and others. The assumption goes back no earlier than the publication in 1957 of Ernst Kantorowicz's massive treatise on the subject. An examination of the book's geneaology shows that Kantorowicz's outlook was moulded by the hieratic monarchism of the circle of Stefan George in 1920s Germany. Kantorowicz's first major work, a biography of the Emperor Frederick II, was a paean to imperial absolutism, to the unified body politic imposed by the monarch's will. Though Kantorowicz fled Nazi Germany after the biography's fantasies had become grimly actualized, that imperial vision continued to underlie the image of the tragically fissured royal body in his later work. Though it did open up a neglected area of political theory, *The King's Two Bodies* also led to the massive inflation of a relatively minor form of political mysticism into the central category of Elizabethan political thought. This has led to a major distortion of the political stance of Shakespeare and of the Puritan revolutionaries, downplaying popular agency by ascribing political opposition to a desire to defend the royal body.

Keywords

Shakespeare, William; Richard II; Kantorowicz, Ernst; new historicism; body politic; historiography

Keywords

Diaspora; British-Jewish literature; Isaac Rosenberg; Israel Zangwill; Clive Sinclair; Elaine Feinstein

Romita Choudhury
'Is there a ghost, a zombie there?' Postcolonial intertextuality and Jean Rhys's *Wide Sargasso Sea*

Jean Rhys's *Wide Sargasso Sea* has been widely read as a postcolonial text, whose postcoloniality is recognized in the strategies of 'writing back to the Centre'. Through the paradigmatic figure of hybridity, Antoinette Cosway, the multiplicity of languages and subject positions, Rhys's text seems to undo the binary certainties upon which its nineteenth-century predecessor, *Jane Eyre*, stands. The intertextual activity of *Wide Sargasso Sea*, however, needs to be understood not only in terms of its differences from the earlier text, but also in terms of its links with it. The nature of these links or interdependencies will show how the rupture that *Wide Sargasso Sea* inserts into the texture of *Jane Eyre* can be sealed; how the canonical text manages to absorb new meanings and remain virtually intact; why the postcolonial text may end up completing and problematizing the colonial text.

Wide Sargasso Sea almost makes *Jane Eyre* an impossibility. By attempting to extricate Bertha Mason/Antoinette Cosway from discursive bondage to England and Englishness, Rhys speaks to the unquestioned ideology of imperialism in which the canonicity of Brontë's text is embedded. Antoinette's story does not topple the Manichean structures of domination present in the master narrative. Rather, it produces a difficulty in re-accommodating the Jamaican Antoinette/Bertha in Brontë's Thornfield Hall. Without Bertha's malignant nature, Jane cannot consolidate her 'soul-making' process; Europe cannot render itself the 'grave and quiet' spectator of the 'demonic gambols' of its Other.

Yet, *Wide Sargasso Sea*'s status as supplier of the 'real history' of the colonial subject makes it serve the dual function of creating the gap and sealing it at the same time. The new knowledge it produces rolls back into the 'original' text, much in the way Rhys's protagonist herself does.

Meanwhile, theorists of 'race' and 'ethnicity' have been questioning how far those constructs offer a secure base for self-understanding and political action; they are inclined to celebrate the hybridity that results from diaspora. Gay men, however, find it hard to carve out any space of our own. For we do not disperse from a mythic unity; most of us begin in heterosexual cultures; in a kind of reverse diaspora, we gather.

In general, theorists have been over-optimistic about the political potential of hybridity. 'Go West', the Pet Shop Boys' remake of a Village People hit offers an evocative reappraisal of the move to California from the perspective of the AIDS crisis. However, the music business is a hybrid formation, and the video of 'Go West' retrieves the recording for the mainstream.

A purposeful project of subcultural work might claim a space for gay men in which we can address, in our own terms, the problems that we face. But that 'we' will have to be re-situated, beyond the limitations of the ethnic model of gayness.

Keywords

Gay men and lesbians; hybridity; Pet Shop Boys; subculture; ethnicity; civil rights

Bryan Cheyette
'Ineffable and usable': towards a diasporic British-Jewish writing

What is interesting about the diasporic realm, which distinguishes much British-Jewish literature, is that it neither universalizes Jewishness out of existence nor strait-jackets it in preconceived images. This sense of being unsettled both in a spurious English universalism, as well as an overly monolithic Jewish particularism, has been a feature of much British-Jewish writing in recent years. At their best, however, the writers under discussion have not replaced their sense of homelessness with fixed or received images of Jewish identity. Instead, their self-conscious extraterritoriality – neither English nor Jewish – enables them to question the misconceived certainties embedded in both an English as well as a Jewish past. This sense of both a 'usable *and* ineffable' textuality has been contrasted with the purely ineffable 'jew' within postmodern theory and the all too usable 'Jew's body' within our current conceptions of modernity.

Abstracts and keywords

Gayatri Chakravorty Spivak
Diasporas old and new: women in the transnational world

This essay opens by listing what the current concept of the diaspora excludes. It names the so-called indigenous populations of the world, resident in one place for over 30,000 years, as the limit of diaspora-thinking, for their alternative visions of what it is to be human are no longer available as discursive formations. Our ideas of justice, as we look back as well as when we look forward, are temporized by the Industrial Revolution. The essay points out that social and economic justice for diasporic men and women is not identical with transnational social-economic justice. The underclass diasporic women cannot act in the awareness of this contradiction. Therefore the implied reader of the essay is the diasporic woman in tertiary education. With her in mind, the essay discusses the problems of teaching transnational feminist theory: a) an unwitting Eurocentrism among radical women; b) inability to recognize 'theory' out of uniform; c) difficulty in historicizing the other imaginatively; d) working from indifferent translations. The essay ends with the reasons why ex-Soviet Asia and East Asia were the empirical limit for syllabus-making by this particular teacher in 1993.

Keywords
Diaspora, transnationality, feminism, globalization, development, postcolonial

Alan Sinfield
Diaspora and hybridity: queer identities and the ethnicity model

Lesbians and gay men are sometimes spoke of as a kind of ethnic group, partly because the model of Black Civil Rights has been so powerful. However, there are drawbacks in rights campaigning.

Notes

1 S. Giedion, *Space, Time and Architecture: The Growth of a New Tradition*, 5th revised edn (Cambridge, Mass.: Harvard University Press, 1967) p. xxxii.

2 The contributors (each accorded a lengthy biographical entry) are Anton Alberts and Max van Huut, Tadao Ando, Ricardo Bofill, Oriol Bohigas, Doug Branson, Santiago Calatrava, Giancarlo de Carlo, Nigel Coates, Pietro Derossi, Elisabeth Diller and Ricardo Scofidio, Peter Eisenman, Hal Foster, Norman Foster, Kenneth Frampton, Elisabeth Galí, Frank Gehry, Michael Graves, David Harvey, Itsuko Hasegawa, Manfred Hegger, Herman Hertzberger, Jacques Herzog and Pierre de Meuron, Steven Holl, Hans Hollein, Charles Jencks, Rem Koolhaas, Leon Krier, Lucien Kroll, Kisho Kurokawa, Lucien Lafour and Rikkert Wijk, Daniel Libeskind, Ernest Mandel, Rafael Moneo, Jean Nouvel, Amos Rapoport, Henri Raymond, Richard Rogers, Martha Rosler, Denise Scott Brown and Robert Venturi, Richard Sennett, Alvaro Siza Vieira, Quinlan Terry, Bernard Tschumi, Oswald Mathias Ungers, Gianni Vattimo, Francesco Venezia, and Peter Wilson and Julia Bolles.

3 For an explicit statement of this thesis, see M. Wigley, *The Architecture of Deconstruction: Derrida's Haunt* (Cambridge, Mass. and London: MIT Press, 1993).

4 T. Eagleton, *Against the Grain: Essays 1975–1985* (London: Verso, 1986), pp. 65–78.

5 See S. Giedion, *Mechanization Takes Command: A Contribution to Anonymous History* (New York and London: Norton, 1969).

6 W. Benjamin, *Illuminations*, ed. H. Arendt, trans. H. Zohn (London: Collins, 1973), p. 242.

7 See R. Krauss, *The Originality of the Avant-Garde and Other Modernist Myths* (Cambridge, Mass.: MIT Press, 1986), pp. 8–22.

8 See D. Tallack, 'Sigfried Giedion, modernism and American material culture', *Journal of American Studies*, 28, 2 (1994), pp. 149–67.

9 See W. Schivelbusch, *The Railway Journey: Trains and Travel in the Nineteenth Century*, trans. A. Hollo (Oxford, Blackwell, 1979).

environments of the new historic districts. The photograph of South Sea Streetport (see p. 412) shows the thirty-four storey Seaport Plaza looming over the sloping roofs of Schermerhorn Row and its ground-floor array of restaurants, a pub, speciality stores, and the Museum Visitors Center. This scene would not seem to require a circumspect 'reading' in which epistemological questions were somehow redundant. In July 1995, the blatant exercise of power was all too visible when New York news stations reported that Fulton Fish Market vendors were being evicted for underworld connections and a further forty vendors were under investigation. It does not take a strategic reading of the little narratives of urban space to put together this news item, the City's comment that it was 'scaling down fishing activities', and the known dislike of the noisy, smelly fish market by the South Street Seaport interests to understand what is going on and what is the motor force. If there is one 'place' from which to view South Street Seaport with old-fashioned (modernist?) eyes and to ask the epistemological questions which postmodern theory disdains, it is from under FDR drive in range of the smell of the old Fulton Street fishmarket and in sight of the few remaining derelict warehouses between the Fulton Market Building and Brooklyn Bridge. Certainly, that is where officers of NYPD station themselves.

Boyer expertly assembles all the perspectives necessary for the critique she patently wants to mount. It is curious, then, that she so willingly opts for the dynamic of memory as the resource upon which to draw, and seems at times to fall in with the cavalier dismissal of history as only 'a constructed or recomposed artifice' (p. 69). And to call, in closing, for 'more ambiguous and open-ended expressions' of urban life (p. 476) is not really to change the vocabulary overmuch from that which she has so successfully criticized. She may have accepted the stereotype of the Modern Movement's antipathy to history and thereby unwittingly gives postmodernism a leg-up. But given that this is primarily a book about the 1970s and 1980s – clearly a depressing period for Boyer in New York – she does a remarkably good job in explaining how 'confrontation was artfully contained and neutralized in the 1980s' media performances that spoke of a new public spirit and civic grandeur overriding existing social and political tensions' (p. 460).

University of Nottingham

Christine Boyer is less prone than most commentators, to distinguish too absolutely between architectural modernism (the Modern Movement) and literary and painterly modernism, with its flux-like characteristics. Certainly, there is a difference and the Enlightenment tradition runs more easily into architectural modernism than into other forms of modernism. But to hold to the distinction too rigidly consigns the Modern Movement to the past, the past left behind by *post*-modernism, from where it can no longer offer alternatives.

Benjamin's and Giedion's similar insights into the coexistence of Cartesian rationality and excess (for example, the excess of images which the new perspectives of modern life produced) check any temptation to resign oneself to 'façadism' or the city as spectacle. If there is one significant criticism of Christine Boyer in *The City of Collective Memory* it is that she jumps – often on the say-so of analogies – from the mental map of the modern city as panorama to the mental map of the contemporary city without adequately considering the way they coexist: 'This contemporary city is pure spectacle, culling a programmed and projected look. For this is the reaction against order: to break apart from the dominating unity that prevailed for so many years in the City of Panorama' (p. 47). So completely is modernity thought to have given way to postmodernity, that Boyer even co-opts the term 'montage' to describe the smooth blending of images and of old brickwork and modern alloys that greets visitors to South Street Seaport, even though a page later she re-instates the modernist meaning of montage, derived from Eisenstein's cinema: an often violent de-familiarizing collision and conflict of images. The point is that the drive towards rationalized city plans in the early years of the century generated discontinuities as well as uniformity. The grid, as Rosalind Krauss has argued (see note 7), is at once centripetal and centrifugal. And mechanization releases possibilities, including, as Giedion demonstrates in *Mechanization Takes Command* (1948), the visual possibilities explored by Eadweard Muybridge, Etienne Marey and Frank Gilbreth.[8]

The city as panorama never took hold as completely as Le Corbusier claimed because the technology which allowed for the bird's eye view also created other, less rationalizable perspectives.[9] It is a pity that Boyer is so enamoured by her mental maps because a less severely periodized framework would have assisted her search (even on the postmodernized tip of Manhattan) for either an unexpected and arbitrary dimension in architecture, which has not arisen from the kind of manipulation of surprise and randomness which characterizes the 'celebratory promenades' (p. 422) of South Street Seaport, or for some external leverage upon the apparently seamless

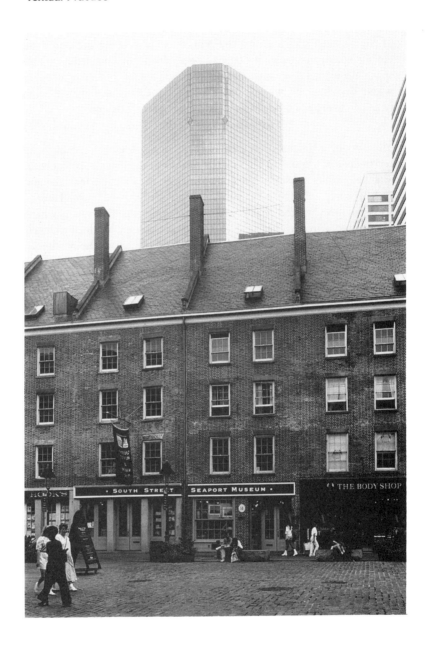

South Street Seaport, New York City, 1995. Author's photograph.

a single point of observation, as was possible when from a window of the château of Versailles the whole expanse of nature could be embraced in one view. It can be revealed only by movement. The space-time feeling of our period can seldom be felt so keenly as when driving, the wheel under one's hand, up and down hills, beneath overpasses, up ramps, and over giant bridges.

(*Space, Time and Architecture*, pp. 826 and 831)

By the end of what has come to be known as 'Giedion's Bible' the rather overdone thesis on the spatio-temporal dimension of modern architecture finds a more lively expression in an experiential view of architecture, at once inside and outside the urban space. Importantly, Giedion invested that space with a temporal dimension which his monumental researches into machine technology led him to attribute as much to the speeding up of modern life as to the aesthetics of Cubists and Futurists.[5]

Walter Benjamin, who is one of the influences upon Christine Boyer's book and appears from time to time in the pages of the other two books, is more direct than Giedion in puncturing the illusion of spatial autonomy which some strands of the Modern Movement promulgated. Benjamin replaces it with what we would now probably call a reading of a building. 'Buildings are appropriated in a twofold manner', he observes, 'by use and by perception. . . . Such appropriation cannot be understood in terms of the attentive concentration of a tourist before a famous building.'[6] In the most stimulating section of Georgiadis' study of Giedion, Benjamin's notion of mechanical reproducibility as an index of modernity is put alongside the architectural version of reproducibility which became possible with mass production. But Benjamin's insistence that the mechanical reproduction of images did not have to result in wholesale conformity and indoctrination by the media offers a way of seeing the difference (and not the sameness) which architectural repetition can bring, the excess which not simply escapes the Manhattan grid, for example, but which is one of the most unexpected repercussions of the much-maligned 1811 grid plan, which established New York's street pattern, and the general pervasiveness of the grid as an index of modernity and modernism.[7] Boyer's discussion of the coming of cinema, the speed-up of urban life with railway and automobile travel around the turn of the century, and the expanses of glass in the city, all of which produced an interpenetration of inside and outside, reveals the mental map of modernity to be far from the panoramic stereotype to which she sometimes reduces it. It is much closer to the spatio-temporal idea we find in Sigfried Giedion. There is a tendency, to which

now distributes information about what Sony offers: a sculpture by Joel Shapiro and (in July 1995) a *Wings of Courage* exhibition which advertises the Sony film of that name running at the Sony Imax Theater on Broadway. This corridor between East 55th and 57th Streets is booming at the expense of the almost deserted IBM atrium, which now has street bums at its doors. Whereas the projects of the 1970s and 1980s analysed by Christine Boyer maintained the illusion of public beneficence, the Sony triumph over IBM for control of this very successful mid-town space is less subtle. Nearly all the outlets are Sony's: the Sony Family Entertainment Center, Sony Plaza Ticket Center, Sony Signatures (new product ideas from Sony), and Sony Wonder Technology Lab. Although there is a (symbolic?) chess table, the amount of public sitting space is less than in the IBM atrium. Security guards in smart blue Sony blazers with mobile telephones have the alertness and the smiles which the IBM guards had just two years ago when Sony Plaza was under construction.

It is worth remarking that when, as in the above digression, IBM comes to represent the more enlightened past, it is surely time to wonder whether site-specific analysis is in danger of getting so caught up in postmodern versions of critique that it is failing to see the woods for the trees. (A few years ago, in an astute essay on Fredric Jameson, Terry Eagleton discerned a fascination for postmodernism in Jameson's own style.)[4] Nevertheless, Boyer is probably correct in resisting a return to the over-arching modernist views of the city, though the question of whether all modernists were so panoramic should be asked in an effort to find theoretical points of view from which to see these new sites.

In spite of his reputation as the champion of an austere modernism, Sigfried Giedion is not portrayed by Georgiadis as pedalling an arid, over-rationalized, bird's eye vision of the modern city. *Space, Time and Architecture* (1941) concludes with a chapter on New York (which Georgiadis surprisingly ignores) in which Giedion seeks to get inside the city. Lacking a literary modernist's way with words, Giedion does his best to convey the experience of Rockefeller Center with a photomontage of angled photographs of the skyscraper complex, as though he were whirling round in Rockefeller Plaza. He compares this visual expression with one of H. E. Edgerton's stroboscopic studies of motion. And, in seeking also to picture the whole city – he does not relinquish modernist aspirations to totalize, to envision a unified city – Giedion fastens upon the experience of driving the urban parkways:

the meaning and beauty of the parkway cannot be grasped from

The main case-study in *The City of Collective Memory* is the post-Lower Manhattan Plan (1966) development from Brooklyn Bridge to Battery Park. Boyer tries to sort out manipulated from authentic memory through a well-researched account of who pulled the strings; who controlled the purse in 'new coalitions of public-private investment' (p. 64); and what compromises were reached, particularly over the proposed museum in the reconstruction of South Street Seaport. Her conclusions that the variety in the new market-places is just as homogeneous as in any all-over city plan and that 'architecture has become a commodity as well as a form of publicity' in these 'packaged environments' (p. 5) are hardly surprising but the getting-there is very persuasive. We see the ways in which the Seaport sells to retailers 'access to a particular clientele delivered in the right frame of mind' (p. 439). In terms of her tripartite periodization, this city of spectacle erases the years of oppositional, utopian (in practice, often dystopian) modernism to produce 'fragmented parcels of city space as autonomous elements that say nothing about the city as a whole' (p. 66). Within these historic districts the advertising potential in the nineteenth-century city-as-work-of-art can be released. Although the scenic reconstructions recall an age of struggles between classes, between a declining craft-economy and mercantile capitalism, and between oppositional artists and economic power (here, we may think of Herman Melville, the New Yorker), Boyer reminds us that the invisible struggles in the 1970s and 1980s are between corporations. Those corporations sponsor and discard art and architecture according to a commercial logic, and this can squeeze out the opposition between corporations and artists and architects.

Since the publication of Boyer's book, Sony has just won a small battle with IBM for lucrative midtown public space in New York. In the wake of IBM's sale of its modernist skyscraper at the corner of Madison Avenue and East 57th Street, its atrium has been all but abandoned as a public space. During the July 1995 heatwave there was no air conditioning, the vegetation was yellowing, there was one poorly-stocked food-outlet, and security guards functioned as though they were policing a completely vacant building. With IBM's departure the much-valued basement art gallery has also closed. Immediately across East 57th Street, a much smaller space has taken over the public role. Sony has purchased the AT & T Headquarters building (1978–83) on Madison Avenue designed by Philip Johnson and John Burgee in the first flush of postmodern enthusiasm. A glass canopy, covering Sony Plaza, has been bolted onto the back wall of the AT & T. The AT & T company has left for New Jersey, taking the sculpture of Electra with it but a helpful, though watchful, official in the lobby

long enough to see its return in the urban heritage projects of the 1970s and 1980s which Christine Boyer examines in *The City of Collective Memory*. Boyer is especially troubled by the picturing of the public sphere in living museums, scenic displays of nineteenth-century trading places, and *trompe l'oeil* wall paintings. Her doubts about the postmodern ethos so confidently announced do not lead her to anything like full support for the modernist cause directed behind the scenes by Giedion in his writings and role as Secretary of CIAM. She periodically recalls the actual mistakes of the post-World War II years and the earlier theoretical shortcomings of Le Corbusier and the Bauhaus ('the Gropius morality' in Michael Graves' dismissive phrase (*The Invisible in Architecture*, p. 472)). The practice and the theory, she argues, violently severed thinking about the city from historical reference and ruled against figurative architecture. Nevertheless, Boyer seems to endorse three modernist tenets: that planning and architecture are inseparable (architecture as style alone gives free rein to the raiding of, and borrowing or quoting from, a self-enclosing architectural dictionary); that one test of authenticity is a relationship with one's own time (she quotes Mies: 'the spirit of the age conceived in spatial terms' (p. 420)); and that the concept of totality still has some currency. On the third of these, she is refreshingly forthright:

> Adrift in a sea of fragments and open horizons, our postmodern position is ambiguous. We cannot speculate or reflect on a more rational and equitable form for the city, for fear of erecting perspectival wholes and illusionary totalities that might exclude or homogenize what we believe must remain plural and multiperspectival.
>
> (p. 3)

Getting at the 'plural and multiperspectival' is tricky when modernist alternatives are so discredited. Also, a site such as South Street Seaport seems to have reinstated public space where, previously, there were derelict factories and rotting wharves, all in the shadow of FDR Drive. Boyer calls for 'a better reading of the history written across the surface and hidden in forgotten subterrains of the city' (p. 21), so that we understand what is going on when the past is excavated, patched up or copied and set in place to mediate our view of the contemporary city. To this end, she borrows Maurice Halbwachs' hypothesis that significant memory is not private but associated with places and other people: 'a man who remembers alone what others do not remember resembles someone who sees what others do not see. It is as if he suffers from hallucinations' (quoted on p. 26).

ational rationale for their book they explain that the contributions are distributed across eight current architectural debates and preoccupations and three 'prevailing ideologically motivated approaches to contemporary architecture' (p. 15). The eight 'vectors' are fairly familiar from theoretical explorations in other fields: durée, context, border, topos, programme, space, identity, and representation. But rather than receiving a superficial architectural inflection, when these concepts appear in essays by Ernest Mandel and Gianni Vattimo and in the conversation with Giancarlo de Carlo, it is apparent that a great deal of contemporary theory has been 'architectural' from its beginnings in Kant through Marx to its full emergence in Heidegger and Derrida.[3] The three approaches or strategies are more specialized: archaism, a tactile orientation; fascinism, a concentration upon the atmospheric in architecture; and façadism, 'a belief in style' and its 'reconciling [of] antagonisms at the level of form' (p. 16).

The underlying issue in the collection, however, remains architecture's great and recent 'event': the end of the Modern Movement and the subsequent twenty-five years of obituaries and new and not-so-new reactions. Without this point of reference, the book, when read as a whole, is just too much, and in their efforts to keep tabs on everything the editors resort to rather silly lists of 'paradigmatic soundbites'. For 'façadism', for example, '... marketing, communication, Rorty ... eclecticism, visuality, city ...' (p. 19). But the essays (including the editors' extensive contributions) are at the very least important, mostly of a very high quality, and proof of how fortunate the profession is (in spite of the opprobrium heaped upon it) to have practitioners like Bernard Tschumi, whose work with Jacques Derrida is well-known, Peter Eisenman, who offers an astute analysis of visuality, electronic media and architecture, and Pietro Derossi, who accepted the editors' invitation to react to the eight vectors of the collection. None of these architects sees any reason not to engage in theory, while Richard Rogers re-states his commitment to a broader political project than the style-merchants have entertained over the past two decades. Architecture is also the kind of intellectual sphere which obliges theorists to inspect more carefully the kind of materialist positions which are sometimes invested with an inviolable authority in literary and cultural studies. Kenneth Frampton's 'In search of a ground', Hal Foster's 'Architecture, development, memory', and Martha Rosler's 'In the place of the public: observations of a traveller' are good instances of convincing materialist analyses advanced in demanding company.

Sigfried Giedion disliked what he called 'façade architecture', though he identified it as a nineteenth-century trait and did not live

what can be learned from the changing spatial form of the city: the traditional city up to the mid-nineteenth century whose 'mental map' is the city as work of art; the modern panoramic city from the late nineteenth century through the first half of this century; and the city as spectacle of the years since the 1960s.

Sokratis Georgiadis, in the first book-length study of Swiss architectural critic and historian Sigfried Giedion, acknowledges Giedion's importance in writing an intellectual history of architecture, rather than simply a conventional, academic history of architectural forms, and in using knowledge of the past to intervene in the story he tells. Moreover, as an arch-modernist, Giedion expressed disquiet about the liberties which architects were beginning to take after the decline of the International Style in manipulating architectural representation. In 'Architecture in the 1960s: hopes and fears' he refers to a current fashion in which 'historical fragments are picked at random . . . a kind of playboy architecture'.[1] Georgiadis concludes his largely approving intellectual biography by marking off Giedion's 'grand conspectus' from a contemporary 'culture based on variety of choice' (p. 196).

While these three books are important enough in their own right to warrant discrete reviews, bringing them together allows some insight into the considerable contribution of architectural discourse to recent thinking about visual theory, spatial politics (especially in an urban context), and the intersection of history, memory and representation, as well as into the latest twists of a modernist-postmodernist debate which refuses quite to go away. This debate had one of its starting points in architecture, has always seemed much more 'alive' in architectural circles, and continues to throw up intriguing case studies.

The Invisible in Architecture is a collection of well over fifty essays and manifestos by, and interviews with, some of the most exciting and independent figures in architecture and theory.[2] Predictably, then, the concept of 'the invisible' gets variously expressed, pointedly ignored and co-opted for eccentric purposes; as well as for purposes which are so straightforward as to make the high theory which excitingly informs most of the book appear itself to be a postmodern distraction. As if in protest against this last tendency, David Harvey bluntly defines Canary Wharf, London, as 'a pure product of the money which circulates through it' (p. 421) and as the 'connection' between Canary Wharf and the Reagan administration's rocketing budget deficit, lubricated by the special relationship which flourished after 1979 and Margaret Thatcher's first election victory. The editors, though, are intent upon sustaining the complexity which they believe attends the concept of 'the invisible'. In the organiz-

Douglas Tallack

Ole Bouman and Roemer van Toorn (eds), *The Invisible in Architecture* (London: Academy Editions, 1994), 151 pp., £69.95 (hardback)

M. Christine Boyer, *The City of Collective Memory: Its Historical Imagery and Architectural Entertainments* (Cambridge, Mass. and London: MIT Press, 1994), x + 560 pp., £34.95 (hardback)

Sokratis Georgiadis, *Sigfried Giedion: An Intellectual Biography*, trans. Colin Hall (Edinburgh: Edinburgh University Press, 1993, first published 1989) xii + 215 pp., £45.00 (hardback)

These three books share a view of architecture as more than a visual form. This is somewhat a truism since architecture patently encompasses the economic, the professional, the material and other more-than-visual elements to a greater and more obvious extent than, say, painting. More is therefore at stake. For Ole Bouman and Roemer van Toorn, the editors of the prestigious collection, *The Invisible in Architecture*, what matters in architecture is precisely what is not seen. The general problem is 'a culture whose products appear more and more to be nothing but representations' and the specific problem is that 'the entire architectural discourse has come to centre around design' (pp. 12 and 14). 'Surface glitter and inner gloom' is David Harvey's summing up of Canary Wharf in his contribution (p. 42). 'Design', the editors continue, 'discourages critical thought and action and by probing the politics of design, this book aims to rehabilitate precisely those attitudes' (p. 14). The 'invisible' in architecture is not a metaphysical bedrock beneath the 'surface glitter' but the intertwining of the visual with 'cultural, social and economic processes' (p. 14) at a particular historical juncture.

Christine Boyer is similarly preoccupied with what she openly describes as a postmodern crisis in architectural representation, manifested most unmistakably in proliferating reconstructions of urban space, such as South Street Seaport in New York City, Ghirardelli Square in San Francisco, and Place Beaubourg in Paris. For Boyer, these deceptive visuals – and, in the end, visuality itself with its manipulation of geographical space and historical reference – must be carefully analysed in the context of larger urban processes and with the assistance of a theoretically reinvigorated debate over the spatial dimension of memory. She is one of a number of critics and theorists, coming from different disciplines, who are interested in

Inuit peoples – would argue against the idea that these countries had achieved a postcolonial status. But such an argument (valid though it is) would problematize the term for others as well.

Although, the 'Introduction' argues (rightly) for a linkage between economics, politics, power and domination there are, with the notable exceptions of Anne McClintock's 'The angels of progress: pitfalls of the term post-colonialism' and Arjun Appadurai's 'Disjunction and difference in the global cultural economy', few contributions that deal with colonialism and economic positioning, issues of class, and production and consumption of cultural capital.

Nevertheless, Laura Chrisman has put together an excellent section, 'Theorising gender', which looks at the problematic relationship between feminism and colonialism; the former of which claims to be in a struggle against the colonizing influence of patriarchy. Chandra Talpade Mohanty's article 'Under Western eyes; feminist scholarship and colonial discourses' queries the positioning of feminism and its (possible) collusion with hegemonic centres of power. Yet significantly, Mohanty's questioning (and that of Mae Gwendolyn Henderson) of the racial positioning of feminism and writing only serves to highlight the paucity of contributions on the issues of race, racism and ethnicity in the book.

Overall, the 'Introduction' splits between a contextualization of a state of affairs in the areas of colonial discourse and postcolonial theory and an indication of areas for further work – many of which address the shortcomings of the selection. It leaves one to wonder why some of these areas were not pursued or adequately represented in what was the first collection of its kind.

Staffordshire University

Notes

1 Stuart Hall, 'New ethnicities', *Black Film, British Cinema*, ICA Documents 7 (London: Institute of Contemporary Arts, 1989).
2 'The Government of Canada recognizes the diversity of Canadians as regards race, national or ethnic origin, colour and religion as a fundamental characteristic of Canadian society and is committed to a policy of multiculturalism designed to preserve and enhance the multicultural heritage of Canadians while working to achieve the equality of all Canadians in the economic, social, cultural and political life of Canada.' (Excerpt from the *Canadian Multiculturalism Act* made law in 1988).

critiques of colonialisms and profoundly influential. In 'Orphée noir', his preface to Senghor's *Anthologie de la nouvelle poésie nègre et malgache de langue française* (1948), Sartre helped to establish the movement of Négritude in the Parisian literary circles. Finally, if the 'Introduction' seeks to point to the work of Hannah Arendt as a critique of fascism then Sartre's *Anti-Semite and Jew* deserves a mention. To omit it is to ignore one of the first critiques of antisemitic discourse. By not mentioning Sartre or including any of his contributions (he does not even get a mention in the index), the book obscures the role that Sartre played in establishing Négritude – a movement which deeply influenced Césaire, Senghor and Fanon's critical positions. It is important to recognize, through Sartre's contributions, the specificities of the Algerian War that are so central to Fanon's *The Wretched of the Earth* and Memmi's *The Coloniser and the Colonised*.

Although a book of this size cannot even begin to do justice to the vast body of material generated around the world on the issue of colonialist discourse and postcolonial theory, the 'Western intelligentsia' is over-represented, leaving the book open to the charge of 'Third Worldism' that Aijaz Ahmad first levelled at Edward Said. Even with the constraints of space, there are no explanations as to the omission of material on entire colonial experiences, e.g., Ireland, South Pacific, and South America and the struggles of indigenous peoples in Canada and New Zealand (Australia gets fleeting references). In regard to Canada, Australia and New Zealand the 'Introduction' dismisses, in a problematic fashion, the case made by the former 'white settler colonies' (Ireland was also known as such) for inclusion in the term postcolonial primarily on the basis of their historical Dominion status. The authors argue that such a status meant in reality that 'Economically and politically, their relation to the metropolitan centre bore little resemblance to that of the actual colonies. They were not subject to the sort of coercive measures which were the lot of the colonies.' However, in Canada (with parallels in Australia and New Zealand) the indigenous peoples faced an attempted cultural (and literal) genocide; were forced to live on 'reservations'; and had their children removed forcibly to be brought up in white foster homes. Surely this is coercion? The recent royal 'apology' to the Maoris can be read as an open acknowledgement of coercion. A case can be made that the continuing anti-colonial struggle for self-government and land claims by the indigenous peoples of these countries – despite the recent spectacular, albeit controversial, successes in regard to aboriginal lands claims in Australia and the agreed creation of Nunavut in Canada in 1999 for the

generator of heterogeneity does not necessarily support his conten-
tion. In fact, it comes perilously close to the C19 European discourses
of the university as the site of 'truth' and 'knowledge' that contri-
buted to the construction of a monoculture. The division of the
reader into two main sections 'Thinking the unthinkable: setting
agendas' and 'Breaking the bounds of discipline' does, as he argues,
offer a specificity in the second section to elaborate the general
theories of the first, but how these contributions are going to fulfil
the general claim to address the material reality of an unequal society
is not fully articulated. The attempt to make public values more
incorporative may make for George Bush's ambiguous version of a
'kinder, gentler America' but it does not guarantee social justice.

In the second book *Colonial Discourse and Post-Colonial Theory*
edited by Patrick Williams and Laura Chrisman, the central concerns
shift from the fragmentation in the body politic and the overt politics
of representation, to the dialectical relationship between the periphery
and the metropolitan that is the central concern of both colonial
discourse and postcolonial theory. Although the politics are not sig-
nalled in the title, they are in evidence in the contributions which
are, in different ways, concerned with the politics of knowledge and
cultural production.

Léopold Senghor is the first contributor followed by Frantz
Fanon. Although the 'Introduction' argues for more critical attention
to be paid to Fanon's contemporaries overlooked by the recent critical
focus on Fanon, it does not include any contributions to adjust
that focus. Despite the fact that the 'Introduction' spends a great deal
of time considering the debates over history and the political recov-
ery of knowledge, the dialectical relationship between the present
and history, and a long critique of Robert Young's *White Mythologies*,
the collection does not include any contributions that directly address
these issues – beyond Amilcar Cabral's 'National liberation and cul-
ture' and Fanon's 'On national culture'. More importantly, what the
'Introduction' omits is precisely a crucial history of the debate on
the colonial question. In attempting to contextualize the history of
debates concerning colonialism within debates about the Enlighten-
ment specifically articulated within the Frankfurt School – namely,
Theodor Adorno and Max Horkheimer, and Hannah Arendt and
Walter Benjamin – the 'Introduction' ignores one of the most influ-
ential thinkers on colonialism to whom Frantz Fanon, Léopold
Senghor, and Memmi are deeply indebted: Jean-Paul Sartre. His
works – specifically 'Le colonialism est un système', 'Situations V' as
well as his prefaces to Fanon's *The Wretched of the Earth* and
Memmi's *The Coloniser and the Colonised* – are powerful radical

berg posits heterogeneity as a more accurate reflection of historical record and culture. He also argues for the artifice of the homogeneous construction by offering migration and hybridity as a dominating historical 'fact'. Although not arguing for nomadism in the way currently undertaken, Goldberg insists that given its historical prevalence migration, rather than stasis, could be seen as the 'defining socio-historical conditions of humanity [...] the human condition is that of going and resting'. This is an argument for a dialectics of movement that transforms the recipient space. It is also the articulation of a Diaspora politics that is not primarily the backward look for self-definition but rather a prospective politics, situated in 'the present context of their metropolitan experiences'. Such debates are key areas of contestations in a number of areas including Irish studies, postcolonial theory and new nationalisms. Goldberg acknowledges, but does not fully address, the central paradox that historically heterogeneity has given way to homogeneity. This is in spite of the fact that the conditions for homogeneity (static community, claims to land, place, space and to political, economic and cultural expressions – all usually couched in terms of origination) are ahistorical or only a partial representation of the historical record. The partial representation severs cultural memory from what is relegated to prehistory (heterogeneity). The concept of heterogeneity has its enemies – it challenges, in Goldberg's words, the 'mythical inward obsessiveness of purity with the generative energy of impurity' while running the same risks as identity/difference discourses in that it can be exclusive as well as inclusive: it can open or promote closure.

One of the natural locations and generators of heterogeneity, Goldberg argues, is the university on the basis of its diverse composition and its history of incorporating transgressive interventions. However, the latter (as in the cases of women's studies and ethnic studies) may be problematic as often the concerns are appropriated for their market value only, and the institution does not undergo a transformative process.

Although committed to counteracting charges that multiculturalism is an ivory tower rhetoric by offering interdisciplinary contributions that cover both theory and practice (from people working within the areas of law – Goldberg himself teaches in the School of Justice Studies in the University of Arizona – cultural studies, media studies, literature, women's studies, philosophy, African-American studies, Chicana/Chicano studies, education, history, political science and anthropology), Goldberg's location of the project of critical multiculturalism and its contestation of the body politic within the academy alongside his identification of the university as the site/

also be read as resistance to the assimilationist model, related multi-culturalisms, and the integrationist model which replaced it in the 1960s. The integrationist model left the body politic intact by allowing a split subjectivity between public and private that Goldberg argues offered a 'pluralist allowance at the margins [. . .] with its univocal core insistences at the centre'. The advocates of integration were offering a strategic form of 'ethnoracial' (a neat collapsing of the terms ethnic and racial which reveals as much as it conceals) relations which sought to address social inequality while simultaneously producing 'good subjects for the monocultural model'. Politically, those still advocating an integrationist policy support a liberal multiculturalism based on a liberal notion of tolerating difference. Such toleration ultimately works on the assumption that power and identity remain within the homogeneous centre. This liberal multiculturalism is akin to forms of managed/corporate and difference multiculturalisms which adhere to philosophic liberalism yet do not seek to redistribute power or resources. Managed and difference multiculturalisms offer a politically correct pluralism which works to reinforce boundaries between groups and offers a 'celebration of cultural distinction' in place of economic redistribution. The corporate identity of managed multiculturalism attempts to just 'meet the letter of the law and thus avoid complaints of discrimination'. In the academy Goldberg argues that difference multiculturalism, in the name of diversity, is invoked rather cynically as a necessary recruiting tactic in a time of decreasing enrolment and scarcity of funds.

In light of further migratory shifts and socio-economic transformations, Goldberg supports the emergence of new 'incorporative' self-conceptualizations and social practices which are 'anti-assimilationist and anti-integrationalist'. Goldberg identifies the project of critical multiculturalism as aiding the transformation of the body politic from the centre, managing the margins to the body politic itself as the site of contestation. What is at stake is the 'canonised status of any one group's control'; one way forward is to aspire to the incorporative ideal. It is the incorporative ideal that drives the debates behind the canon and curriculum, control of legal pedagogy and the issue of rewriting history (or alternative histories) that are the focus of a number of contributions in the book. The central value of incorporation is posited as hybridity and what Goldberg later terms the heterogeneous. Critical multiculturalism then undertakes to 'redefine the public values constitutive of the polls to make those values more open to incorporative transformation'.

Directly contrary to the reversion to claims for homogeneity as a 'necessary condition for community, civility and civilization' Gold-

multiculturalism in light of the competing multiculturalisms and political agendas. Robinson differs in that he argues for the inscription of premodern, modern and anti(post) modern phases on the historical continuum of multiculturalism. Since most contributors deal with the issue of critical multiculturalism, and since multiculturalism is an area of contestation in the UK, it is worthwhile to summarize the various types of multiculturalisms and political agendas that Goldberg wishes to address.

His contextualization of various multiculturalisms as resistance to the 'imperatives of monocultural assimiliation' and the selective history of the monoculture challenges the ahistorical rendering of *the* multicultural project by its opponents. The monoculture in question, which Goldberg locates primarily in the academy, arose from the C19 American adoption of European academic tradition and the importation of the discourses of universality. Both helped to fashion a racialized national identity and canon (conveniently ignoring the African-American presence) which ultimately was policed by a racist immigration policy. The final phase of this policing was the assimilationist (melting pot) policy which entailed the renunciation of one's own subjectivity. The notable official exceptions to this policy, the African-Americans, were considered inassimilable until the 1940s. A specific type of multiculturalism, which Goldberg identifies as conservative multiculturalism, bases itself on a mixture of this assimilationist model and the integrationalist model which replaces it.

It is interesting to note here that the perception of assimilation as the state of affairs within the US from outside the US has attained a mythic status, while within the US it is now almost passé. Nowhere is this more ironically exemplified than in the current state of affairs within Canada – a country with legislation enshrining it as an officially multicultural country.[2] A recent poll in Canada reported in *The Globe and Mail* on 14 December 1993 under the headline 'Canadians want mosaic to melt', stated that 'About 72 per cent of respondents believe that the long-standing image of Canada as a nation of communities, each ethnic and racial group preserving its identity with the help of government policy, must give way to the US style of cultural absorption'. In Canada, the official policy of multiculturalism has increasingly come under attack, most recently in Neil Bissoondath's controversial book, *Selling Illusions: The Cult of Multiculturalism in Canada*. Perhaps the last bastion of assimilationist thinking within the US is to be found in the National Association of Scholars established by the new far right in the academy to safeguard 'real' academic values.

Critical multiculturalism's challenge to the academic canon can

the young Algerian musician, Mohammed, to André Gide. However, it is probable that the sections of this book that will resonate most in contemporary discussions of cultural materialism will not be those devoted to the detailed analysis of texts, but rather the more provocative passages on cultural materialism and its aporias. One awaits the critical responses with interest.

Sheffield Hallam University

Notes

1 Terry Eagleton, 'The Right and the Good: postmodernism and the liberal state', *Textual Practice*, 8:1 (1994), pp. 1–10.
2 Jonathan Goldberg, *Queering the Renaissance* (Durham, NC: Duke University Press, 1994).

Laura Peters

Laura Chrisman and Patrick Williams (eds), *Colonial Discourse and Post-Colonial Theory* (Hemel Hempstead: Harvester Wheatsheaf, 1993), vii + 570 pp., £13.95 (paperback)

David Theo Goldberg (ed.), *Multiculturalism: A Critical Reader* (Oxford: Basil Blackwell, 1994), 340 pp., £14.99 (paperback)

In 'New ethnicities',[1] Stuart Hall remarks that British anti-racism has taken an oppositional stance to multiculturalism, a stance which may now need revisiting in view of David Theo Goldberg's new critical reader, *Multiculturalism*. In a radical introductory essay entitled 'Multicultural conditions' Goldberg seeks to address the polarized components of the debate around various multiculturalisms. The essay counteracts the stereotypical labelling of multiculturalism as a form of political correctness by offering specificities of the forms of multiculturalisms and their inherent political agendas. Ultimately, Goldberg formulates a model of critical multiculturalism which offers a collective political agenda to counteract social inequality and injustice. Multiculturalism, it seems, should be seriously considered as a key player in the transformation of the body politic within the US to an incorporative model.

The contributions in the book, with the exception of Cedric Robinson's 'Ota Benga's flight through Geronimo's eyes: tales of science and multiculturalism', address the necessity for a critical

reality', existing independently of the human mind), then Wilson posits the real in Lacanian terms, as 'that which *resists* symbolic capture' (p. 36; my emphasis). Whereas Marxism is based on a dialectical approach to the relationship between thought and reality, which emphasizes their *unity* as well as their difference, Wilson foregrounds the *'elusive'* nature of the real in its 'heterogeneity' and 'difference' (p. 44). Thus he inclines towards an aesthetic which rejects the mimetic properties of texts and their adequation to the real, in favour of a theory which emphasizes the 'dissidence' of texts and the way in which they transcend 'the fixity of symbolic frames' (p. 37). While Marxism and Cultural Materialism valorize texts in terms of their 'political utility', Wilson celebrates their 'aesthetic surplus value' and the way in which they *exceed* the designs of their creators, even the most politically progressive.

Wilson finds the basis for his aesthetic in a re-reading of Marxian economic categories, as interpreted by Bataille. Returning to *Capital*, Wilson argues that while Marx attempts to distinguish between 'use' and 'exchange' values, the commodity form actually fuses the two, so that use value can only be fully realized in the process of exchange or, to use Bataille's term, 'expenditure'. In fact, Wilson claims rather provocatively that 'genuine use values neither produce nor promise anything' and that 'use value is realized not in production, but in expenditure' (p. 101).

The problem with this formulation is that it falls into the trap of an 'either/or'ism, in which 'use' and 'exchange' become mutually exclusive terms. One accepts the need to move away from utilitarian theories of labour and culture which effectively marginalize the identities of those who are not directly involved in the production process. However, to argue that use value is *only* realized in consumption/expenditure is hardly the basis for an adequate cultural theory or aesthetics. Are we restricted to considering cultural activity exclusively under the sign of the text/consumer relationship? Is artistic creation simply a form of commodity production which can only produce pleasure at the site of expenditure, or does it not also involve forms of cognitive reflection and craft production which have a use value for the artist/producer, as well as the consumer?

Whilst one may quarrel with many of Wilson's formulations and conclusions, there is no question that this is a challenging and penetrating study of cultural theory and its philosophical conundrums. Moreover, Wilson has used his interest in exchange theory as the starting-point for a fascinating exploration of the theme of 'the gift' in a number of key literary 'texts', from the 'archaic' exchange of Portia in *The Merchant of Venice* to Wilde's 'impossible' gift of

category, 'the oppressed', becomes a tyranny, in that the imperatives of the 'ethico-political law' have to be *anticipated*, in a constant process of vigilance and self-disciplining:

> A reading, then, alive to the way ideology functions in texts to smooth over class conflict evident in society at large will necessarily produce a critique alive to its blindness to questions of gender, which will in turn produce a critique that emphasizes race or ethnicity, which might in turn be condemned for complacently assuming, and reinforcing, compulsory heterosexuality, and so on. There are countless examples, both moving away from class and gender, or returning back to them ... For example, in his Introduction to *Queering the Renaissance*, Jonathan Goldberg, the radical gay critic, acknowledges his own need for discipline and stands to be 'corrected [by Dorothy Stephens] for my own blindness in *Endlesse Worke* to female-female sexual possibilities in *The Faerie Queene*' (Goldberg, 1994, p. 3).[2] ... It is indeed endless work all this sexualizing and disciplining, but no doubt enjoyable, nevertheless.
>
> Again, I would like to emphasize that I am not denying very real social prejudices and oppressions, it is just that, like Terry Eagleton, I can see some unfortunate effects, and some significant blindnesses, beyond the next neglected sexualized act, of this institutionalised law of criticism. It is already producing a heavy intellectual and political blockage.
>
> (p. 22).

All this is controversial stuff, not least because of the tone which Wilson adopts in upbraiding his opponents, and no doubt *Cultural Materialism* will provoke strong replies from those who have been on the receiving end of Wilson's barbs. It is not the function of this review to take up cudgels on behalf of figures such as Sinfield and Goldberg, both of whom, I am certain, are quite capable of mounting their own defences. Rather, it might be more productive to move beyond the localized clash of warring parties, to a more 'neutral' ground, and take up some of the broader conceptual issues raised by Wilson's book.

One of the more interesting aspects of *Cultural Materialism* is the attempt to rethink Marxian categories of 'value' and 'the real' in the light of Lacanian psychoanalysis and the relatively neglected work of the French Marxist and Surrealist, Georges Bataille. In so far as Wilson is committed to cultural *materialism*, it is not that of orthodox Marxism. If the latter evaluates human knowledge in terms of its *increasing adequacy* to the 'real world' (defined as 'objective

in aprons' would undoubtedly prevent him from gaining 'top marks' on a course such as the MA in 'Sexual Dissidence and Cultural Change' at Sussex! For Wilson, courses like the Sussex MA challenge Eagleton's 'nostalgic' commitment to an outmoded 'Eng. Lit.' and his restricted concept of opposition to dominant cultural institutions and practices. At the same time, even courses on cultural materialism of the kind associated with Dollimore and Sinfield, which break with the 'authoritarian' traditions of Leavisite and Marxist criticism, have their limitations for Wilson, in that they place both staff and students in a double-bind. Thus, Alan Sinfield's attempt to cast himself as an 'organic gay intellectual' is adjudged to be illusory, since Sinfield cannot ignore his function as 'a voice of the centre' and, hence, the representative of an ideological state apparatus. Sinfield's position as a Professor at Sussex may indicate the strides which cultural material-ism has made in conquering the academic high ground, but it also has its negative side-effects. What were formerly the cultural 'margins' may now occupy the centre, but 'since they have been academically "professionalized" the centralized margins continue to marginalize the non-academic gay voices and voices of colour "out there"' (p. 21).

Whilst the staff teaching courses in cultural materialism are forced into a virtually untenable position so, albeit in a different way, are their students. If the role of the 'careerist gay tutor' is to point to the significant absence of 'the oppressed' from mainstream syllabus, it is the function of the student to fill this 'lack' by his/her presence. However, as Wilson comments, 'living up to the requirements of one's marginality is as impossible as achieving Leavisite maturity' (p. 21). Wilson concludes that the student is loaded with an unbearable intellectual and ethical burden, in that he/she is required to stand in for, and exercise vigilance on behalf of, an 'oppressed' grouping whose boundaries seem to be ever-shifting:

> the problem is ... that an ethico-political law, every bit as unfor-giving as Leavis's morality, now sets the agenda and the limits for thought by setting no limit on the gap that students and future academics must fill. The law sets a limit on thought by making an impossible demand for absolute inclusivity of the oppressed.
>
> (pp. 21–2)

Hence, the 'ethico-political law' is one that constantly adjusts its perspective to include an ever-changing 'series of metonymic shifts' which are always defined in relation to, and in reaction against, 'a general, repressive standard of morality' (the Dead White Male). In effect, the ethical function of acting as the conscience of some general

Wilson embarks on a discussion of culture and materialism in which he compares the Marxist materialism of Terry Eagleton with approaches which have been influenced by poststructuralism and identity politics. Wilson claims that Marxism has tended to respond to Thatcherism and events post 1979 by falling back on 'humanism' and 'Enlightenment categories of truth and value' (p. 17). Although the memory of Lukács is not invoked, and Wilson does not draw any historical parallels with previous periods, this might be seen as an echo of debates in the thirties, when the Popular Front and liberal humanist culture lined up against Fascism and 'decadence'. For Wilson, the difficulty with a reversion to this approach in the nineties is that it tends to set Marxism against natural allies such as Dollimore and Sinfield, whose interest in cultural relativism and 'queer' theory is anathema to 'traditional Marxist puritanism' (p. 18).

Citing a recent article by Eagleton in *Textual Practice* ('The Right and the Good: postmodernism and the liberal state'),[1] Wilson claims that Eagleton is alienated from cultural materialism on two counts. First, he is suspicious of a potentially unbridled relativism in 'the "Culturalist" notion of a subject grounded only on contingent cultural practices'. Such a subject Eagleton ultimately 'dismisses as "a creature of the marketplace" ' (pp. 17–18). Second, Marxists such as Eagleton are supposedly worried by 'the left's movement into areas of political commitment not predicated on a primary class division'. According to Wilson, Eagleton's own anxiety takes the form of a barely concealed homophobia, evidenced in Eagleton's suggestion that ' "the democratic management of the economy" is more valuable and should have civic preference over the freedom to "prance around in a leather apron" ' (p. 18). For Wilson, to make such a comparison is to pander to 'the economics of a "moral majority" that claims that homosexuality is immoral because it is unproductive, unnatural and against the best interests of the heterosexual family (the very site of the *oikos* of economics) – and is that why Eagleton cites a leather apron?':

> This is not an arbitrary comparison. Eagleton's facetious use of the example is a barely veiled attack on the interest taken by cultural materialist and New Historicist writers in alternative or 'dissident' sexual practices, writers theoretically linked with Foucault whose own interest in sado-masochism has received much publicity.
>
> (p 18).

Wilson concludes his skirmish with Eagleton by observing that the latter's 'sneering remarks about leather queens prancing around

self'. Michel is untroubled by difference; his homosexuality is a narcissistic extension of himself which is self-less, and so without psychic content (that is, complexes, repressed conflicts), 'only the chaste promiscuity of a body repeatedly reaching out to find itself beyond itself' (pp. 120–5).

Of Bersani's reading of Genet I've only the space to say that is indeed a fine reading – an attentive and faithfully perverse account of how this writer deploys the dominant terms of his culture not to subvert them but to exploit their potential for erasing cultural relationality itself; a reading especially welcome given that Genet tends to be celebrated in gay culture in terms which suggest that he isn't actually read.

I've devoted this review to exposition, disagreeing hardly at all. This isn't because I concur with everything Bersani says – I don't – but because I regard this as one of the most insightful and demanding books on gay culture and gay theory to appear in a long time and, as such, deserving of careful attention. Other reviews have in my view misrepresented it. This is understandable in that, though lucid, *Homos* is concentrated and consistently challenging, and, as such, the kind of book which inspires resistance before assent. As for the thought police, expect them to repudiate it before taking over some at least of its arguments as their own.

University of Sussex

Chris Pawling

Scott Wilson, *Cultural Materialism: Theory and Practice* (Oxford: Basil Blackwell, 1995), 278 pp., £45.00 (hardback), £13.99 (paperback)

The title of this book may be somewhat misleading to students of cultural studies, since it seems to promise a wide-ranging discussion of cultural theory and its application to a variety of cultural practices. In fact, the illustration on the cover is more indicative of the actual content, showing Shylock from *The Merchant of Venice* and signifying that this is a work of cultural theory whose reference point is primarily literary studies. Although Wilson enters into debate with 'representative' figures in cultural studies, such as Raymond Williams and Dick Hebdige in the first and last chapters, the most interesting and provocative section of his book is devoted to a survey and critique of recent developments in literary theory – viz. Marxism, New Historicism and the Cultural Materialism of critics such as Alan Sinfield and Jonathan Dollimore.

Homophobia might be seen as a refusal of this desire for renunciation, especially if we follow Bersani in regarding homophobia as originating in 'the vicious expression of a more or less hidden fantasy of males participating, principally through anal sex, in what is presumed to be the terrifying phenomenon of female sexuality' (p. 78). And whereas women are probably perceived as being too different from men to hold out the prospect of a man becoming a woman, in gay men the straight man more easily recognizes the otherness in himself: 'in his curious conviction that thousands of heterosexuals could easily be converted to the homosexual cause, the homophobic male must be "remembering" a lost jouissance (that is, female sexuality as a male body has in fantasy experienced it)' (p. 28).

If, for some gay theorists, this kind of perception leads to what Bersani elsewhere calls a climate of self-congratulation which pits the superior queer against the vicious heterosexist community, he, by contrast, wants to trace a theory of love not based on assertions of how gays are different and better, but grounded in the 'very contradictions, impossibilities, and antagonisms brought to light by any serious genealogy of desire' (p. 108).

Homos takes the idea of self-shattering further than before, particularly in the notion that in sexual pleasure that is '*a non-suicidal disappearance of the subject*' which entails a masochism dissociated from the death drive. Partly because masochistic jouissance involves a self-shattering that, although the result of a surrender to the master, 'also makes the subject unfindable as an object of discipline' (p. 99); and partly because in the annihilation of the ego, the disruption of its coherence, there also occurs a dissolution of its boundaries (p. 101) which leads to the extension of the ego; a radical unbinding of the self is also an extension of the self into a tentative notion of community based on in-difference.

In the last chapter of the book, 'The gay outlaw', are some remarkable readings of Gide, Proust and Genet, taking aspects of their work which have been most recalcitrant into a very different kind of erotics. Thus in a discussion of Gide and of Michel, the central figure of Gide's *Immoralist*, Bersani discerns a sexual attraction without sex – a homosexuality without sexuality – a fastidious sexuality which is both less and more than a 'sexual preference' and the more threatening because 'it elimates from "sex" *the necessity of any relation whatsoever*'. Michel's eroticism is uncontaminated by a psychology of desire – 'by which I mean that it is unaccompanied by an essentially doomed and generally anguished interrogation of the other's desires'; its very emptiness constitutes a challenge to a sexual ideology of profundity. This is a sexuality without the 'deep

homo-ness can be found '*anti*communitarian impulses' which resist the oppressive psychology of desire as lack. And if identity is built upon lack, homo-ness suggests that lack may not be inherent in desire (pp. 7, 53, 141, 149). Homosexual desire

> has, as its condition of possibility, an indeterminate identity. Homosexual desire is desire for the same from the perspective of a self already identified as different from itself. . . . My argument is not that homosexuals are better than heterosexuals. Instead, it is to suggest that same-sex desire, while it excludes the other sex as its object, presupposes a desiring subject for whom the antagonism between the different and the same no longer exists.
>
> (p. 59)

Homosexual desire is the desire to repeat, to expand, to intensify the same. And, he speculates,

> The desire in others of what we already are is . . . a self-effacing narcissism, a narcissism constitutive of community in that it tolerates psychological difference because of its very indifference to psychological difference. *This* narcissistic subject seeks a self-replicating reflection in which s/he is neither known nor not known; here individual selves are points along a transversal network of being in which otherness is tolerated as the nonthreatening margin of, or supplement to, a seductive sameness.
>
> (p. 150)

In short, '*homo-ness itself necessitates a massive redefining of relationality*', connected with the fact that 'perhaps inherent in gay desire' is a 'potentially revolutionary inaptitude . . . for sociality as it is known'. It is this which makes homosexuality truly disruptive (p. 76, his italics).

Some of the arguments in *Homos* are developments from Bersani's earlier writing, especially the idea of desire as a self-shattering which is 'intrinsic to the homo-ness in homosexuality. Homo-ness is an anti-identitarian identity' (p. 101). Via Freud, Bersani discerns in the human psyche 'a certain rhythm of mastery and surrender'; we seek to master our environment, survival requiring a degree of 'invasive intent', but we also seek a pleasurable renunciation of mastery:

> Perhaps inherent in the very exercise of power is the temptation of its renunciation – as if the excitement of a hyperbolic self-assertion, of an unthwarted mastery over the world and, more precisely, brutalization of the other, were inseparable from an impulse of self-dissolution.
>
> (p. 96)

a radical or at least a subversive sexual politics, for Bersani it has potentially conservative consequences. Gays like to think they are subverting the dominant heterosexist culture, whereas in fact they are melting into it and in some cases actually complicit with homophobic oppression: unwittingly we are complicit with the fundamental homophobic aim of eliminating gays. And this is desperately intensified in the context of AIDS, one of the consequences of which is that it feeds the wish of 'straight America' that homosexuals be a doomed species. Hence the paradox of a certain kind of gay affirmation: the very politics of making ourselves felt in fact makes us disappear (pp. 2–4, 21, 32).

Bersani wants to focus on what is specific about homosexual desire and regards this move as a condition for being gay-affirmative and politically radical. But this specificity is inseparable from a consideration of fantasy and a recognition that interiority is 'a breeding ground not only for essences but also for a mobility incompatible with all essentializing definitions' (p. 12). Further, since desire always involves a history of the subject's identifications, the desire to have is never entirely distinct from the desire to be. And this means that the political radicalism of homosexual desire is not won easily. There can, for example, be a continuity between a male homosexual's preference 'for rough and uniformed trade, a sentimentalizing of the armed forces, and right wing politics'. And in his desires the gay man always runs the risk of identifying with culturally dominant images of misogynist maleness (pp. 63–4).

Such considerations make Bersani sceptical of the obsession with difference, or what he calls the 'religion of diversity'. Certainly, for many, it has become the redemptive slogan. But for Bersani, difference, especially hetero/sexual difference, is rooted in trauma, lack, antagonism, and 'a hopeless dream of eliminating difference entirely', which conceals the often violent desire actually to annihilate the other (pp. 39–40, 146). All desire involves exclusion – 'I have always been fascinated – at times terrified – by the ruthlessly exclusionary nature of sexual desire' (p. 107).

Bersani wants to devalorize difference and to show how, in homosexual desire, it is not a trauma to be overcome but 'a nonthreatening supplement to sameness'. This renders homo-ness so politically disruptive that it involves 'a redefinition of sociality so radical that it may appear to require a provisional withdrawal from relationality itself'. The homosexual's desire for the same rather than the different, far from being a limitation, is something of inestimable value. But this is not what might be expected – solidarity between homosexuals on the basis of a shared community – but almost the reverse: in

runs with both positions, the subversive and the reformist, alternating between them, or conflating them.

Bersani has always been closer to the subversive perspective. He dislikes the 'rage for respectability' which he finds in gay culture (p. 113). Yet we shouldn't forget that the subversive perspective has a certain intellectual not to say political respectability of its own, trying as it does to decipher the socially obscured truth of sexuality, and often (certainly not always, and probably decreasingly) finding it compatible with a radical politics. What is particularly interesting about his argument is that he finds the process of degaying in not only the integrationist camp but the subversive one as well, not least the most recent claims for queer disruptiveness, e.g. sado-masochism and radical drag. He is critical of Judith Butler's claims for parody and drag. Bersani regards parody, especially the parody of drag, as complicit with what it pretends to subvert. This is his interpretation of the film *Paris is Burning* in which the down and out drag queens perform nothing more subversive than their own submission. Parodistic displays contain elements of longing and veneration which the current theories of parody consistently underplay and disavow in order to arrive at a comforting politics of disruption (pp. 48–9).

Bersani is also critical of the hold of social construction theory in gay studies. Here a self-proclaimed radicalism resurrects an old-fashioned liberalism (pp. 72–3). Worse, gay men and women are making themselves disappear in their sophisticated awareness of how they have been constructed as such – a move which, for Bersani, can only assist and not undermine homophobia. They would rather talk about the homophobic construction of homosexual desire within and by the dominant culture, than about that desire itself. Or, when talking of the latter, they would prefer to dissolve it into an agency of disruption which is itself always absent (e.g. the anti-essentialist queer strategy of refusing to be identified, of saying we're everywhere and nowhere at once).

The problem with this account, as with the current preoccupation with parody, is that gay desire always figures in relation to heterosexuality – so much so that it might be said that gays have an antagonistic desire for the latter (reading Butler's *Gender Trouble*, one sometimes gets the sense that gay desire isn't complete unless it's somehow subversively inside heterosexuality). And then of course there's the figuring of gay desire as the deconstructive agency *par excellence*; as Lee Edelman puts it: 'the signifier "gay" comes to name the unknowability of sexuality as such, the unknowability that *is* sexuality as such'.

And although this self-erasure is often pursued in the name of

persuaded, seduced, corrected; and in others resent it deeply? Initially this seemed too fanciful to mention but then I came across Bersani's own response to a remark of Michel Foucault's about two mindlessly happy gay men he saw in the street; Foucault says: 'there is no anxiety, there is no fantasy behind happiness'. Bersani says of this remark that, though it is at odds with 'nearly everything I have ever thought or written about sexuality', he finds it 'appealing, nearly irresistible' (p. 79). I too find it appealing, but rather more easily resistible than some of Bersani's own ideas, reminding me as it does of an old French proverb: 'Happy people have no history'. The idea of a gay person, happy or otherwise, without a history is almost a contradiction in terms.

Bersani is well aware of that and, both directly and indirectly, as one would expect of someone who engages critically with the history of psychoanalysis, history is the subject of this book. He writes persuasively about how gay men and lesbians are so preoccupied with one kind of history – the historical construction of the homosexual – that they are paradoxically making themselves disappear. He calls it 'degaying'. This points to a real conflict in lesbian and gay studies, one which has been there from the beginning but which is now more acute than ever. On the one hand there's a strong desire to represent queers and dykes as disturbing, disruptive, anarchic, ludic, and, as such, incapable of assimilation in the present order of things. Here is the militant, radical, subversive difference of queer desire, especially when seeking deliberately to pervert sexual difference. On this view the challenge of homosexuality can never be accommodated, either by the existing heterosexist culture or, indeed, by positive or normalising self-representations *inside* gay culture. Queer theory has been in the vanguard of this approach.

On the other hand, we also adopt a more reformist approach, insisting on the sanity of homosexual identity, and becoming indignant at every demonizing representation of it, especially those emanating from the moral right; we deem such representations to be absurd, and are likely to dismiss them as the product of a paranoid, irrational, homophobic imaginary, the implication being that in a more enlightened, non-homophobic culture, homosexuality would be accepted. Critics of this reformist position suggest that by accepting it lesbian and gay studies has inherited one of the most conservative political tendencies of western culture – namely that, in order to defend the different it has first to be censored, sanitized and made respectable. In fact, and much as it might like to, academic queer theory can't entirely dispense with the reformist position. Typically it

Jonathan Dollimore

Leo Bersani, *Homos* (Cambridge, Mass.: Harvard University Press, 1995),
208 pp., £15.95 (hardback)

If there is a lack of self-criticism in the lesbian and gay community,
says Leo Bersani, it's 'partly out of fear of the academic thought
police (any criticism of lesbian and gay self-promotion is condemned
as homophobic)' and partly because such criticism is felt to betray
the cause and give ammunition to the enemy. But:

> we have enough freedom, even enough power, to stop feeling like
> traitors if we cease to betray our intelligence for the sake of the
> cause, and if . . . we admit to having told a few lies about ourselves
> (and others).

<div align="right">(p. 53)</div>

I've always admired Bersani, not least for the way he's prepared to
take on the gay thought police, and also some no less censorious
feminists, lesbian and otherwise. He mentions in passing speaking at
a lesbian and gay conference about gay men's love of the cock, only
to be reproached by a lesbian colleague for having given a talk which
'marginalized women'. I've no idea which conference this was, but I
suspect we've all been there: that most radical of occasions which is
at heart so conformist that the speakers tell the audience what it
wants to hear in the desperate hope of becoming its good objects, or
at least avoiding just this kind of reproach. Not so Bersani.

(The complainant at this conference recalls those who have been
so resentful that Eve Kosofsky Sedgwick hasn't spent as much time
talking about lesbians as about gay men, sometimes with the impli-
cation that this is a deeply damaging, even conspiratorial, exclusion.
In practice, the reverse is the case: the very success of Sedgwick's
project actually helps create a space for someone else to do what she
hasn't; her omissions became others' opportunities.)

Homos takes issues with the comfortable and sometimes spurious
radicalism that some (mostly US-based) gay academics currently
propagate. Bersani is critical of, on the one side, the gay ghetto, on
the other those gay men who beg to be instructed by those who are
demonstrably more oppressed, who even 'apologise for not being a
woman'.

This is a seductive book. So much so that in places it seems to
partake of an erotics of persuasion. Or, to put this as a question:
why in some intellectual encounters do we derive pleasure from being

aim is polemic, addressing the present with some intention of altering it' (p. 155). Through a reading of two satirical articles by Richard Littlejohn in the *Sun* on the Charles–Diana farrago and by Andrew Rawnsley in *The Guardian* on the State Opening of Parliament Easthope notes that, 'I participate in a national culture to the extent that I identify myself as a subject of the national narrative' (p. 151). Despite the interminable contestation of that narrative – one of Easthope's examples is Charter 88's campaign for constitutional rights ('the present English struggle for modernisation') – 'Englishness, like ideology, works behind your back, writing you when you think you are speaking in your own voice' (p. 156). Easthope's example manages to demonstrate his point. The chair of Charter 88 is a Scotswoman, Helena Kennedy.

However, the essay identifies the crucial aporia upon which the collection and the whole discourse it is part of rests: 'to be human means you have to have a group identity but how can we be inside our group except by denigrating outsiders?' (p. 156). In other words, how can identity be defined without frontiers? Exclusion is the fundamental premise of an inter-subjectivity. Clare Hanson's essay offers the reader some relief: she quotes Kristeva, 'Freud does not speak of foreigners: he teaches us how to detect foreignness in ourselves. That is perhaps the only way not to hound it outside of us' (p. 62). The unalterable and positive Otherness which fragments the subject reminds us that the alien can be neither integrated nor hunted to exclusion, but rather that it shares in the 'uncanny strangeness, which is as much theirs as it is ours' (p. 63). Nationality then is part of a larger set of questions related to identity as it is determined by gender, race, sexuality, and class. This allows Easthope to advocate Englishness as an effect of these sites of power, which is good news: 'for if Englishness is an effect it can be changed' (p. 156).

University of Glasgow

Notes

1 Edward Said, *Culture and Imperialism* (London: Chatto & Windus, 1993), pp. 395–6.
2 Jacques Derrida, 'The deconstruction of actuality: an interview with Jacques Derrida', *Radical Philosophy*, 68 (1994), p. 36.

Herron's powerful discussion of the Ciaran Carson poem 'Campaign' in 'Fields for the faction fights: poetry, icons, nationalisms'.

The collection has its own frontiers. It is framed by two important essays: opening with Gerry Smyth's 'Writing about writing and national identity' and concluding with Antony Easthope's 'Writing and English national identity'. Smyth explores the relation between ways of understanding cultural texts and the specific geographic spaces these texts emerge from. His essay convincingly argues that questions of writing and national identity, in terms of Irish cultural history (although the line of inquiry could be justifiably extended to include other national debates), 'can only have significance when framed by a metadiscourse which purports to comment on, but actually constructs, the "original" or "primary" discourse' (p. 8). This is the self-referential problematic the collection sets itself: is its object of study a construction of its own discursive practice? Postcolonialism faces the same accusation as postmodernism, that it arises from and only has meaning inside the academic institution. Smyth writes, 'there could be no national literature of resistance until a prefiguring critical discourse created a series of social and institutional spaces in which such a literature and its particular effects could function and have meaning' (p. 9). It is a curious condition of the book that the material it describes multiplies in direct proportion to the volume of research related to it. Perhaps, as Smyth suggests, critical discourse creates a cultural phenomenon through the discussion of an event which becomes a staging of text. Paradigms, schools, and 'national literatures' are not the product of novelists and poets but of those equally important cultural producers, the literary critics. The postcolonial discourse which this collection is part of and extends not only determines the values by which the texts it scrutinises are judged but it also creates the conditions in which contemporary writing takes on significance.

Having placed themselves within this importantly ambiguous context (both self-defeating and self-legitimizing) the arguments of the sixteen essays combine to provide evidence of the viability and necessity of the discourse they constitute. They repeatedly demonstrate the relevance both of the task of distinguishing and analysing national identity and of the importance of writing to the political discussion. Antony Easthope concludes the volume by attempting to discern reasons for the continued study of national identity even though it may be inhabited (or inhibited) by this self-reproducing problematic. His essay is an attempt to make that most difficult of steps, one which poststructuralism has so often stumbled on in the past, from a critical discourse to a participatory politics: 'in part my

once termed 'narratologists' into the hands of critics versed in this postcolonial theory. Hanson, following Bhabha and Fanon, notes that the questioning of narratives of national identity highlights the metaphysical rather than the essential nature of nation by making visible the imaginary 'disposition of space and time which supports the discursive construction of national identity' (p. 55). History itself then becomes the subject of a rigorous critique. These essays suggest that the international leanings of contemporary feminism subvert the seemingly inevitable retreat behind national boundaries implied by the recent revendication (to use Brecht's term for the recharging of set ideological material with new energy) and success of nationalism. They are a timely reminder for the reader of the link between masculinity and the construction of national identity which excludes not only the foreigner but also the feminine. Feminism would still seem confident enough in its project to give hope to an internationalist leftism which not only recognized 'communities within communities' but also 'communities that transcend nationality or proclaim themselves beyond its limitations' (p. 4).

Modernity and its inevitable re-examination in postmodernity similarly offers an effective complication of national identity through the oppositional stance of the cosmopolitan from modernity's *flâneur* to the postmodern *bricoleur*. The double-bind comes with the realization that this form of internationalism is a consequence not of international leftism but the globalization of capitalism. The opposition is effective, however, because any form of nationalism is fundamentally exclusive and binary and as such begins to crack under the strain of postmodern fragmentation, as Tracy Brain hints in her essay on the transatlantic Sylvia Plath 'These hills are too green'. That characteristically postmodern crisis of ontology (what Dominic Williams in 'Maxine Hong Kingston: "the one with the tongue cut loose"' calls 'hyphenated identity', such as Indo-Caribbean or Afro-American) subverts binarism and begins to dilute its effects of power. Perhaps, the most prominent example of this is the book's tangential object of study, the United Kingdom, which problematically combines four nationalities with a precarious British identity. This Union also represents national identity as the product of an historical process, a continued reworking and rewriting of the boundaries and constraints of nationality. The topic is explored in Willy Maley's witty comparison of the Scottish humanist intellectual John Major's ('Major Major') 1521 *History of Greater Britain* and the other John Major's ('Major Minor') 1992 electoral pamphlet *Scotland in the United Kingdom*. Maley's Scottish-Britishness can be contrasted to the perhaps even more problematic Irish-Britishness explored in Tom

'antisyzygy'. Current conflicts would seem to be the result of the disputation of definitions in which nostalgic concepts of the nation (which declare the political sovereignty of an independent and self-governing state to rest with 'the people' and to be identified with the national culture) compete for ascendancy within the one pre-existing geographic space. This discursive approach by the contributors attempts to demonstrate the irreducible aporetic status of national identity and successfully dissuades the reader from the left-liberal prejudice 'that nationalism is (to put it crudely) a hegemonic deception organized by the ruling class in order to mask its own power' (p. 147), to quote Easthope. A reading of national identity intelligently explored in Richard Kerridge's 'Class masquerades as nation: recent films: Don DeLillo; Martin Amis'.

However, the collection treats its object of inquiry as a cultural phenomenon with all the resultant undecidability that implies, stressing the fictional and textual dimensions of both nation and identity: national narrative, figurative stratagems of ideology, the metaphoric displacements of discourses. The forms of writing implicated in the construction of this cultural context are, according to the editors, 'often characterised by a sense of loss and uncertainty' (p. 1). Writing as the 'expressions of perceived national differences' (p. 4) pulls against the binarism of nationalist definition. A dynamic which questions the relation between history and writing, which 'cannot simply be reduced to text and background' (p. 4). 'Writing' takes on the broadest of definitions, from Kerridge's discussion of *Four Weddings and a Funeral* and Simon Barker's entertaining reading of Andrew Davies's interpretation of Michael Dobbs's *To Play The King* in ' "Between their titles and low name": Shakespeare, nation and the contemporary Roi Faineant', to Vujakovic's essay on the recently published *Concise Atlas of the Republic of Croatia* and Nicola King's searching investigation of Robert Harris's *Fatherland* in ' "We come after": post-Holocaust national identity in recent popular fiction'. This flexible context allows the contributors to scrutinize post-colonialism as the 'associated upheaval in the perceptions of nationhood emanating from both former colony and former coloniser' (p. 5). While the appropriateness of the blanket application of terms of national identity is complicated by an investigation of the relation between nationalism and feminism, by both Gail Low's 'The dis/embodiment of culture: the migrant in V. S. Naipaul and Bharati Mukherjee' and the thoughtful Clare Hanson whose erudite essay, ' "As a woman I have no country": Woolf and the construction of national identity' confirms the suspicion that the responsibility for the cutting edge of narrative theory has moved from what were

to the persecution of the Kurds. The re-emergence of nationalism as an alternative political narrative has forced writers and scholars to re-examine its viability and content. The national space and national identity are back on the critical agenda in a discussion which is an investigation and setting of new boundaries on what was previously thought to be a redundant problem. Jacques Derrida has called for 'a courageous thematisation and formalisation of this terrible combinatory, as an essential preliminary not only to a different politics, but to a different theory of politics, and a different delimination of the *socius*, especially in relation to citizenship and State-nationhood in general, and more broadly to identity and subjectivity as well'.[2]

This handsome and impressive volume is an attempt to grapple with the relationship between writing and national identity. An understanding of national spaces depends upon the concept of the frontier, but the text is also a fine example of an institution's commitment to the dissemination of a research culture. This collection of essays began life as the proceedings of the 'Writing and National Identity' conference at Bath College of Higher Education in July 1994. Conference proceedings are notoriously slippery volumes, with contributions often speaking against rather than to one another. It is to the credit of the editors that the essays in this volume represent a counter-pointing of dialogue and debate which produces a coherent line of inquiry. The book is informed by three of its eponymous components: nation, identity, and writing. Including essays on Spenser, Shakespeare, Virginia Woolf, Ford Madox Ford, and Sylvia Plath 'contemporary' may be an understandably moot point. The collection is characteristically conference material, being both heterogeneous in content and pressing the limits of knowledge. The cogency of the contributions allows the authors to be both rigorously concise and imaginatively suggestive.

The juxtaposition of essays illuminates exciting areas of discussion, primarily the suggestion that the current experience of 'new nationalisms' is postmodernity's reworking of the trace of Nationalism, which Antony Easthope calls 'the mode of collective identity emerging with modernity' (p. 147). This contemporary redefining of national identity occurs in a similarly exclusive and binary form, in which the demarcation of geographic space is frequently determined by ethnicity and race, as discussed in Peter Vujakovic's insightful 'The Sleeping Beauty complex: maps as text in the construction of national identity'. An all too familiar means of identification re-emerges under the guise of postmodern fragmentation, a fragmentation which Tim Middleton, quoting Gregory Smith in his essay 'Constructing the contemporary self: the works of Iain Banks', calls

it remains difficult, without the benefit of local evidence, to imagine empirical pragmatists such as Vesalius and Harvey, ever hearing that terrible cry.

All the same the myth of Marsyas literally functions as a precursor to *The Body Emblazoned*. Centrally positioned on the front jacket beneath the title, Rembrandt's *The Slaughtered Ox* graphically signals the workings of metaphor and myth as being the book's main concerns. This, paradoxically, as when Sawday discusses Rembrandt and Descartes – both were fascinated by butchers' shops – discloses the historicality of the project. Sawday leads us on a tour of the various personae that the dissected body contrived to assume in early modernity as if along a gallery hung with anatomical plates. So, as '. . . we visit the anatomy theatres of early-modern Europe . . .' (p. ix) we pass from 'The Body in the Theatre of Desire' to 'Execution, Anatomy, and Infamy' and then finally to the relatively sanitized realm of 'Royal Science' in Britain. On the way – and the narrowing of geography is not insignificant – stunning anatomical images and illustrations provide a lavish feast for the eyes. The tour is supported by fine printing and binding, and coffee-table dimensions as a tome. Amid the luxuriousness the work is ever learned, with many compelling nuances of discourse elegantly highlighted. Like the dissected body that it deals with, *The Body Emblazoned* is seductive and appealing, an indispensable guide: albeit one more charmed by the workings of power and myth than with viewing them with a 'cautious detachment' (Benjamin).

Buckinghamshire College

Martin McQuillan

Tracey Hill and William Hughes (eds), *Contemporary Writing and National Identity* (Bath: Sulis Press, 1995), vii + 168pp., £13.95 (paperback)

Edward Said called the 1980s 'the decade of mass uprisings outside the western metropolis. Iran, the Philippines, Argentina, Korea, Pakistan, Algeria, China, South America, virtually all of Eastern Europe, the Israeli occupied territories of Palestine'.[1] In the 1990s this postcolonial moment has been transformed and, in contrast to the integration promised by a New World Order and European Union, nationalism is back on the political agenda: Quebec, Ireland, Scotland, virtually all of Eastern Europe. Far from being the much anticipated decade of inclusion this spectre of nationalism has seemingly dominated every form of political discourse from the French Presidential election

and male self-regard. In this sense, the myth – about the repression of female desire – functions (powerfully) as a universal for Sawday, a kind of template against which different texts are to be read. Inevitably here, in the process, *different* cultures of dissection become telescoped into a common denominator, distinguished not by change and transformation, but by a continuity guaranteed through an undisturbed mythology of a single, patrician culture. Indeed, Sawday believes that the 'Medusa will survive' the end of a still-with-us 'culture of dissection' (p. 270). While the readings of 'Sacred' anatomical images are particularly illuminating, especially those of Vesalius and Estienne, by the time of Donne and Burton correspondences drawn between their metaphorics and the work of Harvey and his scientific contemporaries remain unconvincing: though in related fields of discourse and frequently deploying body metaphors, they are finally dealing with different kinds of anatomies and with different bodies, and not with the same presumably given realities. Needless to say, for the to-be-dissected – the condemned felon – the Anatomy Theatre was a non-eloquent and terrifying expression of power: before its doors understanding would have surpassed all language.

The overtly political (and scientific) history of the dissected body is not the burden of *The Body Emblazoned*, though some attention is given to the body as a spectacle of punishment and a medium for education and edification – important components of post-Foucauldian studies of the body. Sawday remains concerned with a far more diffuse, literary-orientated culture. Here his other *authentic* point of origin is the flaying of Marsyas in Ovid's *Metamorphoses*, and the satyr's terrible cry: 'Who is it that tears me from myself?' The ecstatic agony of Marsyas speaks of the profound unease that accompanied man's gaze within his own interior – a sense of being estranged from a part of himself, a feeling that his sense of identity, of an indivisible self, had been permanently fractured and undermined. Anatomy apparently was the occasion and the expression of what Sawday calls the 'alienity' of the 'Renaissance subject', the terrifying, painful and occasionally comic spectacle of the dismembered human form; an aspect of what he calls the 'Uncanny Body', a phrase derived from Freud's notion of the *unheimlich*. The idea that the body, so completely and intimately *ours* is, in certain contexts, profoundly alien and inexplicable, is highly suggestive – as it appeared to have been for Donne and other writers. The flaying image is arguably convincing too and consistently applicable to certain aspects of early modern anatomy, and Sawday provides some rich illustrations of them. Credulous referencing to the timeless realms of the mythical and the cultural, however, drains away confidence in particular claims:

a wider sense of the possible. If there is a lesson to be learned from the diverse voices which make up the volume then perhaps it is this: to make these revisits also means to remain precariously in the critical balance, conversing between realist and aesthetic or representational extremes, between the body conceived as a material presence, an open book requiring only the appropriate tools to be explored and read, and the body as a fluctuating fiction and hermeneutic text, that can be continually deconstructed, rewritten and refurbished anew.

William Harvey liked a good meal. As Jonathan Sawday points out in *The Body Emblazoned: Dissection and the Human Body in Renaissance Culture*, the seventeenth-century anatomist could recommend 'the divine banquet of the brain'. This, together with the ritualized circumstances of the public anatomy that Harvey would lead – dissection halted midway for a sumptuous feast – signals not just a healthy appetite for the job in hand but, as Sawday notes, 'the 'anthropophagistic tendency of Renaissance anatomy' (p. 132). That a cultural formation in which the body was self-consciously explored, cut up and rearranged could provoke such a response from Harvey is unsurprising given its genealogy. Since before the Greeks particular mythical, philosophical and religious expressions of cannibalistic desire would provide for a wardrobe of taboos, symbols, and signs that would leave a profound imprint on both the body and on the development and nature of anatomy as a discourse, particularly in the epistemic and stylistic passage from 'Sacred Anatomy', as Sawday calls it, to its more secular form in the more severely mercantilist seventeenth century. It is between these two temporal poles of cultural formation, from dissection seen as akin to a parodic sacrament to the venture empiricism represented by the Royal Society, that Sawday locates his impressively imaginative study of 'a culture of dissection'.

The Body Emblazoned is an impressive work inasmuch as Sawday synthesizes a large amount of detailed material ranging from anatomical handbooks and their illustrative plates to *The Faerie Queene* and Donne's elegies to treatises by Bacon and Descartes. It is also an imaginative work in so far as the myth of Perseus and Medusa – a male protagonist confronting a female opponent and rendering her powerless by dismembering her and dispersing her body parts – for Sawday serves as an eloquent metaphor for anatomy as an expression of power. The myth surfaces repeatedly through the text as Sawday applies it to dissection as a whole – across centuries, across countries, across all traditions of dissection – and to a specific genre of literary dissection: the courtly 'blazoning', or enumerating, of a woman's exquisite body parts with a mixture of fetishistic rapture

In this respect, Dipiero finds that the victim's body serves as a novelistic medium for the inscription of a politics and poetics of social identity which by marking the limits of representation begins to textualize *real* pain and violence.

This sense of language as being involved in a perpetual wager to avoid mortality also suggests the impossibility of a neat break from the murmur, echoes and voices of previous idioms and dialogues. Elizabeth Heckendorn Cook's 'The limping woman and the public sphere' initially focuses on the cross-historical metaphorics of the body. Following Foucault, she traces significant transpositions between despotic cultures analogically organized around the king's body and later Enlightenment concepts of the civic state, of a Republic of Letters, and of the individual writing subject. In reading Montesquieu's *Lettres persanes*, Heckendorn Cook goes on to argue that these transpositions provide the basis for conceiving a new relationship between author, text, and the reading public while re-endorsing a pre-Enlightenment, 'masculine ideal of a republican citizen' (p. 12). Here, along with problematic figures of lack (eunuchs, slaves, veiled wives, and the impotent despot), the figure of the limping woman (introduced in the novelistic frame of the *Lettres persanes*) comes to mark both the limits and necessity of body metaphors inasmuch as Montesquieu's visions of civic identity and of the writing subject can emerge only through such a series of textual negations and negotiations.

There is much else to recommend in the volume. Peter de Bolla's 'The charm'd eye' (on landscaped gardens) and Veronica Kelly's 'Locke's eye, Swift's spectacles' (on biographical writing) both investigate the cultural production of looking and cultural manifestations of visuality. Equally sophisticated in argument are David Wellbery's 'Morphisms of the phantasmatic body: Goethe's *The Sorrows of Young Werther*' which explores the textual production of a 'body that has neither definite shape or contours but is accessed or projected through the metamorphoses of desire and anxiety' (p. 17), and Helmut Schneider's 'Deconstruction of the hermeneutical body' which engagingly undermines such a preconceived body both by exposing its limitations and by proposing alternative models of corporeality.

Body and Text in the Eighteenth Century is a welcome addition to the field and represents a vigorous response to the stultifying historicism which for so long has dominated eighteenth-century research on the body. Contrary to the direction of much of that work one is forced to come to terms with the past, to revisit it, to live in its ruins and there in the gaps, openings and fragments to grasp

contemporary organizations of the field of vision, of seeing and reading, while decoding representations of the body (mis)appropriately perceived. Tassie Gwilliam's 'Cosmetic poetics: coloring faces in the eighteenth century' discusses how a dominant concept of the body – natural, moral, masculine, colonial – is challenged by the very production for women of cosmetics designed to visually re-legitimate both an ordered, patriarchal sense of the body and to 'domesticate and defuse' (p. 158) questions of female sexuality and representation. In her readings of Antoine Le Camus's oriental tale *Abdeker: Or the Art of Preserving Beauty* and Samuel Jackson Pratt's play *The New Cosmetic, or the Triumph of Beauty, A Comedy*, Gwilliam finds that instead of re-fortifying gender and racial differences cosmetics finally serve to display dominant cultural anxieties concerning femininity, race and representation.

Deirdre Lynch's 'Overloaded portraits: the excesses of character and countenance' explores similar issues of representation, surface and depth, image and self. Reading Locke's *Essay Concerning Human Understanding* alongside treatises by Hogarth and accounts of Garrick's theatrical style, she argues that the face in eighteenth-century debates over art, culture and knowledge serves to mark the point at which culturally legitimate modes of representing personhood shade into illegitimate or popular modes. In particular, she finds that the overloaded face – excessively marked, deformed or caricatured – rather than realistically fleshing out a character works to render 'insensible more or less' (Sterne) a coherent and legitimate identity. Against the grain of eighteenth-century aesthetic theory, what these developments foreshadow, Lynch suggests, is both the psychological complexity of the novel together with a multiplicity of available, if finally undecipherable, personal identities.

Thomas Dipiero's 'Disfiguring the Victim's Body in Sade's *Justine*' extends into a more radical sense notions of excessiveness and deformation. In situating *Justine* in the context of an eighteenth-century poetics of *vraisemblance*, Dipiero argues that the novel generates a political aesthetic at odds with that particular idealistic and moral context: the heroine 'Justine occupies a paradoxical position as both the object of libertine violence and as the narrating subject of that violence' (p. 249). Justine's remarkable powers of bodily regeneration after repeated abuse attest not to the mastery of libertine violence but to ongoing resistance: repeated attempts at annihilation may re-mark her body but as a body *narrating* Justine persistently articulates the avoidance of death. At the same time the continued abuse signals the potential both for the destruction of the subject and an accompanying desire for verisimilitude, for the end of meaning.

read the complex particularities of eighteenth-century culture against the larger paradigms that distinguish the production of meaning in that period from its production in our own' (p. 11). What distinguishes this volume of essays is precisely this twinfold insistence on both the otherness of the eighteenth century as an 'aspect of the current encounter between the body and its histories (p. 2), and of the material embeddedness of the body in both language and the cultural production of meaning. Of that encounter Kelly and von Mücke further write:

> The body provides the 'raw material' in the ordering, cathecting, and processing of sensory data, drives, and affects into symbolic systems, but it can also serve as a medium for the transmission of information. Finally, the body becomes a privileged model or model object for the definition and organisation of such semiotic events as the distinctions between sign and symptom, textual whole and fragment, surface and depth, natural and conventional or artificial, literal, figural, real and imagined.
>
> (p. 9)

Here we find ourselves dealing less with the referential premises of a field of analysis (in particular, of certain Marxist and historicist propositions) and more with its languages of gestation, with its languages of becoming. It is in this sense that our understanding of the body remains a political issue for language, and while representing an insuperable limit in our description of the body, simultaneously involves our in-scription. What changes across time are the techniques of understanding in which the languages of representations are themselves foregrounded, and where what is meant by the *body* remains an open question: there are never any fixed images, no final text, no one body. As Kelly and von Mücke put it, '. . . attention to the body and its representations is perennial because fundamental cultural activities are informed by specific versions of the body' (p. 1). It is upon this perpetual and shifting dialogue between the body considered as an essence of *reality*, and the body perceived as a social construction that the intellectual wager of the volume resides.

The twelve essays that comprise the volume are organized into four sections, the series as a whole adhering to a rough chronological order: 'Discursive shifts and realignments'; 'Technologies of seeing'; 'The limits of the body'; and 'Unnatural bodies'. As Kelly and von Mücke explain, this arrangement is to accentuate a focus on the 'body's place and function within eighteenth-century semiotic networks' and its historical development into 'a model object' of visuality. Two of the essays in the second section specifically focus on

formerly inadmissible in fiction, sexual desire spoken in an unre-pressed way by Molly and incestuous desire in Bloom and HCE, in a sense to free desire from the limitations of a predictable and oppressive return of repression. By having ALP as river return to the sea, described at the end of the *Wake* as her 'cold mad feary father', Joyce metaphorically or symbolically gives voice to the for-merly inexpressible, I believe, in a deliberate way. At the end of both *Ulysses* and *Finnegans Wake*, the final word is given to the women, and in Molly's final 'yes' and in ALP's return to the sea Joyce privileges woman's sexuality, hitherto repressed. This lifting of repression can be seen in both novels and operates not only in terms of freeing sexual desire but also in liberating the minds of the readers. As a reader of Joyce, a problem remains for me at the end of the *Wake*. Is ALP's return to her father a depiction of her incestuous return to origins – an enactment of Freud's theory of the sexual desire of the female child for the father? I think yes, and the book's circularity seems to attest to the never-ending nature of that desire, because it will be repeated *ad infinitum* as will the story of HCE's incestuous desire for Issy. In addition, I believe that the desire of HCE for Issy incites or provokes the return of ALP to her father the sea, as ALP and Issy are combined into one figure who recipro-cates HCE's desire. The problem I see in the *Wake* is that Joyce seems to privilege or celebrate incestuous desire at the end, or is this Joyce's (and Freud's?) reduction of desire to its primal state?

The intriguing essays in Friedman's collection are seminal for further studies of the nature of desire in Joyce's works and, like Fairhall's work, call for greater consideration of the issue of Joyce's politics and use of history.

Morehead State University

Stephen Speed

Veronica Kelly and Dorothea E. von Mücke (eds), *Body and Text in the Eighteenth Century* (Stanford: Stanford University Press, 1994), 349 pp., £32.50 (hardback), £11.95 (paperback)

Jonathan Sawday, *The Body Emblazoned: Dissection and the Human Body in Renaissance Culture* (London & New York: Routledge, 1995), 327 pp., £35 (hardback)

In their Introduction to *Body and Text in the Eighteenth Century* Veronica Kelly and Dorothea E. von Mücke succinctly locate the theoretical cutting edge of the project: '. . . we emphasise the need to

and space, I shall dwell on only a few of these essays that indicate in a remarkable way the theme of the return of the repressed.

In 'The preservation of tenderness: A confusion of tongues in *Ulysses* and *Finnegans Wake*', Marilyn L. Brownstein seems to make *Finnegans Wake* a *supplement* to *Ulysses* (in the sense of a completion or fulfilment of what is left out in the earlier text) in that the incestuous desire of Bloom for his daughter Milly in *Ulysses* is fulfilled at the end of the *Wake*, where the mother as ALP returns to her father, the sea, metaphorically fulfilling the incestuous desire. Using Sandor Ferenczi's therapeutic model for treating female victims of paternal incest, where a maternal presence in the therapy permits the incest trauma to be healed, Brownstein constructs a theoretical model for reading the *Wake* whereby the paternal sin is remediated through maternal language, and she grounds some of her conclusions in linguistic theory.

Carol Ellen Jones in 'Textual Mater: writing the Mother in Joyce' describes Joyce's writing as transgressive of all sexual, philosophical, political and social laws, with an incestuous relation to language. Using Derridean deconstruction of the trace and origin, she describes the maternal body as the origin of what is repressed in language. She contends that the virgin maternal represents the return of the repressed in monotheism. The mother in the *Wake* exists in the parentheses of language as obliterated. Joyce is seen as giving voice to the mother; in presenting motherhood with a language, he accords it a symbolic status.

Christine Froula in 'Mothers of invention/doaters of inversion: Narcissan scenes in *Finnegans Wake*' studies narcissistic strategies in Joyce's art – to 'mother' himself and to reinvent himself. In *Portrait*, the scene of writing is staged as narcissistic. Artistic creativity releases the female soul from the male body, as in seen in the villanelle scene in *Portrait*. Earlier in the novel, Stephen, looking into his mother's mirror after having written his poem to E. C. after the tram ride, is seen by the author as acting out of the desire to recover an archaic, mother-identified self through his creation of a work of art. The mother-identified self is what was repressed in Joyce's text, and what returns in this scene.

Fairhall's book and Friedman's collection show Joyce as a writer totally engaged in 'deconstructing' logocentrism in history and in language. Joyce is seen as striking against the logos in preferring Viconian and 'unofficial' history to linear historical narratives and in admitting the unconscious in the text through the disruption of conventional linguistic form and traditional plotting and characterization. Moreover, the transgressive Joycean texts expose what was

ruptured form and content of the novel – a novel in which the writer describes a day in 1904 in the pre-war past in Dublin from the perspective of an avant-garde literary art very conscious of and influenced by those political and social events. The next chapter, 'Reforming the Wor(l)d', shows Joyce's writing in *Finnegans Wake* as a protest against patriarchal power and phallocentric language by its use of a 'femiline riverspeech', a phrase that describes, for example, the language of ALP at the end of the book as she floats as river out to the sea to meet her 'feary father' and as a compendium of all history. There are historical personages in the *Wake* who merge and re-emerge in endless combinations, and Fairhall describes this as Joyce's deconstruction of essentialist history. Changes in Irish history result in changes in the psyche of HCE, showing that Joyce considers history as both individual and national. Joyce's history destabilizes the borderline between colonial and native. The *Wake* is seen by Fairhall as anti-national, anti-racist, and anti-facist.

The importance of Fairhall's book lies in its attention to the issue of Joyce's politics. Joyce, traditionally seen as a non-political writer, is shown here to have made abundant use of history and politics in his works, although his own perceptions remained those of the Irish middle-class, educated artist whose political intentions, if we could call them political, lay in reforming the minds of his readers rather than in encouraging political action.

To place the Friedman collection on the vicissitudes of the subject in Joyce's fiction in the same review with Fairhall's study of the question of history in Joyce's works seems disharmonious, yet this seeming incompatibility disappears in the consideration that Joyce's intention to deconstruct logocentric, teleological history meets his effort to deconstruct the unified subject, the topic of Friedman's book. *Joyce: The Return of the Repressed* deals with a subject not in command of its autonomy, and, as the title suggests, Freud's theory of the return of the repressed destabilizes and disestablishes the nature of an autonomous subject. Joyce, like Freud, shows the working through and emptying out of what is repressed to prevent its once-predictable and oppressive return. *Joyce: The Return of the Repressed* contains ten essays by notable Joyce scholars, covering *Stephen Hero, Dubliners, Portrait, Ulysses*, and *Finnegans Wake*. All of the essays take up the issue of the return of the repressed in Joyce's works, founded on theories of the textual and political unconscious. What is repressed ranges from Stephen's resistance to and flight from family, church, and state, sexual desire, and the wish to be an artist in *Portrait*, to Bloom's and Molly's desires in *Ulysses*, to narcissism and incest in *Finnegans Wake*. In the interests of time

Room', politically informative and based on the real 1902 and 1903 Dublin municipal elections. The story shows the contrast between Parnell and his unworthy successors, without any interest in Dublin's poor, a characteristic of Joyce's writing in general. Fairhall makes the point that Joyce was formed by a middle-class upbringing, and middle-class values remained although the family of John Joyce became progressively less comfortable and reached poverty at the time of May Joyce's death. Although family poverty disturbed Joyce, he never embraced nor dwelt in his fiction on the values of the poor; and his treatment of women in life and in his fiction reveals as well his middle-class biases. He was affected by political events in Ireland, seeing Sinn Fein in 1906, for example, as Ireland's best hope since Parnell. Fairhall describes the major political conflict for Joyce as that between a nationalism he disliked and a socialism he could not accept; he could not reconcile the nationalist hero Parnell and the socialist Connolly. When Connolly was executed by a British firing squad, the socialism already absent from Joyce's story went out of Irish history.

Fairhall shows how, in *Portrait*, Joyce combines Stephen Dedalus's personal story with the story of Irish history, until the end when Stephen announces that in exile he will forge in the smithy of his soul the uncreated conscience of his race. That lofty aim is undermined by the beginning of *Ulysses*, where Stephen as fallen Icarus is a weltering 'lapwing'. This same pattern of rise followed by fall or aspiration followed by disillusionment can be seen in the first three stories of *Dubliners*, where the boy-narratives show Joyce's depiction of the relation between history and 'personal story', between society and the artist. The entire collection shows the Irish paralysis (or 'hemiplegia' of the will as he described it) that he hated and that he would have lived had he remained in Dublin. The real life situation of the Joyces in exile in Europe did not, however, permit much of the freedom Stephen sought at the end of *Portrait*, and poverty, financial dependence, and eviction were common to the Joyces for many years.

In the chapter entitled '*Ulysses* and the Great War', Fairhall attempts to link the novel with the historical processes that occurred before, during and after the war. It should be remembered that the Great War of 1914–1918 was experienced by Joyce as an Irish National, exiled in neutral Switzerland, where he could see the national and imperial rivalries and technological and social changes that caused the war. During and after the war he wrote *Ulysses*, and we can detect the similarity between the political and social disruptions brought about by the war and the fragmented, decentred, and

radical left of a famous thesis by the originator of historical material-
ism, which Jackson paraphrases: 'You cannot make the world differ-
ent by changing the structure of your narratives about it. (Changing
consciousness or ideology.) You can only change the world by doing
something to it. (By revolution or by labour.)' (p. 167).

Bethany College, Kansas

Rosemarie Battaglia

James Fairhall, *James Joyce and the Question of History* (Cambridge:
Cambridge University Press, 1993), 304 pp., £37.50 (hardback), £13.95
(paperback)

Susan Stanford Friedman (ed.), *Joyce: The Return of the Repressed* (Ithaca,
NY: Cornell University Press, 1993), 328 pp. £42.50 (hardback), £13.95
(paperback)

The first chapter of Fairhall's book examines the murders in Dublin's
Phoenix Park of Lord Frederick Cavendish, Chief Secretary for
Ireland, and Thomas Henry Burke, for many years Cavendish's Per-
manent Under-Secretary, on 6 May 1882. The murders were
attributed to the Irish National Invincibles, and Fairhall shows how
the story of the Phoenix Park murders centrally informs *Ulysses*.
Joyce's vision of history is the major topic of Fairhall's well-
researched and well-documented book, which I read with as much
interest as a related earlier study, *Joyce's Politics* by Dominic Mangani-
ello. Fairhall is careful to describe Joyce's interest in but non-involve-
ment in politics. Joyce never participated in any political action, but
the characters in his fiction reveal his interest in politics. Movements
for Irish nationalism in his time caught his interest only as part of
the fabric of Irish history, one of the 'nets' flung to catch his soul,
as he has Stephen Dedalus describe nationality in *Portrait*. The author
points out, however, that his novels are Joyce's political statement,
rejecting the dominant ideologies of church and state to provide
freedom for the artist. Joyce read Vico's *The New Science* and was
influenced by Vico's rejection of 'official history', as can be seen in
Ulysses and *Finnegans Wake*. He found justification for his use of
myth and popular (or 'unofficial') history in Vico, and like Vico he
wanted freedom from tradition and linguistic convention. Fairhall
describes how Joyce felt politically – as a socialist, a left-wing liberal,
a Vichian, a nationalist and an anarchist. Yet he chose not to act,
reserving his writing as his politics.

Fairhall takes up Joyce's story 'Ivy Day in the Committee

ian forms of the history of ideas, institutions and types of subjectivity'
(p. 259).

But if Jackson is unmerciful to the cultural materialists and
various post-Marxists, he is kind indeed to the 1930s English writer
Christopher Cauldwell, whose reputation within the materialist criti-
cal tradition has been ravaged by charges of 'Stalinism' and 'vulgar
Marxism'. In an effort to rehabilitate Cauldwell, Jackson argues that
his work 'represents . . . a remarkably ambitious and (I think) success-
ful attempt to think through a consistent view of both art and science'
(p. 136). Although Cauldwell's history of English poetry, contained
in the long ignored *Illusion and Reality*, may seem to offer a 'mechan-
istic view of culture', such an impression 'is an artefact of the summa-
rising procedure' employed by Cauldwell in a chart labelled 'The
Movement of Bourgeois Poetry'. Once we put that chart into per-
spective, Jackson states, we realize the enormity of Cauldwell's enter-
prise, which is nothing less than 'the reinterpretation, on an economic
basis, of all the English poets' (p. 131–3).

Jackson's defence of Cauldwell, and his efforts to 're-materialize'
the ghost of Marxist-theory-past by exhuming the principle of eco-
nomic causality, might well lead confirmed post-Marxists to view
him as a curious atavism: an economic determinist (albeit in liberal-
humanist clothing) who has failed to grasp the fine points of the
theoretical developments of the last thirty years. And yet Jackson is
no champion of vulgar Marxism. He is quite clear in stating that
nobody 'has ever supposed that economic factors provide a complete
explanation for superstructural phenomena; still less, that the super-
structure can be reduced to the economic "base" ' (p. 4). The theory
that he finally recommends, in the last section of this stimulating and
challenging book, is causal, rather than reductive. Ironically, it is also
referred to by the name 'cultural materialism'; however, this version
has its origins in Marx, Engels, and the cultural anthropologist Marvin
Harris, rather than the work of Williams and his followers. Jackson
writes that a *truly materialist* cultural materialism 'includes, but goes
beyond, what a Marxist would call the forces and relations of pro-
duction'; it also pays attention to problems of population density
and ecology, which have been neglected in much traditional Marxist
analysis (p. 248). In outline form, this programme seems perfectly
compatible with a Marxist political agenda; however, Jackson is ada-
mant that he has no use for 'radical politics'. Liberal democracy, with
all its problems, is still preferable, he believes, to the Gulags that
have been produced by virtually all Marxist regimes. But his critique
of those regimes aside, Jackson's withering survey of the academy's
current crop of (idealist) Marxists is a necessary reminder to the

and women who have spent the better part of the last two decades 'beavering away at the necessary tasks of destroying theoretical humanism and undermining Western rationality' have done so 'without quite realising the absurdity of the enterprise' (p. 2). While these politically committed critics have been 'operating at the level of ideological representations', tirelessly debating how to end class, race, and gender oppression, Conservative politicians have 'exercise[d] power by operating on the economy first, and getting round to the curriculum a decade or more later' (p. 1). Thus, 'Marxists, and others on the radical left, have lost the class war by turning into idealists; Conservatives have won it by operating on strict materialist principles' (p. 1). This irony at the expense of the left, in Jackson's view, is largely attributable to the influence of a strain of Marxism running from Lukács and Gramsci to the Frankfurt School and Althusser. The content of 'Western Marxism', he argues, 'matched its conditions of production' (p. 145). In its preoccupation with cultural theory and its neglect of 'analytical economics' (p. 145), Western Marxism was a response to the failure of the revolutionary aspirations of the international communist movement. Unlike many early Marxists, who optimistically forecast the collapse of capitalism and the success of the proletariat, later Marxists were compelled to theorize the experience of political defeat. In the hands of these writers, who began to see cultural transformation as a precondition of economic change, Marx was turned upside down and historical materialism went bust. Culture theory boomed, however, and its latest practitioners, in Jackson's view, are even more hostile to the concept of the economic last instance than their Western Marxist forebears.

Much of Jackson's book, then, oscillates between an attack on the wrong-headed idealism of various neo-left Hegelians who masquerade as Marxists and an education in a properly materialist theory of culture. In the process, Jackson grinds axes on the heads of a number of left-wing icons, including Raymond Williams, whose criticism of the base/superstructure metaphor has led many cultural (im)materialist acolytes down a dead-end theoretical road in search of effects without (economic) causes. As Jackson writes, these critics 'are deliberately non-economistic; they are consciously trying to get away from the "base-superstructure metaphor" whereas they ought to be consciously trying to explain as much as possible in terms of it – or, more precisely, in terms of a theory (not a metaphor) of economic causation' (p. 259). Jackson applies the same criticism to 'other types of post-Marxist theory: for example to the neo-Gramscian framework of analysis of popular culture and to Foucauld-